Women's Human Rights Step by Step

A Practical Guide to Using International Human Rights Law and Mechanisms to Defend Women's Human Rights

by
Women, Law & Development International
and
Human Rights Watch Women's Rights Project

Women, Law & Development International
Washington, D.C.

Editors
Margaret A. Schuler
Dorothy Q. Thomas

Principal Writers
Julie Mertus
Florence Butegwa
Dorothy Q. Thomas
Margaret A. Schuler

Contributors
Rosa Briceño
Katherine Culleton
Sheila Gymiah
Athaliah Molokomme
Binaifer Nowrojee
Regan Ralph
Lourdes Indai Sajor

Technical Assistance
Gladys Acosta
Ariane Brunet
Andrew Byrnes
Christine Chinkin
Rebecca Cook
Rhonda Copelon
Joana Foster
Akua Kuenyehia

Design
Xanthus Design, Washington, DC

Copyright © 1997 by Women, Law & Development
International and Human Rights Watch
ISBN: 1-890832-00-6
Library of Congress Catalog Card Number: 97-60863

Printed in the United States of America

Acknowledgements

This manual reflects the input and assistance of many people over the two years since we started the project. We would like to acknowledge in particular the principal writers, contributors and technical advisors without whose guidance, expertise and commitment, the book simply would not have been possible. In addition, special thanks are due to Alda Facio, Ann Goldstein, Tokunbo Ige, Ariane Brunet, Cristina Cerna, Mahnaz Afkhami, Shireen Huq, Shanthi Dairiam, Roberta Clarke, Isabel Duque, Sharon Hom, Radhika Coomaraswamy and Sonia Picado. All offered much appreciated, valuable advice and support throughout the process and for that we are also grateful.

Finally, thanks to Xanthus Design for their ideas and assistance in the design and layout of the book and to Sara Hartfeldt, Seema Kumar, Rebecca Sewall, Sneha Barot, Kristen Noth, and Kerry McArthur for their invaluable help in the final preparation of the manuscript.

Women, Law and Development International

Women, Law and Development International (WLD) is a non-governmental organization committed to the defense and promotion of women's rights globally. Through capacity building for advocacy and issue and strategy development, WLD works to build the capacity of women around the world to be advocates for their own rights. The staff includes Margaret A. Schuler, executive director, Marcia Greenberg, democracy and governance Specialist, Seema Kumar, director of Administration, Astrid Aafjes, research associate, Rebecca Sewall, director of social research, Sara Hartfeldt, executive assistant, Tracey Knox, administrative assistant, Gabrielle Fitchett, director Russia office, Larissa Ponarina project associate. Board members include Florence Butegwa Uganda, Chair of the Board, Shireen Huq, Bangladesh Akua Kuenyehia, Ghana, Roberta Clarke, Trinidad and Tobago, Irina Mouleshkova, Bulgaria, Judy Lyons Wolf, USA, Sakuntala Rajasingham, Sri Lanka/USA, Gladys Acosta, Colombia, Nancy Duff Campbell, USA, Willie Campbell, USA, Radhika Coomaraswamy, Sri Lanka, Noeleen Heyzer, USA/Malaysia, Asma Jahangir, Pakistan, Athaliah Molokomme, Botswana, Sonia Picado Sotela, Costa Rica, Dorothy Q. Thomas, USA.

1350 Connecticut Avenue, NW
Suite 407
Washington, DC 20036- 1701 USA
Tel: +1-202-463-7477
Fax: +1-202-463-7480
E-mail: wld@wld.org
Website: http://www.wld.org

Human Rights Watch Women's Rights Project

Human Rights Watch is a nongovernmental organization established in 1978 to monitor and promote the observance of internationally recognized human rights in Africa, the Americas, Asia, the Middle East and among the signatories of the Helsinki accords. It is supported by contributions from private individuals and foundations worldwide. It accepts no government funds, directly or indirectly. The staff includes Kenneth Roth, executive director; Michele Alexander, development director; Cynthia Brown, program director; Barbara Guglielmo, finance and administration director; Robert Kimzey, publications director; Jeri Laber, special advisor; Lotte Leicht, Brussels office director; Susan Osnos, communications director; Jemera Rone, counsel; Wilder Tayler, general counsel; and Joanna Weschler, United Nations representative. Robert L. Bernstein is the chair of the board and Adrian W. DeWind is vice chair.
The Women's Rights Project was established in 1990 to monitor violence against women and gender discrimination throughout the world. Dorothy Q. Thomas is the director; Regan E. Ralph is the Washington director; Samya Burney and LaShawn R. Jefferson are research associates; Evelyn Miah and Kerry McArthur are administrative associates. Kathleen Peratis is chair of the advisory committee and Nahid Toubia is the vice chair.

485 Fifth Avenue
New York, NY 10017-6104 USA
Tel: +1-212-972-8400
Fax: +1-212-972-0905
Website: http://www.hrw.org

iv

Contents

Introduction

The Manual, Purpose and Users 2
Why women's human rights 2
Why was the manual written 3
How can the manual be used 4
How is the manual organized 5

Chapter One

INTERNATIONAL HUMAN RIGHTS 8
What are human rights? 8
How did human rights develop? 8
Where do we find human rights law? 11
How are human rights standards enforced? 12
 Types of enforcement mechanisms 13
What types of procedures do the mechanisms entail? 15
 Complaint procedures 15
 Monitoring and reporting procedures 17
Where are enforcement mechanisms found? 17
 National human rights mechanisms 17
 International human rights mechanisms 18
How should mechanisms be evaluated? 19
 Type of procedure 19

Chapter Two

UN HUMAN RIGHTS SYSTEM 24
UN Committee on Human Rights 24
 Special Rapporteurs and Working Groups 32
UN Committee on the Elimination of Discrimination
Against Women 36
1503 Procedure 40
The International Labour Organisation (ILO) 45
Commission on the Status of Women 50
UN High Commissioner for Refugees 52

Chapter Three

REGIONAL HUMAN RIGHTS SYSTEMS 58
The European Human Rights System 58
 Council of Europe 59
 Organization on Security and Cooperation in Europe 76
 The Institutions of the European Union 80
The Inter-American System 85
 Inter-American Commission on Human Rights 86
 Inter-American Court of Human Rights 94
 Inter-American Commission on Women 98
The African System 101

Chapter Four

NATIONAL HUMAN RIGHTS SYSTEMS **108**

How do national human rights systems work? 108

Are there strategies for using international law nationally? 110

What are the benefits of national human rights systems? 111

What are the drawbacks of national systems? 112

Chapter Five

HUMAN RIGHTS ADVOCACY **116**

What is advocacy? 116

What is human rights advocacy? 117

What makes human rights advocacy effective? 118

Strong organization and leadership 118

A compelling human rights issue 119

Clear definition, documentation and analysis of the issue 120

A dynamic strategy 120

An appreciable constituency or support group 125

Effective communication and education 126

Visible mobilization and action 127

Chapter Six

INVESTIGATING VIOLATIONS **138**

Why investigate and document? 139

Preparation 140

Fieldwork/Investigations 145

Follow-up and analysis 149

Chapter Seven

STEP-BY-STEP GUIDE TO HUMAN RIGHTS ADVOCACY **156**

Choose the issue 156

Research the human rights issue and explore solutions 156

Set objectives and demands 157

Design the strategy 157

Educate the public and gain support 158

Secure required resources 158

Mobilize for action and implement the strategy 159

Evaluate the advocacy effort 159

Appendices

Glossary of Terms 162

List of Human Rights Instruments 172

Status of Treaty Ratifications 174

Bibliographical Resources 180

NGO's Resources: International Women's Human
Rights Advocacy Groups 188

List of Human Rights Offices 194

Preface

In the past decade, women from all over the world have launched an unprecedented international movement for women's human rights. At the 1985 UN World Conference on Women in Nairobi Kenya, human rights began to emerge as a key issue for women, although it was hardly mentioned in the Conference's official declaration. By the 1995 World Conference on Women in Beijing, human rights had been taken up by thousands of women and became the framework for the entire government plan of action. At intervening world conferences in Vienna (human rights), Cairo (population) and Copenhagen (social development), women's rights activists challenged the neglect of women and their rights in all of these areas and argued that the improvement of women's status anywhere depends on advancing their rights everywhere.

The effect of this activism has been remarkable, particularly at the international level. For the first time in history, governments have committed themselves to protect and promote women's human rights as a "high priority." They have acknowledged the widespread use of rape as a tactical weapon of war and included its prosecution in the mandates of the ad-hoc criminal tribunals for the former Yugoslavia and Rwanda. The United Nations Human Rights Commission has appointed a Special Rapporteur on Violence Against Women, the UN General Assembly has adopted a Declaration on Violence Against Women and the Organization of American States has established a new regional convention against violence.

Yet, despite these and other promising changes in international law and policy, women the world over still face a day to day reality that is characterized by the denial of their fundamental human rights. Moreover, they too often lack the tools and training needed to shape and use the human rights system to combat abuse and advance their rights. Many women are unaware of their human rights, have no knowledge of the women's human rights movement and see the human rights system—to the extent they are aware of it at all—as something abstract and beyond their reach. Thus, while activism over the last decade has clearly made women's human rights more visible, the challenge now is to make them more accessible.

Awareness of rights must extend beyond the international human rights elite to every woman. Human rights literacy must include not only awareness but the capacity to assert rights. This means understanding the various levels of human rights protections and their

institutional mechanisms of enforcement. It means recognizing the legal and political options and alternatives available and acquiring the skill to shape the strategies and alliances that are fundamental to the assertion of rights.

Women's Human Rights Step by Step: A practical guide to using international human rights law and mechanisms to protect women's human rights is designed to empower women to bring human rights home. In creating it, Women, Law and Development International and the Women's Rights Project of Human Rights Watch have benefited greatly from the input of women (and some men) from many different parts of the world who have been active both in shaping the human rights system to be more responsive to women's human rights concerns and in applying that system to secure concrete changes in women's everyday lives. In drawing on their experiences, and on the growing body of research in this area, we sought to create a resource that would demystify the human rights system, demonstrate its accessibility to women and detail—step by step—how activists can use it to build powerful advocacy strategies.

Margaret A. Schuler
Women, Law & Development International

Dorothy Q. Thomas
Women's Rights Project Human Rights Watch

June, 1997

THE MANUAL, PURPOSE AND USERS

What is the manual about?

This manual is about women's human rights in practice. It describes in simple language and in a practical manner the concept and content of human rights law and its application to women and to the rights issues of concern to them. Designed as a basic guide to the operation of human rights mechanisms and strategies at national, regional and international levels, the manual explains why and how to use these strategies and mechanisms to promote and protect women's human rights. Given the diversity of organizations, institutions and individuals working to promote women's human rights, the manual is designed as a flexible tool, adaptable to different cultural, legal and political contexts. It offers a wide range of possible strategies to consider in defending the human rights of women.

Why women's human rights?

Every human being is entitled to enjoy human rights and to have them protected by the laws and practice of her/his country of residence. Under international human rights law, women and men alike are vested with fundamental freedoms and human rights without regard to characteristics such as sex and race. Regardless of cultural particularities, religious tenets and levels of development, women all over the world are entitled to enjoy human rights. There are three main reasons for calling attention to women's human rights:

1 *To inform women that they have human rights and are entitled to enjoy them.*
Women cannot meaningfully exercise their rights unless they know they have them. It is through awareness and knowledge that women can exercise their rights and use national, regional and international human rights systems to demand protection. Information on women's human rights also helps women recognize cultural practices and national laws that violate their human rights.

2 *To expose and combat rights violations that are based on sex or gender.*
Historically, human rights practice has failed to recognize rights violations in which being female is the risk factor. Some of these violations are justified on the basis of biological differences (e.g. a woman's capacity to be pregnant). Others are based on gender, or the socially constructed roles and values ascribed to women (e.g. "home-making"). In either case, abusive laws or practices motivated or justified by sex or gender have

not yet gained full international recognition as human rights violations. Writing and talking about women's human rights creates an opportunity for women, men and organizations interested in promoting a life of dignity for all human beings to work towards recognition of these practices as violations of the human rights of women.

3 To shape a new human rights practice that fully addresses the human rights of women.

Although existing human rights aim to protect all human beings, male or female, in practice human rights have not been applied equally. The understanding of how human rights could or should protect women remains underdeveloped. Advocates for human rights often lack adequate theory and methods to investigate gender- or sex-based violations. Standard methods of investigation do not necessarily encompass gender nor do they always make the necessary link between the state and action by private individuals, who are often the immediate culprits in many violations of women's human rights. Another difficulty is that human rights mechanisms (like the United Nations Commission on Human Rights) have not adequately developed procedures that facilitate women's access to them. Many women are not aware of the existing mechanisms and how to make the best use of them. Writing and talking about women's human rights creates an opportunity for academics and practitioners to develop a human rights jurisprudence with specific reference to women.

Why was the manual written?

Human rights play an increasingly important role in relationships between states and in national politics, particularly as calls for democracy intensify throughout the world. In different contexts, advocates perceive the human rights framework as having great potential to further aspirations for social justice, including the elimination of discrimination against women and greater protection of children, prisoners, indigenous peoples and other socially and economically disadvantaged groups.

It is within this tradition of social justice that in recent years tens of thousands of activists from around the world began to coalesce as a movement for the recognition and protection of women's human rights. Many had been advocates of women's rights at local and national levels using national laws. Others were involved in movements for economic empowerment, women's health and education and other women-specific issues. Those joining this growing movement all came to believe that human rights could provide a powerful additional tool for advancing women's interests.

Until recently, however, human rights law and practice were not generally applied to women and many of the rights violations they suffer. Most human rights organizations and advocates had relatively little experience with women's human rights issues. The "mystification" of international law further served to maintain human rights practice as the singular domain of specialized human rights professionals. Even today, human rights materials provide little guidance to those wishing to promote and defend women's rights within a human rights context. There are few easily accessible and understandable materials that illustrate the link between women's concerns and human rights. In most cases traditional approaches to investigating rights violations need to be revisited and modified to address women's human rights.

Thus, despite the new passion for women's human rights, many advocates have limited understanding about the workings of the human rights system at

national, regional and international levels. They do not know how to access existing human rights bodies or how to influence their work. They lack skills in monitoring and documenting abuses of women's rights and knowledge of how best to report them for effective impact.

Without mastery of technical concepts and skills, women's human rights advocates are too often left with little to work with but slogans and enthusiasm. This manual was developed to fill this gap. It provides an educational tool designed to:

- help women's rights advocates appreciate the relevance and importance of human rights law and mechanisms in the promotion and defense of women's rights;
- provide information on how to use the human rights system at national, regional and international levels;
- explain in some detail the importance and methods of documenting and reporting violations of women's human rights;
- outline key advocacy strategies that can be used to promote women's human rights; and
- demonstrate, through cases and experiences, how women's human rights advocates are already using the human rights system to enforce their rights.

How can the manual be used?

The manual is intended for all organizations and individuals working to promote women's human rights. Particularly, it is meant to be used by:

- organizations and individuals working on women's issues and wishing to incorporate the human rights framework into their work;
- organizations and individuals working on human rights issues and wishing to incorporate women's rights into their work;
- groups seeking to plan and implement strategies to influence governments, UN bodies and other key players

whose work has significant impact on women's human rights;

- organizations with experience in women's human rights but which have reached a stage where they need additional tools to plan strategies for enforcing women's human rights through regional and international mechanisms; and
- organizations and individuals whose work involves training groups on how to use the human rights system in defense of women's rights.

The manual is not prescriptive–not everything in it will be relevant to every context–but it does offer a point of view, a framework for building strategies and concrete suggestions for initiating women's human rights advocacy. It is intended to be a flexible tool for a very broad constituency of women's human rights advocates from different regions and socio-legal and political contexts.

It can also be used for more diverse purposes. It can be used as a beginning "course" for activists on the key concepts of human rights law. It can be used as a reference to selected human rights mechanisms for understanding the structure and process of the human rights system. It can be used as a process tool for developing strategies geared toward various objectives within the arena of women's human rights. It can also be used as a guide for planning and carrying out an investigative mission to document abuses and for setting up ongoing monitoring activities.

In addition to providing synthesized, factual information, the manual is designed to help advocates and activists sort out:

- issues that need to be considered and decisions that should be made when crafting a women's human rights advocacy strategy;
- components that might be included in a strategy;
- advantages and disadvantages of

various approaches;

- creative ways to use human rights mechanisms; and
- methods for conducting rigorous fact-finding and documentation of violations and monitoring on-going human rights performance.

In order to create a strategy that will suit specific circumstances, it is incumbent upon users to appropriate the ideas, examples and suggestions in the manual and then to apply them to their own particular contexts. The manual offers advice, information and an orientation to human rights strategy building, but in the end, it is the activist who must make the relevant choices, decide what to do and carry out the strategy.

It should also be noted that while this manual provides an introduction to and an overview of women's human rights advocacy, it is not exhaustive on the topic. In many cases, additional informa-

tion will be needed and more targeted research will be required. For example, updated facts about a particular mechanism may be needed before deciding to use it. More research on existing jurisprudence may be essential to building a case as a specific strategy develops. *Women's Human Rights Step by Step* offers suggested further reading on these topics.

How is the manual organized and how should it be read?

The manual is organized into six chapters covering various aspects of women's human rights advocacy. The first chapter presents key human rights concepts and their relevance to women's rights. Subsequent chapters introduce and explain different mechanisms and strategies for enforcing women's human rights at national, regional and international levels and the challenges still facing women's human rights advocates in these areas.

Throughout the manual, there are

Contents Overview

Chapter One: International Human Rights

Introduces the human rights framework and its significance as a tool for addressing women's human rights.

Chapter Two: The UN Human Rights System

Describes International human rights systems and mechanisms and explains how they work and how to access them.

Chapter Three: Regional Human Rights Systems

Describes Regional human rights systems and mechanisms and explains how they work and how to access them.

Chapter Four: National Human Rights Systems

Describes National human rights systems and mechanisms and explains how they work and how to access them.

Chapter Five: Human Rights Advocacy

Introduces and explains the concept of human rights advocacy for demanding accountability for women's human rights and explores characteristics of effective advocacy efforts.

Chapter Six: Documenting Human Rights Violations

Describes, step-by-step the process of investigating and documenting violations of women's human rights and reporting them to the human rights community.

Chapter Seven: Guide to Human Rights Advocacy

Presents a step-by-step guide for constructing a strategy together with questions and issues needing resolution at each step of the way.

The Appendices

Offer reference materials including a glossary of terms, a list of instruments, and an address list of human rights offices in various countries and of institutions associated with the mechanisms covered in this manual.

charts, checklists, "words to the wise" and case studies to assist the reader in understanding and using the material presented.

A final word of advice as you grapple with the best ways to approach women's human rights advocacy. . .

Be flexible, be creative! Remember that the human rights system itself developed as a result of people's commitment to finding effective means to assure the universal respect for human dignity. Your advocacy initiatives to promote and defend women's human rights contribute to this process and are essential to the continued development of human rights. There's no one way to do human rights advocacy. Every innovation and new idea helps us all in our quest to assure universal and consistent respect for women's rights.

To make the best use of this manual, here are a few suggestions for reading

- *Look at the table of contents* to see how the manual is organized and what it covers.

- *Read the manual with constant reference to the Glossary of Terms.* Since many of the terms are technical in nature, they cannot be substituted with "vernacular" expressions and still maintain conceptual integrity.

- *Reinforce the reading of the text with attention to the boxes and charts* highlighting significant ideas.

- *Refer to the reference section* (Appendix 2) as needed. Although footnotes are not used within the text, the reference section lists source books and articles used in preparing this manual and provides a reading list for further study.

- *Read the manual several times,* giving attention to different aspects each time. Here is a suggestion on how to read the manual:

 Begin with Chapter One (introducing the human rights system), reading it with careful attention. It provides a basis for understanding some key human rights concepts and the structure of the system.

 Skim Chapters Two, Three and Four (covering national and international mechanisms and systems), with attention to the overall structure and kind of information contained therein, but not focusing on specific mechanisms in the first reading.

 Read Chapters Five (the human rights advocacy process) and Six (on investigating and documenting violations), paying attention to the process of strategy development. It is important to keep this framework in mind throughout the study of the human rights system, so as not to get bogged down in technical details or forget that the power of human rights advocacy is anchored in committed and critical activism.

 Return to Chapters Two, Three and Four, giving special attention to those mechanisms that seem relevant to your specific issue or case.

- *Work through the advocacy steps* with a specific issue or case in mind, with emphasis on those aspects of the process that seem most relevant.

- *Refer to the Appendices to identify additional reading or contacts,* if needed, to complete the strategy design.

INTERNATIONAL HUMAN RIGHTS

1

THE HUMAN RIGHTS SYSTEM

What are human rights?

Human rights are those rights that every human being possesses and is entitled to enjoy simply by virtue of being human. At the 1993 World Conference on Human Rights, governments reaffirmed in the Vienna Declaration that human rights are the birthright of all human beings and that the protection of human rights is the first responsibility of governments. Human rights are based on the fundamental principle that all persons possess an inherent human dignity and that regardless of sex, race, color, language, national origin, age, class or religious or political beliefs, they are equally entitled to enjoy their rights.

The 1993 World Conference also specifically recognized the human rights of women and the duties of states to protect and promote such rights, including the right to freedom from violence. Most national, regional and international systems and mechanisms for enforcing human rights have been developed and implemented mainly with a male model in mind and, to date, the human rights system has not adequately taken into account the experiences and circumstances of women. This scenario is changing, however. Advocates for women's rights are increasingly using human rights to demand redress for injustices in women's lives.

The concept of human rights and human rights law is dynamic in nature. Although a range of fundamental human rights has already been legally recognized, nothing precludes existing rights from being more broadly interpreted or additional rights from being accepted at any time by the community of states. It is this dynamism that makes human rights a potentially powerful tool for promoting social justice and the dignity of all people. Human rights thus acquires new meaning and dimension at different points in history as oppressed groups demand recognition of their rights and new conditions give rise to the need for new protections.

How did human rights develop?

Current international human rights obligations are rooted in the Charter of the United Nations. Established on universally accepted principles of human dignity, the founding of the United Nations represented a critical point in the evolution of human consciousness. The trauma of World War II, the widespread abuses of people and groups—including genocide, mass killing and other forms of violence against humanity— motivated governments to demand and set standards for the treatment of people by their own governments.

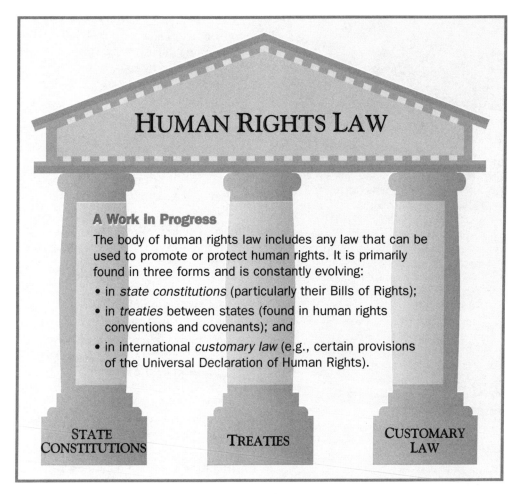

HUMAN RIGHTS LAW

A Work in Progress

The body of human rights law includes any law that can be used to promote or protect human rights. It is primarily found in three forms and is constantly evolving:

- in *state constitutions* (particularly their Bills of Rights);
- in *treaties* between states (found in human rights conventions and covenants); and
- in international *customary law* (e.g., certain provisions of the Universal Declaration of Human Rights).

STATE CONSTITUTIONS TREATIES CUSTOMARY LAW

The first attempt to codify such standards was the Universal Declaration of Human Rights (UDHR) in 1947. The Declaration has come to be recognized as a common standard for all peoples and all nations to strive for in the promotion of human dignity. Among the rights enshrined in the Declaration are the rights to equality; freedom from discrimination; life, liberty and security of the person; freedom from slavery, torture or degrading treatment; recognition as a person before the law to seek a remedy by a competent tribunal; and freedom of expression and political participation.

Established to oversee and implement the UN human rights system, the United Nations Commission on Human Rights held its first regular session in February 1947. In addition to framing a declaration (the Universal Declaration of Human Rights), the Commission also established a *convention* (later divided into two sections and called *covenants*) as well as *mechanisms*, or measures, of implementation, including complaint, monitoring, reporting and other procedures.

The General Assembly of the United Nations adopted the Universal Declaration on December 10, 1948. Like most recommendations of the General Assembly, the UDHR was non-binding. Indeed, countries never ratified the UDHR as they would a formal treaty that creates legally binding obligations. However, most commentators now agree that most provisions of the Declaration have become binding as part of interna-

The Dynamics of Human Rights

▶ The universally acknowledged list of protected human rights (as found in the Universal Bill of Rights and subsequent human rights instruments) represents a powerful and important human consensus about the dignity that must be accorded all human beings and about the willingness of human society to respect basic rights for all. At the same time, human rights may exist that are not yet on any list of protected rights or acknowledged as part of the universal consensus. As a result, violations of human rights occur which are not seen as such and for which no one is held accountable.

▶ The history of human rights essentially traces two intertwining streams of human development: one stream represents the struggle to name previously unnamed rights and to gain their acceptance as human rights; the other stream represents the ongoing struggle to ensure the enforcement of established rights.

▶ This dynamic characteristic is what makes human rights a powerful tool for promoting social justice:

• If the right is not *recognized,* the struggle is to assure recognition.

• If the right is not *respected,* the struggle is to assure enforcement.

• The process of gaining recognition of a right leads to better enforcement and the process of enforcing leads to greater recognition of the rights.

tional customary law. (In other words, countries do in fact act as if the provisions of the UDHR were law, thus making the UDHR law).

In order to translate the Universal Declaration's principles into legally binding human rights obligations—at least for the states that ratified them—the Commission drafted the first human rights *instrument.* The General Assembly eventually split it into two "covenants," one on civil and political rights, and another on social, cultural and economic rights. This division was motivated by political considerations and reflected a compromise between states with "market-oriented" or "capitalist" economies (which tended to emphasize civil and political rights) and states with "planned" or "socialist" economies (which tended to emphasize economic and social rights). In 1966, after years of consideration by the Commission on Human Rights, the UN's Third Committee (the General Assembly's committee on human rights) finally adopted the two separate documents: The International Covenant on Economic, Social, and Cultural Rights (ICESCR) and the International Covenant on Civil and Political Rights (ICCPR)—which together with the Universal Declaration of Human Rights became collectively known as the International Bill of Rights—took effect in 1976. The ICCPR contained an Optional Protocol (or amendment to the treaty) allowing states to permit their own nationals to lodge petitions against them and requiring separate ratification.

Even as the international covenants were being drafted, the UN also started to use *treaties* to guarantee human rights in specific subject areas. The first such treaty, the Convention on the Prevention and Punishment of Genocide, entered into force in 1948. The Genocide Convention contained no enforcement provisions, meaning that although the

states were obligated to prevent genocide, the UN held no effective means to enforce this obligation. In contrast, most of the subsequent human rights treaties contain enforcement provisions. A listing of many of these treaties is found in Appendix 2. The primary convention pertaining to women, the Convention on the Elimination of All Forms of Discrimination Against Women (CEDAW), was signed in 1979 and entered into force in 1981, with many of the ratifying states entering a record number of *reservations*, that is, treaty provisions from which the signatories claimed exemption.

As a consequence of the development of the first two covenants, the UN Human Rights system tends to speak of two main categories of rights: civil and political rights, and economic, social and cultural rights—once termed "first generation" and "second generation" rights. According to some interpretations, social and economic rights merely reflect "goals" while civil and political rights are the only "true" rights. This kind of thinking has been flatly rejected by the United Nations. At the conclusion of the World Conference on Human Rights in Vienna in 1993, representatives from 171 countries adopted the Vienna Declaration, stating: "All human rights are universal, indivisible, interdependent and interrelated." This reaffirmed the original intent of the framers of the human rights system, who gave civil and political rights equal weight with economic, social and cultural rights. Still, the oversight and enforcement mechanisms for civil and political rights remain far superior to those of economic and social rights.

An emerging "third generation" of "people's rights" or "solidarity rights"—including the right to development, the right to peace, and the right to a healthy environment—have begun to be recog-

What Do Human Rights Treaties Offer?

- They guarantee specific rights to individuals.
- They establish state obligations related to the rights.
- They create mechanisms to monitor states' compliance with their obligations and allow individuals to seek redress for violations of their rights.

nized in UN General Assembly resolutions and other documents. However, they have not yet been transformed into binding treaty obligations. The "right to development" appears to find the most support in the United Nations. The Vienna Declaration called this right a "universal and inalienable right and an integral part of fundamental human rights." For the time being, however, it looks like human rights treaty-making by the UN has slowed and a new "right to development" treaty will not emerge in the near future. The UN General Assembly adopted an important resolution in 1987, which called on the UN and member states to give priority to the implementation of existing standards.

Where do we find human rights law?

Any law that can be used to promote or protect human rights may be considered to be part of human rights law. Thus, human rights law may be found in national constitutions, legislation and unwritten or common law. It can also be found at regional and international levels in various human rights treaties and in customary international law.

A *treaty* is a formal agreement between states. It creates legally binding obligations and rights among the states which are party to the treaty. At times a treaty may create rights in favor of individuals while creating obligations

with which states must comply. Human rights treaties fall within this category. The states agree to guarantee specific human rights for all individuals within their respective jurisdictions and to comply with corresponding obligations. Countries are supposed to adopt internal legislation and policies to implement applicable human rights standards. Countries that fail to abide by the set standards should be held accountable.

Some human rights treaties create mechanisms for monitoring and reporting on state compliance. Others provide avenues for individuals whose rights are violated to seek redress (see Chapters Two and Three).

Human rights treaties, often called "conventions" but also called "covenants," serve to define human rights concepts and set standards for government conduct. In doing so, they educate the public and help create conditions for external and internal pressures for improved human rights enforcement. Ratifying a treaty binds a member state to a dual obligation: first, to apply its provisions and second, to accept a measure of international supervision. While states can pick and choose which conventions to ratify, they are obligated to report regularly on their compliance with those they embrace.

Over time, the impact of international conventions tends to grow as the norms embodied in them enjoy more widespread respect. The more agreement there is among nations about the treaty, the greater the force of the treaty in human rights law.

Still, ratification of conventions may have little to do with their actual observance. Domestic institutions may pay lip service to international standards in principle and then ignore them altogether in practice. Moreover, the conventions may reflect agreement at the lowest common denominator. In order to garner as many ratifications as possible,

drafters may intentionally write vague standards and governments may assert reservations that negate or compromise the ultimate goal even though those reservations may be theoretically inadmissible under international law. Moreover, most of the bodies established to monitor treaty implementation have little or no ability to require states to comply and are severely backlogged and under-funded. All of these limitations, however, should not discourage rights advocates, but inspire them to find ways to move the development of the international human rights system toward more effective operation.

Note well that not only states are obligated to refrain from human rights abuse. Under international humanitarian law, like the Geneva Convention, parties to a conflict, whether state or non-state, are bound to refrain from certain abuse including rape and other sexual violence and enforced prostitution.

How are human rights standards enforced?

Every state has the primary responsibility within its territory to ensure that all members of society enjoy their human rights. States resistant to fostering social and economic rights have argued that civil and political rights involve only *negative obligations* (that is, they only prohibit governmental action that violates specified rights.) But others have demonstrated that most rights impose *positive obligations* as well. By signing and ratifying human rights conventions, governments at national and local levels must commit to avoiding any actions that would violate or lead to a violation of human rights. In addition, most treaty obligations require the government to take positive steps to adopt affirmative measures, to ensure or protect the enjoyment of human rights. They may also require enacting and enforcing legislation or adopting other appropriate measures to

ensure that individuals and other entities respect women's human rights.

To ensure enforcement of human rights obligations, various mechanisms exist at national, regional and international levels. At the international level, most of these mechanisms provide vehicles for monitoring compliance. Some offer petition procedures which allow individuals to challenge breaches by the state of their human rights obligations. In some cases mechanisms are linked to constitutions and national legislation, in others to human rights treaties and in still others to specialized agencies of the UN charged with the enforcement of specific rights, such as labor, refugee and health rights. The procedures and remedies provided by the full range of human rights mechanisms vary widely. Chapters Two Three and Four of this manual explore some of them in depth.

Mechanisms linked to national constitutions and legislation may offer more concrete and enforceable remedies and usually should be tried first, before turning to international petition procedures. At the national level the weight of the nation's legal system can be brought to bear on the enforcement of human rights; it may be possible for the victim to approach the courts to make a complaint and seek an enforceable remedy. Where this is not the case, it may be possible or necessary to seek redress beyond national boundaries. Unfortunately, international mechanisms tend to be less straightforward than national ones because the international legal system and human rights law depend on the good faith of states or their sensitivity to internal or international criticism of their human rights practices. International mechanisms have little power to force states to comply.

In order to achieve an effective improvement in the exercise of women's

human rights, it is important to understand the mechanisms that exist and the remedies they can provide. Using them to seek redress for specific violations keeps pressure on states to comply with their treaty obligations. Much of this manual addresses the potential of human rights mechanisms in this context. But before plunging into analysis of specific enforcement mechanisms, the rest of this chapter will discuss the origins, types and procedures of key international mechanisms.

Types of enforcement mechanisms

International human rights mechanisms can be divided generally into three categories: *charter-based, treaty-based and specialized agencies of the UN*.

Charter-based bodies

The Charter of the United Nations, the founding document of the UN, directly and indirectly creates several bodies that have a role in human rights standard setting and enforcement. The principal Charter-based bodies are the Security Council, the General Assembly, the Economic and Social Council, the Commission on Human Rights, the Sub-Commission on Prevention of Discrimination and Protection of Minorities and the UN Commission on the Status of Women. All of these bodies have jurisdiction over women's rights.

The primary charter body dealing with human rights is the Commission on Human Rights. The UN Charter did not create the Commission directly, but rather indirectly, by establishing the Economic and Social Council (ECOSOC) and declaring that this UN organ "shall set up commissions in economic and social fields for the promotion of human rights." Under these terms, in 1946, ECOSOC established Commission on Human Rights.

The Commission on Human Rights is the primary body responsible for monitoring existing international

standards, recommending new standards, investigating violations and providing advisory and other technical services to countries in need of assistance. Human rights complaints can be brought directly to the Commission under the Resolution 1503 procedure and to the Commission's various thematic and geographic working groups, sub-commissions and special investigators, including the Special Rapporteur on Violence Against Women, Its Causes and Consequences, who is responsible for reporting on violence against women. Known as a "functional commission" of ECOSOC, the Commission is comprised of fifty-three governmental members elected in regional groupings by ECOSOC. The Commission reports its recommendations directly to ECOSOC.

The Sub-Commission on Prevention of Discrimination and Protection of Minorities is the only sub-commission of the Commission. Although technically reporting to the Commission, the Sub-Commission has considerable autonomy and latitude in initiating substantive studies, proposing standards, and investigating human rights violations pertaining to minorities around the world. The Sub-Commission is comprised of twenty-six members, selected by the Commission by geographic region.

The UN Commission on the Status of Women (CSW) is another functional commission of ECOSOC. Established by ECOSOC in 1946, the CSW prepares recommendations and reports to the Council on promoting women's rights in political, economic, civil, social and educational fields. The CSW also makes recommendations to the Council on urgent problems requiring immediate attention in the field of women's rights. Its mission has been expanded in recent years, and the CSW is one of the primary bodies responsible for monitoring the implementation of the Platform for

Action adopted by the 1995 Fourth World Conference on Women. The Commission consists of 45 members elected by the Economic and Social Council for a period of four years.

The General Assembly, the most representative decision-making organ of the United Nations, also has broad powers with respect to consideration of human rights. The General Assembly elects the members of ECOSOC and reviews recommendations from ECOSOC. Chapter IV, Article 10 of the Charter authorizes the General Assembly to "discuss any questions or matters within the scope of the present Charter [and]...make recommendations to Members of the United Nations...on any such questions or matters." Article 13 authorizes the General Assembly to "make recommendations" for the purpose of "assisting in the realization of human rights." These recommendations are often in the form of declarations which, although non-binding, are important indications of international norms. For example, in 1993, the General Assembly passed a Declaration on the Elimination of All Forms of Violence Against Women. The main committees of the General Assembly which have participated in the drafting of human rights declarations or other processes on human rights are the Social, Humanitarian and Cultural Committee (Third Committee) and the Legal Committee (Sixth Committee).

The *Security Council* is comprised of five permanent members: China, France, the Russian Federation, the United Kingdom and the United States, as well as ten other members elected by the General Assembly. The Security Council's powers are set forth in Chapter VII of the UN Charter. These powers range from making recommendations to state parties to end a dispute, to taking military action "to maintain or restore

Types of Enforcement Mechanisms

Charter Based

Some Mechanisms	What They Monitor
• Economic and Social Council (ECOSOC)	• Human Rights questions generally; activities of the Commission on Human Rights, Sub-Commission on Minorities, Commission on the Status of Women, and treaty-monitoring bodies and other bodies
• Commission on Human Rights - 1503 Procedure - Working Groups - Special Rapporteurs - Sub-Commission on Prevention of Discrimination and Protection of Minorities • Commission of the Status of Women	• Human rights questions generally and on specific targeted issues: - Gross and systemic violations - Specified issues - Thematic and geographic issues - Human rights of minorities throughout the world - Human rights of women throughout the world - Broad discretion to initiate studies, recommend, promote, encourage, discuss and make recommendations to assist in the realization of human rights
• General Assembly • Security Council	• Threats to the peace, breach of the peace, or acts of aggression (Chapter VII, Article 39)
• Human Rights Committee	• International Covenant on Civil and Political Rights (ICCPR)

Treaty-Based

Some Mechanisms	What They Monitor
• Committee on Economic, Social and Cultural Rights	• International Covenant on Economic, Social and Cultural Rights (ICESCR)
• Committee on the Elimination of Discrimination Against Women	• Convention on the Elimination of All Forms of Discrimination Against Women (CEDAW)
• Committee on the Elimination of Racial Discrimination	• International Convention on the Elimination of All Forms of Racial Discrimination

Specialized Agencies

Some Mechanisms	What They Monitor
• UN High Commissioner for Refugees (UNHCR)	• Rights of refugees
• International Labour Organization (ILO)	• Labour rights
• UN Educational, Scientific and Cultural Organization (UNESCO)	• Cultural and educational rights
• UN World Health Organization (WHO)	• Health rights

15

international peace and security" (Article 42). The Council has increasingly taken an active role in peace-keeping, peace-making and peace-building, processes that inevitably involve human rights.

Treaty-based bodies

Most human rights treaties establish a committee or a commission to monitor how well the signatory states follow their obligations under the treaty. The treaty provides the substantive guarantees; the committee oversees implementation of those obligations. The committees of the UN human rights system, known as "treaty-monitoring bodies," include:

- The Human Rights Committee, which monitors the International Covenant on Civil and Political Rights;
- The Committee on Economic, Social and Cultural Rights (CESCR, technically a subsidiary body of ECOSOC), which monitors the International Covenant on Economic, Social and Cultural Rights;
- The Committee on the Elimination of All Forms of Discrimination Against Women, which monitors the Convention on the Elimination of All Forms of Discrimination Against Women ("the Women's Convention"); and
- The Committee on the Elimination of All Forms of Racial Discrimination, which monitors the International Convention on the Elimination of All Forms of Racial Discrimination.

The scope of these committees differs greatly from the Commission on Human Rights. While the Commission on Human Rights, the Charter-based body discussed above, can monitor and establish standards for human rights in all countries, the work of the committees applies only to the states that have ratified or acceded to the respective covenant.

The Centre for Human Rights, based at the UN in Geneva, staffs most of these treaty bodies (except for CEDAW, which gets staff support from the Division for the Advancement of Women in New York). The type of enforcement procedures available under treaty-monitoring bodies can include: monitoring and reporting functions and inter-state and individual complaint procedures.

Specialized agencies of the UN

Treaty-monitoring bodies provide only one vehicle for redress of human rights violations at the UN level. Other means include the complaint and/or monitoring procedures of various UN organizations and agencies, such as the office of the United Nations High Commissioner for Refugees (UNHCR), the International Labour Organisation (ILO), the United Nations Educational, Scientific and Cultural Organisation (UNESCO) and the World Health Organisation (WHO). Each of these organizations may consider human rights questions within their topical area of focus.

What types of procedures do the mechanisms entail?

There are two general types of procedures: complaint procedures and monitoring/reporting procedures.

Complaint procedures

Commentators have identified two types of complaint procedures based on different goals and outcomes: complaint-recourse and complaint-information procedures.

Under *complaint-recourse* procedures, the goal of the procedure is the redress of specific grievances. The complainant (or plaintiff) is entitled—to various degrees—to participate in the proceedings. A successful complaint in this case may result in legally enforceable or in specific, albeit formally unenforceable, remedies such as orders that force the government to compensate a victim, reprimand the perpetrator or even change government policies and practices. For example, a woman unfairly fired from state employment may demand

reinstatement in the workplace; a woman abused by police may seek monetary damages; a woman's group denied the right to assemble and speak freely may demand a declaration that their rights were violated and a change in governmental policy.

The decisions reached under UN complaint-recourse procedures are not technically binding on states, but most states comply. Under the regional human rights systems in Europe and Africa, judgments of special courts are legally binding under international law (see Chapter Three).

Under complaint-information procedures, the goal is not to redress individual grievances but to identify broad human rights violations affecting a large population. Petitions are received only as part of the information before a body considering the matter. Authors of petitions have no right to a remedy, and may not even have a right to be informed about the disposition of the case. The UN Human Rights Commission's 1503 Procedure is an example of a confidential proceeding of this kind.

Monitoring and reporting procedures
Monitoring and reporting procedures do not generally result in legally enforceable remedies, nor do they rely on "law-like" complaints or other communications from individuals or groups. On the contrary, monitoring and reporting procedures resemble "reports" or "audits" of government behavior and result in authoritative, non-binding recommendations. There are two ways in which the reporting procedure is generally activated. At times, the reporting resembles a "self-inspection" in which governments report on their own compliance with human rights obligations. In other cases, a monitoring body initiates the report on government behavior. Alternatively, the monitoring proceeds according to a regularly scheduled plan of inspection or, again, the process could be triggered by advocates who underscore a particularly pressing problem. Advocates may or may not be permitted to comment on the findings of the monitors. From the standpoint of human rights advocates, monitoring and reporting procedures are successful if they bring publicity to human rights abuses and shame governments and other human rights violators into changing their behavior.

Where are enforcement mechanisms found?

NATIONAL LEVEL
The first place an advocate should look for enforcement mechanisms is right at home, to the courts, commissions and other investigative and judicial bodies that exist at the national level. Countries are bound by treaties they have ratified or acceded to and by human rights principles that are accepted as part of

What Activists Can Do Using →	Complaint Procedures	→ Monitoring Procedures
Direct advocacy - submission of arguments in a case.	✔	
Meeting with experts and representatives of human rights system.	✔	✔
Publicize a case.	✔	✔
Review, self-critique state's human rights practice.	✔	✔

international customary law. The enforcement of procedures and mechanisms varies greatly from country to country. For example, effective human rights commissions exist in some countries while they are unheard of in others. Similarly, constitutional courts may or may not exist and these and other domestic courts may or may not have jurisdiction to hear claims of violations of human rights based on domestic or international law. These courts may fully implement international law, or merely give lip service to it. Advocates should look to their own country's human rights systems to discover possibilities for human rights enforcement under national law and the potential limitations of this approach, particularly with regard to the adjudicability of international human rights norms. Chapter Four describes, in general terms, what procedures are used with respect to human rights litigation in national courts and national institutions for the protection of human rights.

INTERNATIONAL LEVEL

Regional human rights systems

A second place to look for human rights mechanisms is at the regional level. In several geographic regions, interstate agreements have established regional human rights "systems," in which groupings of human rights laws, courts, investigative bodies and other organizations provide enforcement mechanisms for a region. These systems establish procedures that may allow individual cases to be brought involving violations of regional human rights instruments. They may also provide for on-site visits to review systematic human rights violations in a country, or they might conduct general studies and educational programs concerning human rights issues. Regional human rights instruments may set up courts, commissions and/or other monitoring or adjudicative bodies. The

exact types of mechanisms and their function depend on the wording of particular regional agreements and their procedures and practices. There are three regional human rights systems, whose procedures are analyzed in Chapter Three. They are: the Inter-American, the European and the African systems. Where a region does not have its own human rights system (as in Asia), or where the existing systems may insufficiently address a claim (as, quite possibly, when the violation pertains to war and/or to refugee status), advocates may look instead to universal human rights procedures.

UN human rights system

Finally, advocates can look to enforcement mechanisms at the UN or "universal" level. In order to use treaty-based procedures, the state concerned must have accepted both the obligations under the relevant treaty and the particular procedure advocates may want to use. They must check whether their countries have ratified the relevant conventions, and in some cases (such as the International Covenant on Civil and Political Rights) whether they have acceded to the provisions that give international bodies jurisdiction over claims of individuals. Other mechanisms/procedures may be available against any state which is a member of the UN or specialized agency without the state having explicitly accepted the mechanism. Chapter Two of Women's Human Rights Step by Step will survey several international mechanisms of particular relevance to women, including:

1. Individual complaint procedures, monitoring procedures and interstate complaints based on UN treaties (focus on the UN Committee on Human Rights which monitors the ICCPR);

2. Monitoring procedures of Special Rapporteurs and Working Groups (focus on the Special Rapporteur

on Violence Against Women);

3. The reporting and monitoring proce-
dure of the *Committee on the
Elimination of Discrimination Against
Women* (CEDAW), which monitors
the "Women's Convention";

4. Complaints directly before the United
Nations under the *1503 Procedure;*

5. Complaint procedures of the
International Labour Organisation (ILO);

6. Individual communications before the
*UN Commission on the Status of
Women*; and

7. Gender-specific reporting mechanisms
before the *United Nations High
Commissioner on Refugees.*

How should mechanisms be evaluated?

Whether on the national, regional, or
global level, human rights enforcement
mechanisms raise the following issues:

* What type is the procedure?
(complaint, monitoring and reporting
or "mixed")

* To whom is the procedure available?

* What must activists do to access the
procedure? (admissibility requirements)

* How does the system work and what
role can activists play?

* What are the possible remedies?

* What are the advantages and disadvan-
tages of using the particular
mechanism?

In Chapters Two and Three, specific
mechanisms of relevance to women are
analyzed according to this set of
questions. They provide a checklist for
deciding which mechanism will be the
most appropriate and which strategy the
most effective for women's rights
advocates to pursue. The remainder of
Chapter One provides general informa-
tion for advocates to consider when
answering these questions with respect to
specific mechanisms.

Type of procedure

The goals and strategies of an advocacy
effort will be influenced by what type of
enforcement procedures are available to
the activist. For example, while a
complaint procedure may help establish a
legally enforceable precedent and gain a
clear remedy in a particular case or class
of cases, it may not be available or desir-
able. On the other hand, monitoring and
reporting procedures may better address
broad, systemic problems and win more
sweeping changes to advance women's
human rights, but will not necessarily
provide individual relief. Some human
rights enforcement mechanisms use a
combination of these two types of proce-
dures or allow for some degree of choice.

Availability of procedure

Before expending any time developing a
strategy around a mechanism, activists
must learn whether it is available to
them at all. Availability of an enforce-
ment mechanism usually depends upon
whether the country of origin (where the
human rights abuse occurred) has ratified
a human rights instrument that allows
the human rights system to hear the
matter–in other words, to have jurisdic-
tion. For example, some human rights
treaties attach provisions or amendments,
known as optional protocols, that estab-
lish an individual complaint mechanism
by which the treaty can be enforced. In
these cases, only countries that have
specifically agreed to the complaint
procedure or signed and ratified (become
parties to) the optional protocol will be
able to use that procedure. If the country
in which the suit is to be filed has not
accepted the procedures under the
optional protocol, advocates will have to
look elsewhere for an international
enforcement mechanism. However, some
enforcement mechanisms do not require
a country to agree in advance to submit
itself to the jurisdiction of a judicial or
fact-finding body.

Admissibility requirements

Even if a procedure is generally available, advocates will not be able to use it in a particular case unless they satisfy the admissibility requirements: general rules defining who can have access to a particular enforcement mechanism and what they have to do to use it. These rules vary greatly, from seemingly bureaucratic niceties on filling out papers, to strict requirements for stating the case (such as pleading requirements), to general exhaustion requirements—typically stating that activists must first try all reasonable possibilities available at the national level before resorting to international mechanisms. Advocates may satisfy this requirement by showing that domestic procedures are either nonexistent or inadequate. Admissibility requirements also typically require that the case or issue not be simultaneously addressed by another human rights system. This means that activists usually will have to choose only one enforcement mechanism at a time. They normally cannot proceed, for example, in both the African human rights system and the United Nations system at the same time.

Advocates often plan their strategy of a case over the long haul, crafting an international strategy at the outset, with admissibility requirements figuring prominently in their plan. Advocates may invoke directly provisions of international treaties before the national court, thus preparing in advance for international admissibility requirements.

How the system works and the role activists can play

Once activists have determined that a procedure is available and that they satisfy the admissibility requirements, they need to know more about specific rules and proceedings in order to assess their possible role. The degree of formality and openness to activist input varies greatly from mechanism to mechanism. Some

bodies require formal hearings, others are more flexible and informal. Generally speaking, each human rights mechanism involves several steps, including: investigating and reviewing cases by human rights experts; communication with the government in order to hear its side; a determination as to whether a human rights violation has been committed and if the government is legally responsible. The roles that activists may play while engaging a human rights enforcement mechanism range from direct advocacy and arguments in a case, to meeting with experts and representatives of the human rights system, to simply waiting for the system to make a decision or take an action. The rules of some systems do not allow for direct contact with the human rights experts charged with reviewing the matter while others allow for active participation by advocates.

Remedies

Remedies can be very specific and geared towards compensating an individual woman whose human rights were violated, or they can be mandates for broad changes in government policy. In some systems, the remedies are weak because the human rights enforcement mechanism does not have the power to tell a government what it must do, but can only make recommendations. In cases of particularly weak remedial procedures, the outcome is not even made public. Advocates need to know what remedies are available in tailoring their strategy.

Weighing advantages and disadvantages

When advocates have a choice of mechanisms, they must weigh the advantages and disadvantages of each option. "Advantages" may include: a useful outcome that would advance the human rights of individual women or of women as a whole; a high degree of input permitted for activists; relative speed of decision; a wide scope of available remedies; and responsiveness by governments to the

outcome. "Disadvantages" might include: failure to take the needs of the women affected by the violation into consideration; restricted input from activists; limited remedies; and lack of government respect for the outcome. A checklist to allow activists to weigh advantages and disadvantages for themselves closes this section.

A Note of Caution
Chapters Two, Three and Four provide very specific information on fourteen human rights mechanisms. Chapters Five, Six and Seven present a process model for designing an overall strategy and deciding which mechanism to use or to use none at all. It may be useful to take a quick look at Chapters Five to Seven at this point in order to keep the reading of mechanisms in strategic perspective and avoid getting lost in the details of particular procedures.

Checklist for Weighing Advantages/Disadvantages

	Check if applicable to system	Check if important to you
Allows for direct participation of activists	_____	_____
Allows for indirect participation of activists	_____	_____
Remedies are specific	_____	_____
Remedies are geared toward compensating individual women	_____	_____
Remedies are broad	_____	_____
Remedies are geared toward change in government policies	_____	_____
Results in a legally binding decision	_____	_____
Results in non-binding recommendations for action	_____	_____
Women can participate while remaining anonymous	_____	_____
Women cannot participate unless named	_____	_____
NGOs can have substantial input	_____	_____
NGOs have limited input	_____	_____
Quick procedure	_____	_____
Slow procedure	_____	_____

THE UN HUMAN RIGHTS SYSTEM

2

Numerous mechanisms and approaches are available at the level of the United Nations. This chapter examines those mechanisms that have most relevance to women, specifically:

- individual complaint procedures, monitoring procedures and interstate complaints based on UN treaties (especially the UN Committee on Human Rights, which monitors the ICCPR);
- monitoring procedures of Special Rapporteurs and Working Groups (especially the Special Rapporteur on Violence Against Women);
- the reporting and monitoring procedure of the Committee on the Elimination of Discrimination Against Women (CEDAW), which monitors the "Women's Convention";
- complaints directly before the United Nations under the 1503 Procedure;
- complaint procedures of the International Labour Organization (ILO);
- individual communications before the UN Commission on the Status of Women; and
- gender-specific reporting mechanisms before the Office of the United Nations High Commissioner on Refugees (UNHCR).

UN Committee on Human Rights

In some cases, individuals have the right to complain directly about human rights violations to expert bodies established under the UN human rights conventions. Three such expert committees currently allow individual complaint procedures:

- the Human Rights Committee under the Optional Protocol to the International Covenant on Civil and Political Rights (ICCPR) (since 1977);
- the Committee on the Elimination of Racial Discrimination (CERD), under Article 14 to the International Convention on the Elimination of All Forms of Racial Discrimination (since 1982); and
- the Committee Against Torture, under Article 22 of the Convention Against Torture and Other Forms of Cruel, Inhuman and Degrading Treatment (since 1988).

All of these procedures are contingent upon the state parties recognizing the competence of the expert body to hear individual complaints. The individual complaint procedure under CERD has been used most sparingly. The procedure under the ICCPR has been the most visible and effective of the complaint procedures administered by human rights treaty bodies; since the

Human Rights In the United Nations System

High Commissioner for Human Rights
Tasked with coordinating human rights throughout the UN system.

Security Council

General Assembly

| Meeting of Chairpersons of Treaty Bodies* | Committee Against Torture (CAT) | Committee on the Elimination of Racial Discrimination (CERD) | Special Committee to Investigate Israeli Practices Affecting the Human Rights of Palestinian People** |

Economic and Social Council (ECOSOC)

| Committee on the Elimination of Discrimination Against Women (CEDAW)** | Committee on Economic, Social and Cultural Rights (CESCR)* | Commission on Human Rights and its Sub-Commission* (See Chart 1) | Commission on the Status of Women (CSW)** |

| Human Rights Committee (CCPR)* | Committee on the Rights of the Child (CRC) | Commission on Sustainable Development (CSD) | Commission on Crime Prevention and Criminal Justice |

Legend
The darker shaded boxes on this chart are UN treaty-monitoring bodies.
* Bodies serviced from Geneva
** Bodies serviced from New York
*** Bodies serviced from Vienna

Commission For Human Settlements

and others

UN Specialized Agencies and other bodies (all of whom now have some concern for, and responsibilities in the area of, human rights). including:

International Labour Organization (ILO)–trade union rights, child labour, bonded labour, and labour rights generally

UN Educational, Scientific and Cultural Organization (UNESCO)–the right to education, human rights education

World Health Organization (WHO)–the right to health, including HIV/AIDS

UN development Programme (UNDP)–the right to development

Food and Agricultural Organization (FAO)–the right to food

UN Children's Fund (UNICEF)–the rights of the child

UN High Commissioner for Refugees (UNHCR)–rights of refugees and displaced persons

Bretton Woods institutions, including the **World Bank** and the **International Monetary Fund** (IMF)–to do human rights impact assessments

Adapted from Human Rights Internet

UN Commission on Human Rights and its Subcommission

Office of the High Commissioner for Human Rights/UN Centre for Human Rights
(Services all bodies on this chart)

UN Commission on Human Rights

Sub-Commission on Prevention of Discrimination and Protection of Minorities

Special Procedures

Working Groups

- Enforced or involuntary disappearances
- Arbitrary detention
- Situations of gross violations (Res. 1503)
- Structural adjustment programmes and economic, social and cultural rights
- Right to development
- Drafting a declaration on human rights defenders
- Drafting an optional protocol to the Torture Convention
- Drafting an optional protocol to the Convention on the Rights of the Child, on children in armed conflict
- Drafting an optional protocol to the Convention on the Rights of the Child, on sale of children, child prostitution and child pornography

Special Rapporteurs (Thematic)

- Summary or arbitrary execution
- Torture
- Religious intolerance
- Mercenaries
- Sales of children, child prostitution and child pornography
- Freedom of opinion and expression
- Violence against women
- Racism, racial discrimination and xenophobia
- Internally displaced persons
- Independence of the judiciary
- Illicit movement & dumping of toxic and dangerous products

Special Rapporteurs or Representatives (Country-specific)

Afghanistan	Guatemala	Occupied Territories *(Palestine)*
Burundi	Haiti	
Cambodia	Iran	Somalia
Cuba	Iraq	Sudan
Equatorial Guinea	Myanmar	Zaire
Former Yugoslavia		

Working Groups

- Communications on gross violations
- Detention
- Indigenous populations
- Contemporary forms of slavery
- Minorities

Special Rapporteurs & Studies

- Traditional practices affecting health of women and children
- Cultural property of indigenous peoples
- Compensation to victims of gross violations
- Impunity of perpetrators of violations of human rights
- Discrimination against HIV- or AIDS-infected people
- Right to adequate housing
- Right to fair trial
- States of emergency
- Human rights in extreme poverty
- Treaties with indigenous peoples
- Human rights & population transfers
- Administration of justice
- Conscientious objection
- Forced evictions
- Human rights and income distribution
- Realization of economic, social and cultural rights
- Solution of problems involving minorities
- Privatization of prisons
- Human rights and the environment
- Peace and human rights
- Independence of the judiciary

Advisory Services, training, fellowships, and promotional activities for:

- National plans of action
- Constitutions
- Free and fair elections
- Legislative reform
- National and regional human rights institutions
- Human rights in law enforcement
- The judiciary and the legal professions
- Human rights in prisons
- Human rights and the armed forces
- Internal conflict resolution
- Parliament and human rights
- Curriculum development and human rights in education
- Treaty reporting and international obligations
- Strengthening NGOs and the mass media

The Special Rapporteurs/Special Representatives and Working Groups change according to resolutions of the Commission and Sub-Commission. This chart is intended to be illustrative, not definitive.

Adapted from Human Rights Internet

2

Optional Protocol entered into force in March 1976, over 500 cases have been registered under the procedure.

Advocates for women's rights may explore bringing individual claims under every procedure that is available to them—in other words, as long as the subject matter of their complaint falls under a procedure to which their state has consented. Although CERD does not apply specifically to women's human rights, for example, many of the kinds of rights violations women experience concern both gender and race discrimination. Similarly, although the Torture Convention does not mention gender explicitly, incidences of rape, sexual assault, abuse in detention and other acts may constitute torture or other forms of cruel, inhuman and degrading treatment. However, some of these procedures do not allow other procedures to be pursued in parallel.

In contrast to some other conventions, the ICCPR explicitly prohibits sex discrimination under Articles 2(1)3 and 26. The Human Rights Committee has interpreted these provisions broadly to include bans on state practices which have the purpose or effect of burdening women, regardless of whether men are treated in an identical manner. In the past, states have been responsive to recommendations of the Committee with respect to violations of women's human rights, and have in fact changed national laws as a result.

The general procedure for bringing individual complaints before any of these expert bodies is similar. Moreover, each of these treaty bodies provides for monitoring procedures and some kind of inter-state complaints. This section focuses on the procedures before the Human Rights Committee, the most utilized and developed set of procedures.

Type of procedure
The Committee provides for state reporting and committee monitoring, interstate communications (or complaints) and individual complaints (complaint-recourse) procedures.

Availability of procedure
For the reporting procedure, a state must be party to the ICCPR.

For the inter-state complaint procedure, the state must have accepted Article 41, which "recognizes the competence of the Committee to receive and consider communications to the effect that a state party claims that another state party is not fulfilling its obligations under the present Covenant…"

For individual complaints, the state must have accepted the Optional Protocol of the ICCPR, which "recognizes the competence of the Committee to receive and consider communications from individuals subject to its jurisdiction who claim to be victims of a violation by that State Party."

An individual must be directly affected by a violation of the ICCPR. He or she cannot ask for a declaratory judgment or otherwise challenge a national law in an abstract way. This means that the Human Rights Committee cannot review in the abstract whether national legislation contravenes the ICCPR. Where the victim is unable to submit an application (for example, because the state is responsible for her disappearance), a close relative may submit the application. An individual need not be a resident of the state concerned as long as she was subject to the jurisdiction of the state at the time of the complaint. Normally this is interpreted as requiring the individual to have been present in the territory of the state concerned at the time of the alleged violation.

Getting access to the process

For the monitoring and reporting procedures:

Usually only state parties can submit monitoring and reporting information. The Committee may consider information from individuals affected by an alleged state practice. Individual reports should be well-documented, factual and not frivolous, and they should show, if possible, the systematic nature of violations of one or more of the provisions of the Covenant.

For individual complaints:

Below are some of the requirements that the Human Rights Committee will take into account before deciding on the admissibility of an individual complaint.

1. Domestic remedies must be exhausted, unless it can be proved that domestic avenues of redress would entail unreasonable delay.

2. The problem cannot be under investigation or settlement by another international procedure (Article 5(2)(a). The Committee tends to interpret this requirement narrowly as "identical parties to the complaints advanced and the facts adduced in support of them."

3. The communication cannot be anonymous, abusive or incompatible with the provisions of the ICCPR.

4. If it is proved that the alleged victim cannot submit the communication, a close relative may do so on her behalf provided that the relative can prove a sufficiently close connection to the alleged victim.

5. The violation must have occurred after the Optional Protocol took effect for the state in question. However, if a violation appears to have a continuing effect after the Protocol came into effect, the Committee still may consider the complaint.

6. The Committee has produced a model communication to assist complainants in making applications. Essential information includes:

- name, address and nationality of victim and
- the author of complaint, if different;
- the state against which the complaint is made;
- the provision(s) of Parts II and III of the ICCPR that have been violated;
- steps taken to exhaust domestic remedies;
- a statement as to whether the same matter is being dealt with before another international body;
- a detailed description of the facts substantiating the allegations.

The Committee may ask the complainant or the state concerned for additional information within a prescribed period of time. There is no time limit for submitting complaints; however, "fresh" (i.e. more recent) complaints are generally better.

How the system works and the role of advocates

For state reporting:

Article 40 of the ICCPR requires states to submit periodic reports on their efforts to comply with the Covenant, including any measures adopted to effect the rights protected by the Covenant and any progress on the enjoyment of rights. An initial report is due one year after the Covenant enters into force for a state, and thereafter at five-year intervals. The Human Rights Committee may also request supplementary reports when the state reports are insufficient or when a new problem arises.

A working group of the Committee reviews the state's report, identifies issues, and provides a list of additional questions to the state. Then the Committee publicly reviews the report. A state representative introduces the report, and Committee members question him or her in a strictly non-judicial proceeding.

The United Nations has emphasized that the Committee's role is not to pass judgment on the implementation of provisions of the Covenant in any given State. The main function of the Committee is to assist State parties in fulfilling their obligations under the Covenant.

The Committee studies the report and then submits its concluding observations to the state. The Committee is mandated to submit an annual report on all of its activities to the General Assembly (through ECOSOC).

Although no explicit provision in the ICCPR requires consideration of outside information by the Committee, in practice the Committee does accept information from NGOs and others. Specialized agencies of the UN and NGOs have been invited to the public meetings of the Committee where state reports are considered, and the Committee has sometimes invited NGOs to comment on reports.

At informal meetings with Committee members, advocates can attempt to influence their own state's writing of reports and can comment on Committee recommendations. Advocates can also issue their own, unofficial "alternative reports" on the status of women under the ICCPR in their country, and they may attend open meetings of the Committee. However, the Covenant does not mandate that the Committee consider NGO communications. Many advocates have found that the best path involves sending information directly to individual members of the Committee (such as those most likely to be sympathetic), who use it to raise the issue during the questioning of the representative of the reporting state.

For individual complaints:

Individual complaints must go through three stages:

Pre-admissibility: The Communications Section of the UN Centre for Human Rights screens applications to determine whether the complaint raises issues under any of the relevant international instruments. The secretariat registers applications and forwards them to the Committee's Rapporteur on New Communications, who in turn asks for additional information on questions of admissibility if needed. Once an individual communication has been declared preliminarily admissible, the complaint is forwarded to the state. The state normally has two months to respond; the author of the complaint can then comment on the state's response.

Adoption of a decision on admissibility or inadmissibility: At this stage, it must be determined whether the applicant has exhausted all available domestic remedies; whether the claim is not being examined by another international or regional investigation; whether the claims are sufficiently substantiated; and whether they are compatible with the rights protected by any of the relevant international instruments. A working group of at least five members of the Committee meets one week prior to each session. This group can declare a case admissible so long as the decision is unanimous. Otherwise, the entire Committee considers the question of admissibility. Should the author fail at this point, he or she may request a review of the admissibility decision.

Consideration of the substance of a case previously declared admissible: Once a case has been declared admissible, the state concerned has an opportunity to explain the problem and any settlement of it (Article 4(2) of Protocol). The state has six months to reply. The complainant then has six weeks to reply to the state's communication. Documents relating to individual complaints are confidential and consideration of communications under the Optional Protocol takes place in closed meetings (Article 5(3) of Protocol). After a review of all communications, the Committee makes a decision,

which is sent to both the state and the complainant and made public (Article 5(4) of Protocol). There are no provisions in the Protocol for oral hearings or on-site investigations, and the Committee is not mandated to facilitate settlement.

Advocates can play a major role in this process, from the decision to go forward with an individual complaint, to submitting communications to the Committee about a complaint, to commenting on the final decision and monitoring state response to the comments of the Committee.

For interstate complaints:
The Committee will also consider state communications about the failure of other states to abide by their commitments under the ICCPR (Article 41). Roughly 44 countries have accepted the procedure, but to date no interstate complaint has been filed.

If one state party believes that another state party has violated the Covenant, the state may submit a communication to that effect. The state receiving the communication is obligated to respond within three months. If the matter is not resolved to the satisfaction of both parties, either party may refer it to the Human Rights Committee by giving notice to the Committee and the other state.

The Committee's primary function is to push for an amicable solution. During its closed sessions, the Committee may call the states parties to submit information. The Committee is to submit a report within twelve months of its involvement. Documents relating to interstate complaints are confidential. If no solution is reached, the Committee may appoint an ad hoc Conciliation Commission.

Remedies
The Committee does not issue legally binding opinions, merely recommendations (termed "views"). Individual members of the committee may include a summary of their own opinion. Under

new measures adopted in 1990, whenever the Committee finds a violation of the Covenant, it gives the state concerned 180 days to inform the Committee of the action it has taken in relation to the case. The Committee's annual report lists the states that have failed to provide a remedy.

The Committee has also appointed a Special Rapporteur for the follow-up of views to recommend action that should be taken when victims claim that states have not provided an appropriate remedy. The rapporteur may communicate directly with governments and victims. To increase the visibility of follow-up activities, the Human Rights Committee includes a summary of such activities in its annual reports.

Weighing advantages and disadvantages
Advantages:
One of the best attributes of the ICCPR is the availability of individual complaint procedures under the Optional Protocol. This allows individuals to bring their allegations directly to the Committee. The individual complaint procedure is best suited for flagrant, egregious violations, where advocates want to make a political statement, not where individuals want a remedy to an immediate problem. The 1990 revisions to the enforcement procedures, and in particular the creation of a Special Rapporteur for the Follow-Up of Views, has improved the effectiveness of the complaints procedure. Individual complaints have been increasing.

The reporting mechanisms have also proved advantageous in many cases. The periodic reports by state parties, and the reports, formal decisions and official documents of the Committee are made public. While some states have been delinquent, many states have complied with the reporting requirements. By their very nature, the reporting requirements make states deal with human rights issues (and force them at least to try to explain

How a Compliant Procedure Works
"Typical" Steps Through the System

Step 1
Submission

Submission of
complaint or request
for investigation

Step 2
Investigation

Investigation and review of
cases by human rights experts
(generally on HR Commissions,
committees, etc.)

Step 3
Communication

Communication
with the accused
government to
hear its side

NGO Input
(Not always available)

Step 4
Negotiation

Attempts at settlement

Step 5
Determination

A determination by the human rights body
as to whether a human rights violation has
occurred, and whether government (and
some other body) is responsible

If it is determined that no violation
has occurred—Case Closed
If it is determined that a violation has
occurred, the case moves to judgment

Step 6
Judgment

If a Violation has occurred, a
judgment can result in:
• Non-binding Recommendation...or...
• Binding Judgment

away problems). In practice, individual members of the Committee may rely greatly on NGOs in considering state reports. The reporting system has encouraged some states to bring their laws into compliance with the Covenant.

Advocates for women's rights have often found the Committee to be at least initially receptive to their claims. The Committee uses a relatively broad definition of discrimination, examining whether women are being disadvantaged because of their gender, not whether women are treated in an identical manner to men.

Disadvantages:

The individual complaint procedure is long and arduous. The process of determining admissibility may take up to a year. The process of determining the merits of a case may take up to three years. However, during the course of proceedings the Committee can order immediate, emergency relief (such as recommendations against imminent executions and expulsions). The Human Rights Committee is not a court with power to issue binding decisions in individual complaints.

The Committee has been conservative in its review of individual complaints. When considering whether a violation has occurred, the Committee will ordinarily defer to the judgment of national authorities in areas of their expertise (where the state has already evaluated the situation). States have an excuse to retain the status quo whenever the Committee refuses the complaint, even though the refusal may only have been on technical admissibility grounds and not on its merits.

Special Rapporteurs and Working Groups

Much of the work of the Commission on Human Rights is carried out through special rapporteurs and working groups— mechanisms that allow for immediate and targeted reporting on various human rights situations, dealing with individual

claims and making suggestions for action to improve respect for human rights. Special rapporteurs and working groups can be extremely effective at putting human rights issues prominently in front of the international community. Through offering information and comments, NGOs often play a role in the work of special rapporteurs and working groups.

Special rapporteurs are assigned to countries with particularly pressing human rights situations. In addition, thematic mandates have been established dealing with investigating and issuing reports on particularly serious violations, wherever they may occur, including arbitrary executions (1982), torture (1985), religious intolerance (1986) and the rights of the child (1990).

In March 1994, the Commission on Human Rights appointed Radhika Coomaraswamy as the *Special Rapporteur on Violence Against Women, Including Its Causes and Consequences.* The Special Rapporteur has a mandate to collect and analyze comprehensive data and to recommend measures aimed at eliminating violence at the international, national and regional levels. The mandate is threefold:

1. To collect information on violence against women and its causes and consequences from sources such as governments, treaty bodies, specialized agencies and intergovernmental and non-governmental organizations, and to respond effectively to such information;
2. To recommend measures at the national, regional and international levels to eliminate violence against women and its causes, and to remedy its consequences;
3. To work closely with other special rapporteurs, special representatives, working groups and independent experts of the Commission on Human Rights.

The Special Rapporteur on Violence Against Women already has carried out

Working Groups and Special Rapporteurs: Areas of Concern (as of May 1997)

Working Groups

- Disappearances
- Arbitrary Detention
- Situations of Gross Violations (Res.1503)
- Right to Development
- Drafting a Declaration on Human Rights Defenders
- Drafting an optional protocol to the Torture Convention
- Drafting a declaration on the rights of indigenous peoples
- Drafting an optional protocol to the Rights of the Child Convention on children in armed conflicts
- Drafting guidelines for an optional protocol to the Rights of the Child Convention on sale of children, child prostitution and child pornography
- The United Nations and Human Rights

Special Rapporteurs: Thematic

- Summary or arbitrary execution
- Torture
- Religious intolerance
- Mercenaries
- Sale of children, child prostitution and child pornography
- Freedom of opinion and expression
- Violence against women
- Racism, racial discrimination, and xenophobia
- Internally displaced persons
- Independence of the judiciary
- Effect of illicit movement and dumping of toxic and dangerous products on the enjoyment of human rights

Special Rapporteurs: Country

Afghanistan	Guatemala	Occupied Territories
Burundi	Haiti	(Palestine)
Cambodia	Iran	Somalia
Cuba	Iraq	Sudan
Equatorial Guinea	Myanmar	Zaire
Former Yugoslavia		

investigations in many countries and has reviewed information submitted by NGOs and states. A preliminary report in 1994 by Ms. Coomaraswamy focused on three areas of concern where women are particularly vulnerable: in the family (including domestic violence, traditional practices, infanticide); in the community (including rape, sexual assault, commercialized violence such as trafficking in women, labor exploitation, female migrant workers, etc.); and by the state (including violence against women in detention, refugee women and women in situations of armed conflict). The work of the Special Rapporteur has increased the visibility of the issue of violence against women.

NGOs and individuals should submit information on human rights problems to any and all of the special rapporteurs who are investigating the issues in question. Information can be sent to rapporteurs in care of the Centre for Human Rights (using the Centre's address). In order to be included in a rapporteur's annual report, information should be submitted by the end of October each year. In

addition, should a rapporteur be scheduled to visit a given country (upon the consent of the state), NGOs may wish to invite the rapporteur to their offices to investigate their evidence of human rights violations.

The working groups of the Commission on Human Rights, which for the most part are drawn on thematic lines, consider ways to strengthen existing human rights mechanisms and debate possible clarifications of human rights norms and mechanisms. Working groups of particular importance to women's human rights are the Working Group on Disappearances and the Working Group on Arbitrary Detention.

In 1996, the working groups pursued the adoption of a declaration on the rights and responsibilities of individuals, groups and organs of society to promote and protect universally recognized human rights and fundamental freedoms; drafted an optional protocol to the Convention against Torture and Other Cruel, Inhuman or Degrading Treatment or Punishment concerning visits to prisons or places of detention; and drafted an optional protocol to the Convention on the Rights of the Child, on the involvement of children in armed conflicts. Work is also underway on guidelines for a possible optional protocol to the Convention on the Rights of the Child on the sale of children, child prostitution and child pornography.

NGOs and individuals can submit information to working groups in care of the Centre for Human Rights. In order to be considered in the working group's annual report, such information should be submitted by the end of August.

Mechanism Overview	THE UN HUMAN RIGHTS COMMITTEE
WHAT IT COVERS	The ICCPR
OF INTEREST TO WOMEN	The ICCPR prohibits sex discrimination and the Human Rights Committee has interpreted this broadly.
TYPE OF PROCEDURE	The Committee monitors human rights violations and reports to member states. It also serves as a communications forum where states and individuals can bring complaints.
AVAILABILITY OF PROCEDURE	Participating states must be parties to the ICCPR for individual complaints and have ratified the Optional Protocol to the Convention.
ACCESSIBILITY REQUIREMENTS	States must explicitly recognize the competence of the Human Rights Committee to receive and consider formal complaints against each other. Individual complaints can only be received when the state has signed the Optional Protocol.

continued

continued

The UN Human Rights Committee

For monitoring and reporting procedures, only state signatories and legally recognized NGOs can submit information. The Committee may consider information from individuals affected by an alleged state practice.

PROCEDURES & HOW THE SYSTEM WORKS

For monitoring and reporting: states must submit periodic reports on their efforts to comply with the ICCPR. A working group reviews the report initially, then the Committee publicly reviews the report. The Committee studies the report then submits its own report to the state and to the General Assembly through the Economic and Social Council.

For individual complaints: the UN Centre of Human Rights screens applications and submits them to the Committee's Special Rapporteur on New Communications. The complaint is forwarded to the State and the State can respond. The complainant then has six weeks to respond to the State's response. The Committee makes a decision based on the review of all communications.

For interstate complaints: States must submit a communication to the violating state. The violating state then must respond. The Committee will try to facilitate an amicable solution after which it submits a report.

ROLE OF ADVOCATES

The Committee sometimes invites NGOs to comment on reports. Advocates can influence their own state's writing of reports and can comment on Committee recommendations.

REMEDIES

The Committee issues recommendations. When a violation has occurred, the Committee gives the state 180 days in which it is to inform the Committee what action it has taken to remedy the violation.
The Committee has a Special Rapporteur for the Follow-up of Views to recommend actions when states have not provided an appropriate remedy.

ADVANTAGES AND DISADVANTAGES

Many of the reports and formal decisions are made public.
The reporting requires states to engage in human rights issues. Individual members of the Committee often rely on NGOs in their review of reports. The individual complaint mechanisms allows some individual complaints, thus giving individuals a formal role.

UN Committee on the Elimination of Discrimination Against Women

The United Nations General Assembly adopted the Convention on the Elimination of All Forms of Discrimination Against Women (CEDAW or "the Women's Convention") in December 1979. It entered into force in September 1981. Although over 150 countries have signed the Women's Convention, many have done so conditionally, entering many reservations to specific provisions. Some of the objections to the Convention undercut its very purpose, despite the Convention's prohibition of reservations that are "incompatible with (its) object and purpose" (Article 28(2)).

The Women's Convention seeks to do away with discrimination against women, which it defines broadly as:

> any distinction, exclusion or restriction made on the basis of sex which has the purpose or effect of impairing or nullifying the recognition of enjoyment or exercise by women, irrespective of their marital status, on a basis of equality of men and women, of human rights and fundamental freedoms in the political, social, cultural, civil or any other field.(Article 1).

The most important part of this provision is that it applies to both intentional discrimination and acts that have a discriminatory effect.

Unlike other treaties, the Women's Convention calls for the elimination of all forms of discrimination against women, not just the elimination of all "sex discrimination." In other words, instead of calling for gender neutrality (i.e. the same treatment for men and women), the convention prohibits any practices that perpetuate women's inequality. For example, Article 3 requires states to:

> ensure the full development and advancement of women, for the purpose of guaranteeing them the exercise and enjoyment of human rights and fundamental freedoms on a basis of equality with men.

As Rebecca Cook points out (Cook, 1994), under the Women's Convention states assume obligations of both means and results, that is both

> obligations to act by a specific means toward the achievement of aspirational goals and obligations to achieve results by whatever means are determined to be appropriate (Article 2).

The "means" specified in Article 2 require states:

- to embody the principle of equality of men and women in their national constitutions or other appropriate legislation if not yet incorporated therein, and to ensure, through law and other appropriate means, the practical realization of the principle;
- to adopt appropriate legislative and other measures, including sanctions where appropriate, prohibiting discrimination against women;
- to establish legal protection of the rights of women on an equal basis with men and to ensure through competent national tribunal and other public institutions the effective protection of women from any act of discrimination;
- to refrain from engaging in any act or practice of discrimination against women and to ensure that public authorities and institutions shall act in conformity with their obligations;
- to take all appropriate measures, including legislation, to modify or abolish existing laws, regulations, customs and practices which constitute discrimination against women; and
- to repeal all national penal provisions which constitute discrimination against women.

The Committee on the Elimination of Discrimination Against Women (CEDAW) was established to monitor compliance with the Women's Convention. The Committee is composed of twenty-three experts in the fields covered by the Convention. Experts are elected by the state parties to the Convention for a term of four years and serve in their personal capacity.

Unlike the Human Rights Committee, CEDAW cannot consider individual complaints. Some commentators argue that this omission is of little consequence, as a complaint of sex discrimination can be brought under Article 26 of the ICCPR. However, the mandate of the Women's Convention may be interpreted as reaching more forms of discrimination than covered by the ICCPR. In particular, Article 1 of the Women's Convention obligates states to eliminate all forms of discrimination against women, matters that are not usually brought under the ICCPR.

Efforts continue as of this writing to establish an Optional Protocol to the Women's Convention that would allow for individual complaints—as under the ICCPR, the Convention on the Elimination of All Forms of Racial Discrimination, the Inter-American System and the European System. The Protocol would apply only to state parties who ratify or accede to its terms. The main proposal, known as the "Maastricht draft," would give the Committee the power to (1) receive complaints from individuals or groups that have suffered a harm as a consequence of a failure by a State to fulfill its obligations under the Convention; and (2) inquire on its own motion into the situation in a state on receipt of information which indicates a systematic pattern of serious violation of the Convention. For the moment, the only enforcement procedure available under the Women's Convention is the state reporting and monitoring procedure described below.

Type of procedure
Reporting and monitoring.

Availability of procedure
Only states that are parties to the Women's Convention are obliged to conform to its provisions. States need not comply with provisions to which they have made reservations. States have made a record number of such reservations.

Individuals and groups do not have formal access to the monitoring process. However, the committee willingly receives NGO information on an informal basis and in its discretion will receive and sometimes consider communications from individuals and groups in a more formal sense. In addition, NGOs can monitor many CEDAW proceedings.

Getting access to the process
CEDAW proceedings are open to NGOs, both those accredited by the United Nations and others who have obtained special permission.

How the system works and the role of advocates
The Convention obliges state parties to submit to the Secretary General a report on the legislative, judicial, administrative or other measures they have adopted to implement the Convention within a year after its entry into force and then at least every four years thereafter or whenever the Committee on the Elimination of Discrimination against Women requests. The Committee meets once a year to review these reports and consider the progress of women's rights under the Convention. The review process may include an oral presentation by the state party, with questions by Committee members. After the review, the Committee can make suggestions to the state parties in the form of concluding observations and concluding comments and/or general comments and general recommendations. The general recommendations of CEDAW are often extremely important for the future inter-

pretation and application of the Convention.

Advocates have little formal access to this process. However, in recent years, the Committee has allowed advocates to submit their own views directly to the Committee, either to individuals on the Committee or to the group as a whole. Some advocates submit information in the form of "Shadow" or "Alternative Country Reports," presenting their own views on the human rights of women in their country. CEDAW members increasingly are using such reports as one source of authoritative information when considering the state report.

CEDAW has no immediate remedies for women whose rights are violated. The Committee may, however, advise the concerned state on steps to take to rectify the situation.

Weighing advantages and disadvantages

Advantages:

The definition of discrimination under the Women's Convention is broad. Unlike most treaties, the Women's Convention "recognizes the inextricability of subordination and the economic and social structures that generate and perpetuate it." Input of activists into the process, through submission of "alternative" country reports, has improved CEDAW's effectiveness. The duty to report under CEDAW serves at least to keep state parties conscious of their legal accountability for discrimination against women.

Advocates for women are enjoying greater access to the monitoring process as Committee members increase their willingness to consider "Alternative Country Reports" and other NGO submissions.

Disadvantages:

One of the primary disadvantages to CEDAW is that there is no avenue for individual petitions (unlike the ICCPR, the Racial Discrimination Convention and the Torture Convention). In addition, many state parties to the Women's Convention have ratified or acceded to it with reservations that undercut the very purpose and meaning of CEDAW. "Few states have objected to others' legal reservations, fewer to others' tardiness in practice" (Cook, 1994).

The work of the Committee is also hampered by inadequate resources. Every other treaty-monitoring committee has a longer meeting time than CEDAW (usually three to nine weeks, compared with CEDAW's two weeks). As of 1997, CEDAW will have a second session each year.

Finally, the enforcement arm of CEDAW is extremely weak. CEDAW depends almost entirely upon state self-reporting; many states fail to meet their reporting obligations, either submitting incomplete documents or failing to submit any report whatsoever. The Committee has been reluctant to adopt formal recommendations or to interpret the Convention's substantive provisions.

Mechanism Overview	THE UN COMMITTEE ON THE ELIMINATION OF DISCRIMINATION AGAINST WOMEN
WHAT IT COVERS	Covers the scope of "the Women's Convention," the Convention on Elimination of All Forms of Discrimination Against Women.
TYPE OF PROCEDURE	Reporting and monitoring.
AVAILABILITY OF PROCEDURE	Individuals/groups can not access the monitoring process but can communicate at times. NGOs can monitor CEDAW.
ACCESSIBILITY REQUIREMENTS	Only states have access to it; individuals and groups do not. States have to comply only with the provisions they have not made reservations against.
PROCEDURES & HOW THE SYSTEM WORKS	1) States submit periodic compliance reports. 2) The Committee meets once a year to review reports and consider progress of women's rights under the convention. 3) The Committee issues general comments and general recommendations. 4) The Committee may advise states on steps for rectification of situations where women's rights have been violated.
ROLE OF ADVOCATES	Advocates can submit "shadow reports" to CEDAW/individual members.
REMEDIES	No immediate remedies for women whose rights are violated.
ADVANTAGES AND DISADVANTAGES	*Advantages:* Definition of discrimination is broad under the Women's Convention. Shadow reports have improved its effectiveness. Duty to report under CEDAW keeps states conscious of their legal accountability for discrimination against women and has encouraged some states to bring their laws into compliance with the convention. *Disadvantages:* There is no avenue for individual petitions. Enforcement under convention is weak, cannot enforce states' obligation to report. Reservations by states undermine its usefulness.

1503 Procedure

Throughout the history of the United Nations, individuals have often sent complaints of human rights violations directly to the Secretary General. It was not until 1959 that the Commission on Human Rights was authorized to review such communications; still, the Commission had no power to take any action with respect to the complaints. Eight years later the Commission and its Sub-Commission on the Prevention of Discrimination and the Protection of Minorities ("Sub-Commission on the Prevention of Discrimination") were empowered to study "situations which reveal a consistent pattern of violations of human rights..." and make recommendations to the Economic and Security Council (ECOSOC) (E.S.C. Res. 1235 (1967). Authority under this provision was limited largely to apartheid and other consistent patterns of racial discrimination.

It was not until 1970 that ECOSOC opened the way for UN consideration of individual petitions about human rights violations. In that year, ECOSOC adopted Resolution 1503, "Procedure for Dealing with Communications Relating to Violations of Human Rights and Fundamental Freedoms" (the "1503 Procedure"). Less than a year later, the Sub-Commission on the Prevention of Discrimination adopted a more specific set of guidelines for individual complaint procedures.

As explained below, the 1503 Procedures are designed narrowly to address "situations which appear to reveal a widespread pattern of gross human rights abuses." The entire hierarchy of UN human rights organs are involved in the process: the General Assembly, ECOSOC, the Commission on Human Rights, the Sub-Commission on the Prevention of Discrimination and the Centre for Human Rights in Geneva. The Sub-Commission on Prevention of Discrimination is a body of independent experts who serve in their individual capacities. The Centre for Human Rights is effectively the Secretariat for the process.

The 1503 Procedure should not be confused with what are known as 1235 Procedures. ECOSOC Resolution 1235 permits public discussion of "gross and reliably attested violations of human rights." Unlike 1503, it is not directly accessible to individuals, although it is to NGOs.

Type of procedure

Complaint-information. Only complaints of a pattern and practice of human rights violations will be accepted.

Availability of procedure

The 1503 Procedure is available to any person or group complaining of "gross violations of human rights and fundamental freedoms" As one commentator observes, "The phrase 'gross violations' may have a qualitative as well as a quantitative aspect, particularly insofar as the resolution distinguishes 'gross' and 'systematic' violations. Thus, the Commission or Sub-Commission may refuse to consider a situation which is either not sufficiently serious in terms of rights allegedly violated or which is not 'systematic' because it relates to only a few individuals or was restricted by a very short period of time" (Shelton, 1984).

Complainants need not be the direct victim of violations. They need only to be able to show "direct and reliable" knowledge of violations. Allegations of individual violations will not be treated as cases in and of themselves, but individual cases may be taken as evidence of a pattern and practice. Complainants need not be nationals of the state complained against. The complaint may be against any country, even if it is not a member of the United Nations.

Getting access to the process

The rules to be followed in submitting 1503 communications are set forth in Sub-Commission Resolution 1(XXIV) (1971). Communications may be sent to any body of the United Nations, although they should be addressed to the Secretary General of the United Nations at the Human Rights Centre in Geneva. The Secretary requests that twelve copies of communications be submitted (although communications will not be rejected for failure to do so). Anonymous complaints are not accepted, although the complainant may request that his or her identity be concealed during the proceedings.

Communications can be written in any language, and should specify the facts of the violations of human rights and/or relate them to specific articles of the Universal Declaration of Human Rights and/or related Covenants.

Communications will be rejected if they use abusive and/or insulting language, if they are manifestly political in violation of the UN Charter or if they seek to impinge upon the rights and freedoms of others.

Communications should prove that national remedies have been exhausted, provided that such remedies are generally effective and not unreasonably prolonged. Usually the communication must be submitted within a "reasonable time" after national remedies have been exhausted. If resort to national mechanisms would prove futile because of a deliberate state policy to the contrary, the communication should explain the situation in as much detail as possible. The burden of proof to show that national remedies have not been exhausted is on the country concerned.

How the system works and the role of advocates

Communications are first considered by the Centre for Human Rights in Geneva. The Centre summarizes the communica-tion in a confidential list which is circulated to members of the Human Rights Commission, the Sub-Commission on the Prevention of Discrimination and the state against which the accusation is directed.

The Sub-Commission begins to consider communications on a "first-come, first-served" basis when it meets in August or September of every year. To ensure consideration, advocates should submit their communications at least two months before these sessions. A five-member working group of the Sub-Commission conducts a preliminary review of 1503 communications before the August sessions. The working group screens out many applicants at this early stage, determining whether there are "reasonable grounds to believe that the communication reveals a consistent pattern of gross violations of human rights and fundamental freedoms."

The 1503 Procedure is extremely confidential. Although the working group may request additional information from the author of a communication or the accused government, usually all communication ceases once the author of a complaint receives acknowledgment that her/his communication has been received. Neither the author of the complaint nor the government has a right to a hearing or to information about the procedure.

The working group forwards to the Sub-Commission the small number of cases it deems worthy of further consideration. The Sub-Commission then determines, based on the communications and other "relevant information," which cases should be referred to the full Commission. While individuals and NGOs do not have a right to submit information, they may still attempt to make informal contacts with individual members of the Sub-Commission. In making its decision, the Sub-Commission can consider together several communi-

cations regarding the same country and referring to the same situations.

At this point, the Sub-Commission can reject a case, postpone consideration until the following session, refer a case back to the working group for further consideration or refer the case on to the Commission. Should the Sub-Commission decide to forward the case to the Commission, the government (but not the author of the communication) is notified and invited to present written comments to the Commission.

The Human Rights Commission considers 1503 communications in private sessions, during its February and March sessions in Geneva. A five-member working group, made up of members from different regions, first reviews the cases and reports back to the full Commission. If the full Commission decides to consider the case, the state (but not the author of the communication) is notified and asked to answer Commission questions.

The Commission can dispose of a case in four ways. First, it can terminate consideration on the grounds that no gross human rights violations occurred or for some other reason. Second, it may postpone consideration until a later session. Third, it may decide to initiate a thorough study of the situation, with or without the consent of the government. Fourth, with the consent of the government, the Commission may set up an ad hoc committee to make an investigation.

The names of countries subject to 1503 decisions and recommended actions are published in the Commission's annual report to ECOSOC. ECOSOC may accept the Commission's recommendations, adopt them as its own and/or draft its own recommendations for approval by the UN General Assembly.

Advocates can participate directly in the process, initiating complaints under the 1503 Procedure where they have reliable evidence of gross human rights

violations. Advocates can also try to offer supplementary information at any time, either to individual members of the Commission or to the Sub-Commission or Commission as a whole, although there is no guarantee that such information will be considered.

Remedies

The 1503 Procedure leads not to a remedy for a particular individual but rather to a general Commission decision, and possibly a decision by ECOSOC and the General Assembly, that gross human rights violations have occurred and should be remedied. The impact of Commission decisions has been hampered by the confidentiality of the procedures. Since 1978, the Commission has announced the names of countries that have been subject to 1503 decisions, although the content of the decisions is usually confidential. (In the few cases in which it has conducted "thorough studies," the Commission has made public the results.) Once the decision reaches the level of ECOSOC, however, confidentiality restrictions are removed.

Weighing advantages and disadvantages

Advantages:

This is one of the few procedures available where a nation has not signed international covenants; indeed, the government at issue need not even be a member of the United Nations. The 1503 Procedure is an innovation as it allows the United Nations to consider some human rights complaints, albeit a narrow category of cases involving gross violations. Philip Alston (1992) has described the immense "historical value" of the 1503 Procedure as follows:

> It paid once and for all the domestic jurisdiction canard; it accustomed states to the need to defend themselves and gave them practice in defending (and prosecuting) the performance of others; it galvanized

NGOs *at a time when some of the other procedures offered even lower rates of return; and it exposed the Commission and Sub-Commission to the real world of violations more effectively than any other earlier exercise had."*

An advocate can use the procedure under 1503 without jeopardizing the availability of any remedy for individual violations of human rights.

Disadvantages:

The near-total secrecy of the 1503 Procedure minimizes the ability of advocates to participate in the procedure and to use it to fulfill advocacy aims. Some commentators have even suggested that it is dangerous for human rights, as it could become a mechanism for concealing violations. The complainant essentially has "one shot" at offering information and thus the initial complaint should be as complete as possible.

Where individuals seek restitution or other particular relief for their claims, the 1503 Procedure will not meet their needs as it cannot provide individual-based relief. Claims of women's human rights violations will not be heard under the 1503 Procedure unless the violations are of a gross and systemic nature.

The process is slow and cumbersome, resulting in few decisions. In addition, the process is heavily politicized and both the Sub-Commission and Commission may be subject to governmental pressure. As one commentator has observed: "While government observers cannot attend the private meetings, they can learn from confidential summary records and their own nationals what the experts said and how they voted. Secret voting might provide greater protection against intimidation, but only a few experts believe the sub-commission could make that procedural change unilaterally." Neither the Sub-Commission nor the Commission can deal with emergency communications between sessions.

Mechanism Overview	THE 1503 COMPLAINT PROCEDURE
WHAT IT COVERS	Situations which appear to reveal a widespread pattern of human rights abuses.
TYPE OF PROCEDURE	Complaint-information. Only complaints of a pattern and practice of human rights violations will be accepted.
AVAILABILITY OF PROCEDURE	Any person or group complaining of "gross violations" of human rights can use this procedure. The complainant need not be the victim of the abuse but show "direct and reliable" knowledge of the situation. The complaint may be against any country, even if it is not a member of the UN.
ACCESSIBILITY REQUIREMENTS	Complaints must be addressed to the Secretary General of the UN in care of the Human Rights Centre in Geneva.

continued

2

Communications should prove that national remedies have been exhausted or show that recourse to national mechanisms would be futile because of deliberate state policy to the contrary.

PROCEDURES & HOW THE SYSTEM WORKS

Centre for Human Rights in Geneva summarizes the communication and circulates it to members of the HR Commission, the Sub-commission and the state involved.

Complaints are screened by a 5-member working group of the Sub-Commission. The procedure is confidential. Neither the author nor the government has a right to a hearing or to information about the procedure.

The Sub-Commission sends on the "worthy" cases to the Commission for further consideration.

After the complaint is in the hands of the Commission, the government, but not the author, is invited to present written comments and/or to answer questions.

There are four ways to dispose of a case:
- Terminate it on grounds that no gross violation occurred.
- Postpone consideration until a later session.
- Initiate a thorough study of the situation with or without the consent of the government.
- Set up an ad hoc Committee to investigate the situation with the consent of the government.

ROLE OF ADVOCATES

Advocates can participate directly in the process by initiating a complaint. They can also offer supplementary information at any time—although there is no guarantee that it will be considered.

REMEDIES

No remedy for an individual case, but procedure can lead to a decision (by the Commission, ECOSOC or the General Assembly) that gross human rights violations occurred and they should be remedied.

ADVANTAGES AND DISADVANTAGES

Advantages
Any government can be the target of a complaint, not just those which have agreed to international covenants.

Disadvantages
The strict secrecy of the procedure jeopardizes ability to use it for advocacy purposes.

The International Labour Organisation (ILO)

The International Labour Organisation (ILO) was founded in 1919 under the Treaty of Versailles. The only element of the League of Nations to survive World War II, the ILO is now a specialized agency of the United Nations. It has its own constitution and membership and its own organs, budget and staff; it has concluded an agreement with the United Nations, which governs their mutual relations and cooperation.

The ILO was founded upon three ideals:

1. Promotion of peace through social justice;
2. Recognition of collective solutions rather than isolated solutions; and
3. Development of the notion that no country should gain competitive advantage over others through the application of sub-standard working conditions.

The ILO is the only organization in the UN with full voting members from outside the government sphere. ILO operates through a tripartite structure comprised of representatives of governments, employers and employees. The General Conference is composed of representatives of member states; the Governing Body and the International Labour Office are comprised half of government representatives and half of representatives of employers and workers of member states.

Members of the United Nations can become members of the ILO provided that they undertake the obligations set forth in the Constitution (as updated by the 1944 Declaration of Philadelphia and subsequent amendments). States that are not members of the United Nations may be accepted by a two-thirds majority vote of the General Conference.

The main activity of the ILO is to set international labor standards in the form of conventions and recommendations, and to supervise how governments are applying them at the national level. While these labor standards may be technical in nature, they often also have a human rights component that specifically addresses the situation of women workers. For example, ILO Convention No. 111 specifies that all persons should enjoy equality of opportunity and treatment in respect to hiring, pay, advancement in employment, hours and conditions of work and access to training. These are all very important to women, who traditionally have been denied equal pay for equal work and access to better, more secure jobs. Other human rights components found in ILO conventions include freedom of association, freedom from forced labor, and protection of workers from unsafe or unhealthy working conditions.

The ILO adopts *recommendations* and *conventions* at the annual International Labour Conference. It closely supervises how countries apply the conventions they ratify. ILO conventions are legal instruments regulating some aspect of labor administration, social welfare and/or human rights. Ratification involves a dual obligation for a member state: both a formal commitment to apply the provisions of the convention, and willingness to accept a measure of international supervision. Recommendations provide more specific guidelines and practices which countries can choose to adopt; unlike conventions, they are not legally binding. While states can pick and choose which conventions to ratify, they are obligated to report regularly on their compliance with the conventions they have ratified.

Of special interest to advocates for women's human rights:
The Preamble to the ILO Constitution includes the protection of women on its list of work conditions requiring immediate improvement, and affirms the principle of equal pay. Many individual

ILO conventions relate to equality. These conventions have had profound impact both within and beyond the ILO system, as their provisions have been copied or adapted into legislation in many countries. The main ILO Convention pertaining to equality in the workplace, Convention No. 111, has been widely ratified (118 countries as of 1993).

In general, ILO standards relating to women serve two objectives:

1. To protect women workers from exploitation at work and against dangerous working conditions; and
2. To promote the prospects for women in work by ensuring equal rights for women and men. Several ILO conventions and recommendations pertain to equality for women in the workplace, however for the most part these have not been widely used.

The supervision of ratified conventions entails regular reporting by states and monitoring by the ILO and, in addition, complaint procedures. This section considers only the complaint procedures.

Type of procedure

Complaint (akin to complaint-information and reporting and monitoring procedures).

There are four types of complaint procedures under the ILO Constitution and conventions:

1. "Representations" (Articles 24, 25 and 26(4) of ILO Constitution);
2. "Complaints" (Articles 26 to 29 and 31 to 34);
3. Special procedures for freedom of association (Conventions No. 87, 98); and
4. Special surveys on discrimination.

The final type of complaint has never been used and thus it will not be discussed in detail here. The third type listed above, the special procedures for freedom of association, are among the most widely used human rights procedures. While advocates have found these provisions to be useful for protecting trade union rights, advocates for women's human rights would most likely file cases as either "representations" or "complaints" and thus, these are the two types of procedures addressed in this section.

Availability of procedure

Usually the ILO procedures are not available to individual complainants—only to a government, a trade union, an employees' association or a delegate to the ILO. The procedures tend to be used most often in cases in which there is an allegation of a widespread violation of rights.

Representations: A representation may be filed if a country has "failed to secure in any respect the effective observance within its jurisdiction of any convention to which it is a party" (Article 24). A representation may be submitted by "an industrial association of employers or workers." The ILO determines what constitutes an "industrial association"—that an organization is not officially registered within its own country, for example, is not determinative. The association may be national, regional or international, and it need not have a connection to the case (although the ILO may give its claim more credence if it does have a connection).

Complaints: A complaint must also be based on an ILO convention that the country in question has ratified. Complaints may be submitted by: (1) governments (any member state of the ILO that has ratified a convention may complain that another state party is in violation); (2) delegate(s) to the International Labor Conference (delegates may be employer or employee representatives and, while one delegate may file a complaint, the vast number of cases are brought by groups of delegates); (3) the Governing Body of the ILO (the

Governing Body may convert a representation into a complaint or otherwise institute the complaint procedure at any time).

Getting access to the process

Representations and complaints:
Representations and complaints are to be submitted to the Director-General of the ILO. They must be in writing, in any language, and they must refer to Article 24 of the ILO. The subject matter of the representation must concern a member state of the ILO, and it must refer to the state's alleged breach of an ILO convention that it has ratified. While not required, representations and complaints should also include as much documentation to substantiate the allegations as possible. In addition, in the case of representations, the filing organization should submit proof of its status as an industrial association of employers or workers.

How the procedure works and the role of advocates

Representations: Once the representation meets the "accessibility requirements" described above, a special committee of the Governing Body examines the complaint to determine whether the complaining organization has made a prima facie case(i.e. whether the facts as stated would, if not contradicted, constitute a violation of the convention).

If the representation makes it past this stage, the special committee may ask the organization and the government concerned for more information. When all the information has been received, or if a set time period passes without reply, the Committee considers the representations and makes its recommendation to the Governing Body.

If the Governing Body considers that there is no violation of the Convention, the complaint is not made out, the procedure is closed and the allegations and replies may be published. If the Governing Body decides that the government's explanations for the allegations

are not satisfactory, it may decide to publish the representation with the government's reply, as well as its own discussion of the case.

Complaints: The Governing Body forwards the complaint to the government for its comments. Ordinarily, the Governing Body then forms a quasi-judicial body, a Commission of Inquiry, to investigate the complaint.

Commissions of Inquiry normally require written submissions from both sides, and submissions from each party are usually communicated to one another for comments. The Commission has discretion to ask for information from NGOs, to hold hearings in which witnesses are examined and to conduct on-site visits to the countries concerned.

Once evidence collection is complete, the Commission arrives at its decision and makes recommendations to the parties (if warranted). The Commission reports its findings to the Governing Body and publishes them in the Official Bulletin of the ILO.

If it does not accept the Commission's recommendations, the Governing Body may refer the case to the International Court of Justice (Article 29 (2)). To date, this has never occurred.

Remedies

Representations: The decision of the Governing Body constitutes a published finding of a government's compliance or non-compliance with its obligations under the ILO. The matter may be referred to the ILO's regular supervisory machinery.

Complaints: A decision states whether a country is in compliance with a convention. The recommendation accompanying the decision makes suggestions about how to reach compliance, such as possible changes in national legislation. As with representations, in most cases the regular supervisory machinery of the ILO will continue to review the complaint.

If a government does not implement the recommendations of the Commission within a specified period of time, "the Governing Body may recommend to the Conference such action as it may deem wise and expedient to secure compliance therewith" (Article 33). A government may also request that the Governing Body create another commission to determine whether it has complied with the recommendations (Article 34).

Weighing advantages and disadvantages

Advantages:
The ILO mechanisms are among the most comprehensive in the human rights system. Governments usually cooperate with the ILO and often implement its decisions. Moreover, ILO standards often are copied into or adapted into national legislation. The ILO is unique in that its structure includes representatives from both the government and non-governmental sectors (i.e. workers/trade union members). In addition, delegates to the ILO may be employer or employee representatives.

Disadvantages:
NGOs cannot access the ILO procedures except through cooperation with trade unions and employee associations. The decisions reached through the ILO procedures do not result in any compensation or other awards for individuals harmed by a government's practices. ILO decisions rely mainly on the "shame factor" for enforcement.

Mechanism Overview	THE INTERNATIONAL LABOUR ORGANISATION
WHAT IT COVERS	International labor standards.
MAJOR ORGANS	Tripartite structure consisting of General Conference, Governing Body and International Labour Office.
OF INTEREST TO WOMEN	Can be helpful in protecting women workers and the right to equal pay.
TYPE OF PROCEDURE	Four types of complaint procedures including: representations, complaints, special procedures for freedom of association and special surveys on discrimination.
AVAILABILITY OF PROCEDURE	Representations can be submitted by an "industrial association of employers or workers" deemed as such by the ILO. Complaint procedures available to governments, trade unions, employee's associations and delegates to the ILO.
ACCESSIBILITY REQUIREMENTS	The matter of the representation must concern a member state of the ILO and refer to the state's alleged breach of an ILO convention to which it has agreed.
PROCEDURES & HOW THE SYSTEM WORKS	*Representations:* A special committee of the Governing body examines the

continued

THE INTERNATIONAL LABOUR ORGANISATION

continued

merits of a representation to see if it constitutes a violation of the convention.

The committee considers the representations and makes its recommendation to the governing body.

If the Governing Body accepts the government's side, the procedure is closed and the allegations and replies are published.

If the Governing Body finds the government's explanations for the allegations unsatisfactory, it may publish the representation with the government's reply and its own discussion of the case.

Complaints:
The Governing Body forms a Commission of Inquiry.
The Commission can hold hearings to examine witnesses and conducts on-site visits to the countries concerned.

The Commission reports its findings and decision and recommendations to the Governing Body.

If the Governing Body does not accept the Commission's recommendations, it may refer the cases to the International Court of Justice.

ROLE OF ADVOCATES

The Commission of Inquiry has the discretion to ask for information from NGOs for complaint investigations. NGOs can collaborate with trade unions and employee organizations.

REMEDIES

Representations:
The decision of the Governing Body constitutes a published finding of a government's compliance or non-compliance with its obligations under the ILO.

Complaints:
The decision states whether a country is or is not in compliance with a convention. Recommendations include suggestions about how to reach compliance. If governments do not implement the recommendations, "the Governing Body may recommend to the Conference such action as it may deem wise and expedient to secure compliance therewith." (Article 33).

ADVANTAGES AND DISADVANTAGES

Advantages:
The ILO mechanisms are comprehensive.

Governments usually cooperate with the ILO and implement its decisions.

Disadvantages:
NGOs do not have direct access to the ILO procedures.

Individuals do not receive any compensation or other awards for violations they have incurred.

ILO decisions lack strong enforcement mechanisms.

Commission on the Status of Women

Established in 1947, the UN Commission on the Status of Women prepares studies, reports and recommendations on human rights and related issues affecting women. It has played a role in the drafting of contemporary treaties dealing with women's rights, such as the Convention on the Elimination of All Forms of Discrimination Against Women, and in initiating UN programs concerning women. In recent years, the Commission has served as the preparatory body for important international conferences and has focused more on improving women's political, economic and social status.

The Division for the Advancement of Women (DAW) is responsible for servicing the CSW and the Committee on the Elimination of Discrimination against Women (CEDAW). In this role, DAW acts as a focal point for coordination and mainstreaming of gender issues in the United Nations system. It has been the Secretariat of the four UN world conferences on women: 1975 (Mexico), 1980 (Copenhagen), 1985 (Nairobi) and 1995 (Beijing).

The CSW has struggled to obtain the resources and status it needs to address concrete violations of human rights. The Commission meets once a year for only three weeks. In the early 1980s, ECOSOC empowered the Commission on a very limited basis to review communications concerning violations of women's rights. To date, the Commission has tended to use communications as a source of information for its own studies, rather than as a vehicle to address specific cases of violations. Recently, there has been a concerted attempt to expand the role of the Commission into a monitoring mechanism with powers of investigation.

As the communications procedures of the Commission have had little impact to date, this section discusses them in brief.

Type of procedure
Complaint-information.

Availability of procedure
The Commission will receive communications from any individuals or groups complaining of a violation by any state. Communications received under the 1503 Procedure (see above) concerning the status of women may be sent to the CSW for its consideration under this procedure.

How the system works and the role of advocates
A working group of the Commission considers communications. This group reports to the Commission on trends and patterns of discrimination evidenced by the communications—but the group does not have to recommend specific action on individual cases. Governments are simply asked to respond to communications concerning them, and the Commission may, at its discretion, then make recommendations to ECOSOC.

Apart from submitting the initial communication, advocates have little role in the procedure. The communications are confidential and until recently the Commission did not even notify the complainants of any recommendations it may have made in response to their communications.

Remedies
The system offers no clear remedies for individuals. The Commission may make recommendations but it has little power to force states into compliance.

Weighing advantages and disadvantages
Advantages:
This communication procedure has potential. It is possible that the more women's human rights advocates use it, the more the Commission will evolve

2

towards becoming an effective monitoring body.

Disadvantages:
The Commission does not address specific complaints in a manner that leads to relief for the victims of human rights violations. The Commission has limited resources and little power to prod governments to change their behavior.

Mechanism Overview	COMMISSION ON THE STATUS OF WOMEN
WHAT IT COVERS	All women's rights.
OF INTEREST TO WOMEN	It prepares studies, reports and recommendations on issues affecting women.
TYPE OF PROCEDURE	Complaint-information.
AVAILABILITY OF PROCEDURE & ACCESSIBILITY REQUIREMENTS	The Commission receives communications from individuals or groups.
PROCEDURES & HOW THE SYSTEM WORKS	A working group of the Commission reports to the Commission on patterns of discrimination. Governments are asked to respond to communications concerning them. The Commission may make recommendations to ECOSOC.
ROLE OF ADVOCATES	Advocates may submit a communication but have little role in the procedure.
REMEDIES	There are no clear remedies for individuals. The Commission may make recommendations, but cannot force states to comply.
ADVANTAGES AND DISADVANTAGES	As more women's groups use the communication procedure, the Commission may see a need to respond formally to complaints. The Commission cannot provide relief for victims of violations. It has limited resources and power.

UN High Commissioner for Refugees

About 80% of refugees are women and children. Today, over 18 million refugees and over 20 million "displaced people" (people who have left their homes but have not crossed state boundaries) exist worldwide, and their numbers continue to grow. Refugee women face human rights violations at every stage during their flight.

During the flight women risk rape or other abuse and violence, which may be used as weapons of war. In refugee camps women are exposed to sexual violence and other intimidation by local security personnel and even male refugees. Furthermore, women suffer from inadequate sanitary facilities and medical assistance; they are often lacking food and necessary non-food items because the UNHCR and/or other relief agencies have directly distributed only to men. In addition, because there are fewer female staff, women refugees have a more difficult time getting medical assistance, education and training, and reporting incidents like sexual abuse to camp authorities.

To begin to overcome these burdens and obstacles, the UNHCR developed "Guidelines on the Protection of Refugee Women" (1991) and "Guidelines on the Prevention and Response to Sexual Violence Against Refugees" (March 1995). These Guidelines confirm the need for the UNHCR and individual states to address gender-based persecution. The Guidelines specify that gender-based persecutions can qualify as legitimate claims under the 1951 Refugee Convention when classified as discrimination due to political opinion, religious affiliation or "other social group." The UNHCR plans to promulgate the guidelines through women's rights awareness workshops in most refugee camps.

The two sets of UNHCR guidelines include the call for preventive actions or measures to be taken in response to violations of women's human rights by refugee camp staff, the host government or the UNHCR. Moreover, the guidelines include provisions for cooperation between refugee workers and refugee women. Refugee women are empowered to take part in planning and implementing the guidelines. The underlying principle behind the UNHCR guidelines and policies is the recognition that only refugee women themselves can describe their needs and problems and the actions necessary to correct them.

Although the guidelines do not constitute an international "procedure" in the same sense as other mechanisms included in this manual, they do illustrate one of the specific types of procedures available within UN-affiliated bodies (another example is the more formalized complaint procedure of UNESCO). The existence and operation of the guidelines also illustrate the influence of NGOs on the operations of UN organizations. Thus, this section surveys the UNHCR's gender-specific guidelines in brief. Note that this section addresses solely issues brought under such guidelines and not the larger question of gender-based asylum claims brought before national authorities in individual states.

Type of procedure

Complaint-information. Rudimentary procedures are available for refugee women to report incidents of gender-based violence to any UNHCR personnel and, if they wish, follow up with a complaint to specially trained UNHCR officials. The UNHCR is contemplating the enactment of more procedures. However, because the guidelines take the view that the UNHCR should not interfere unless refugee women specifically ask for their intervention, a more comprehensive complaint procedure is perhaps not foreseeable unless women refugees and activists take decisive initiative.

Although the guidelines also recognize other forms of violations of women's human rights, such as the right to access any benefits provided by the UNHCR without discrimination, no procedures have been promulgated to enforce those rights. However, refugee women or their advocates can make complaints to superior personnel within the UNHCR if local camp personnel are not complying with their obligations under the guidelines.

Availability of procedure

Only refugee women in UNHCR refugee camps have access. The camps are created on an ad hoc basis to respond to crises and long-term refugee situations which the UNHCR decides to address under its general mandate to protect persons who are legally defined as refugees. What this means for women refugees is that, because the guidelines only apply to women under the jurisdiction of the UNHCR, the only women refugees who have access to the enforcement of their human rights under the guidelines are those within UNHCR camps.

Getting access to the process

Unlike most human rights enforcement mechanisms, there are no specific admissibility requirements. Any refugee woman under the jurisdiction of the UNHCR may make a complaint.

How the system works and the role of advocates

A refugee woman can bring a complaint of gender-based violence to the attention of UNHCR personnel. Also, if a UNHCR staff member knows of an incident of gender-based violence, the guidelines say that the staff should try to interview the refugee woman but not seek more information than necessary, only what she wishes to provide. Whether the information comes from the refugee woman or from a UNHCR staff member, it is relayed and reported from the field office to UNHCR headquarters. It is unclear at this time what the UNHCR will do with this information.

The UNHCR is beginning legal literacy and rights education programs in its refugee camps. Women's human rights advocates may be able to participate in such programs and influence the further development and implementation of guidelines and policies to defend women refugees' rights. Because the UNHCR has very clear legal duties to follow women's human rights norms, advocates can use that opening to try to strengthen and amplify the work begun through the current guidelines. Advocates may also visit refugee camps directly and try to assist refugee women in bringing forward complaints about gender-based violations and other women's human rights violations in the camps, such as instances of unfair distribution of food resources. The UNHCR can be lobbied to take actions to remedy these situations. Because there is no specific complaint procedure, the push for the UNHCR to take remedial actions must be political and/or utilize the media to expose the violations of women's human rights.

This can result in further actions. The current example is the work done by women's human rights advocates in documenting and reporting cases of rape of women in the former Yugoslavia. The documenting of the reports of rape occurred in UNHCR refugee camps, and eventually led to a special international war crimes tribunal. The special tribunal was designed to address these women's human rights issue in a very direct manner. In the short run it may be unable to stop the violations; in the long run it may be effective in redressing the violations of women's human rights.

For women's human rights activists to use the system effectively, they should find a means to visit refugee camps and talk extensively and directly with refugee women. Above all, wherever possible, refugee women activists should have a leading role at every stage of any activist involvement.

Remedies

No specific remedies are available as of yet. The only way this system can be used to force solutions to the problems exposed by the guidelines is by using political tools and the media to pressure the UNHCR or other bodies to take action.

Weighing advantages and disadvantages

Advantages:

The UNHCR guidelines, as problematic as they are, represent the most advanced set of guidelines and policies currently used by any UN agency with respect to women's human rights. The UNHCR also has a very good record of commitment to defending refugees' human rights, even under highly adverse conditions. Progress has been made on a camp-by-camp basis, because many UNHCR officials are themselves activists who have undertaken rights education, political organizing and other projects in favor of women's human rights. The promulgation of the guidelines has made a great difference in the attitudes and policies of UNHCR field office staff who run the refugee camps and who have direct power over women refugees' survival needs. The guidelines are most effective when camp officials are trained in and supportive of women's human rights.

The UNHCR also tends to be very accessible to activists. This situation invites women's human rights activists, including women refugees, to lobby local UNHCR offices directly for change, participate in workshops and voice the concerns of refugee women. The progress already made represents significant steps forward from the traditional humanitarian or development agency model of ignoring violations of women's human rights or even of being the agents of such violations.

Disadvantages:

The UNHCR policies and guidelines on gender violence are so vague that they are open to subjective interpretation by UNHCR field officers and other staff who may not always understand or be sympathetic to the issues. Some UNHCR officials or publications take on a paternalistic tone that is not favorable to women refugees, especially when they blame violations on women themselves.

The UNHCR only seeks information and reporting in cases of gender-based violence; it does not offer protection. Women reporting violence face the risk of being beaten in retaliation; the period just after a woman files a domestic violence complaint is the most dangerous time. Some UNHCR reports exhibit faulty presuppositions, for example reasoning that refugee women are unwilling to report incidents and that they do not want intervention. Women refugees would be more willing to make complaints if they would receive protection.

Mechanism Overview	THE OFFICE OF THE UN HIGH COMMISSIONER FOR REFUGEES
WHAT IT COVERS	Protection of refugees.
OF INTEREST TO WOMEN	Has gender specific guidelines.
TYPE OF PROCEDURE	Complaint-information.
AVAILABILITY OF PROCEDURE	Only refugee women in UNHCR refugee camps have access.
ACCESSIBILITY REQUIREMENTS	Any female refugee under the jurisdiction of the UNHCR may make a complaint.
PROCEDURES & HOW THE SYSTEM WORKS	Individual women and UNHCR field staff members send communications to the UNHCR headquarters.
ROLE OF ADVOCATES	Advocates can participate in legal literacy programs run in camps and assist refugee women in bringing up complaints. Advocates can lobby the UNHCR to take action on complaints received.
REMEDIES	No specific remedies as of yet.
ADVANTAGES AND DISADVANTAGES	*Advantages:* UNHCR is accessible to advocates. *Disadvantages:* The UNHCR only reports cases of gender-based violence. It does not offer protection against violations. Female refugees outside of camps cannot file complaints.

REGIONAL HUMAN RIGHTS SYSTEMS

3

Regional blocks of countries have signed treaties to promote human rights within their territories. These create additional and/or alternative avenues for advocates to promote women's human rights within specific regions.

This chapter introduces three regional human rights systems: the *European System*, the *Inter-American System* and the *African System.* (While human rights activists in Asia have pressed for many years for a "made in Asia" regional agreement, and despite the many options for creative, sub-regional arrangements, to date these proposals have not been successful. Thus, although many networks of human rights groups exist within Asia and the Pacific, advocates there still can look only to national and international systems and mechanisms for enforcement of human rights.)

The European Human Rights System

The political upheavals in central and eastern Europe since 1989 and the drive toward a unified European economic system have set the tone for debate over possibilities for a uniform European human rights system. The exact shape of such a system cannot be foreseen, but it is likely to draw from existing European international organizations, including the Council of Europe, the Organization on Security and Cooperation in Europe (OSCE) and the European Community/ European Union. In addition, it will draw from the existing major regional agreements, those of the Council of Europe: the European Convention on Human Rights, the European Social Charter, the European Convention on the Prevention of Torture; that of the OSCE: the Helsinki Accord; and those of the European Community/ European Union: the Treaty of Rome and the Maastricht Treaty. This section introduces each European entity and then proceeds to explain how each applies its own respective agreements, providing a brief explanation of those agreements.

The *Council of Europe,* a regional intergovernmental organization, has directed its attention to the protection of human rights ever since its founding in 1948. The Council drew up the European Convention on Human Rights, which was adopted in 1950 and entered into force in 1953 (and which has been supplemented by a number of protocols). By the 1980s, the acceptance of basic human rights norms and the legitimacy of the European Convention machinery was so widespread that ratification had become a de facto political condition for membership in the Council of Europe.

The Council subsequently adopted a human rights instrument focusing more on economic and social rights, the European Social Charter, in 1965 (revised in 1996), and a specialized torture convention, the European Convention on the Prevention of Torture and Inhumane or Degrading Treatment or Punishment, in 1989.

The Council of Europe also established the European Commission on Human Rights, the European Court of Human Rights and the Committee of Ministers, each of which plays a role in implementing and enforcing the European Convention on Human Rights. The Court and Ministers also help administer the European Social Charter.

The **Organization on Security and Cooperation in Europe** ("OSCE," formerly CSCE) emerged out of the 1975 Helsinki Final Act, a general statement of human rights principals. For over twenty years the group was essentially an ongoing forum for political dialogue on security issues. With the fall of the Berlin Wall, however, the OSCE has taken on more permanent form and greater importance in monitoring human rights and preventing conflict.

The **European Community/European Union** ("EC" or "EU") is primarily concerned with economic issues, especially the creation of a single European market. Nevertheless, its various organs have considered human rights issues, in particular the question of discrimination in the workplace. Article 7 of the 1957 Treaty of Rome, the foundation of the European Community, prohibits discrimination between EC citizens; Article 119 provides that men and women shall receive equal pay for equal work. The **European Court of Justice** has interpreted and applied such provisions. In doing so, the Court has often referred to the rights and freedoms in the European Convention on Human Rights, the Council of Europe document.

Human rights advocates can also take advantage of the **European Parliament's** petition procedure. This procedure gives every EC citizen the right to submit written petitions to Parliament concerning any matter within the activities of the Community. The Committee can investigate and report on petitions, and request the Commission of the European Community to bring an action against an offending state. The European Parliament also has a Human Rights Sub-Committee which is charged with considering human rights issues globally. NGOs can use this as a channel for communicating human rights information to the European Parliament.

The Mechanisms Available Under the Council of Europe

The Council of Europe administers the European Convention on Human Rights and the European Social Charter through three organs: the **European Commission on Human Rights**, the **European Court of Human Rights** and the **Committee of Ministers**. The Council also created the **European Committee on the Prevention of Torture** to administer the European Convention on the Prevention of Torture and Inhumane or Degrading Treatment or Punishment. The bodies work in a complex, interrelated relationship. Each mechanism is described below.

European Commission On Human Rights

The European Commission on Human Rights ("the European Commission") is the primary body administering the **European Convention**, technically, the **European Convention for the Protection of Human Rights and Fundamental Freedoms**. The European Commission is aided by the **European Court of Human Rights** and the **Committee of Ministers**. Each of these bodies may have a role in the investigation of individual or state complaints. This section explains the European Convention and the European

The European System: Access for Advocates

The European system for the protection of human rights is one of the world's best and most accessible. Advocates can access the system through multiple avenues:

European Commission on Human Rights. Individuals and NGOs, as well as states, can petition the European Commission about violations of the European Convention on Human Rights (after exhausting all domestic remedies).

European Court of Human Rights. Under Protocol No. 9 of the European Convention on Human Rights, women's human rights advocates can play a major role in initiating cases, informing the Court and achieving settlements.

European Committee for the Prevention of Torture. Every citizen of the Council of Europe can invoke the Convention on Torture, whether or not they themselves are victims.

Organization for Security and Cooperation in Europe. Individuals and NGOs can submit information to the OSCE's monitoring and reporting mechanisms. Enforcement mechanisms are strongest in situations of national or inter-ethnic conflict.

Commission's role in its enforcement.

The machinery for enforcement of human rights agreements under the European Convention is the most developed in Europe and perhaps the world. Over time, a considerable body of substantive and procedural case law and commentary has been published on the Convention and its supporting system.

The majority of applications under the European Convention have concerned freedom from torture or inhuman or degrading treatment (Article 3), unlawful detention (Article 5) or the right to a fair trial (Article 6). Cases before the European Commission and the EC's European Court of Justice, which sometimes interprets and applies the provisions of the Convention (see below), have included other issues such as press freedoms, gay and lesbian rights and compulsory sex education.

While the European Convention does not include a general ("stand alone") duty of non-discrimination, gender-based discrimination claims can be considered under the various substantive provisions of the Convention, read in conjunction with Article 14, which provides that the enjoyment of rights and freedoms under the European Convention shall be secured without "discrimination on any ground such as sex...". Most gender-based claims to date have been based on the European Convention's protections for privacy and family life (Article 8). The European Court of Human Rights can refuse (and indeed it has refused) to consider violations under Article 14 if it has already found a violation of a substantive right guaranteed under other articles of the European Convention.

The procedures before the European Convention are undergoing drastic restructuring with the submission of Protocol No. 11. This section explains

the procedures presently in effect; a succeeding section explains the changes that will occur if Protocol No. 11 is ratified.

The European Commission is a quasi-judicial body composed of the same number of jurists as the number of states that have ratified the European Convention (although the judges serve in their personal capacities, not as representatives of their home states). Meetings occur twice a year in sessions lasting five weeks. The European Commission has become a semi-permanent body, meeting nearly monthly. The Commission receives complaints from both individuals and states. A state must agree in advance to subject itself to individual complaints (Article 25). The Commission's decisions are not legally binding.

Type of procedure

Complaint-recourse. The European Commission contemplates both individual and inter-state complaints addressing the European Convention.

Availability of procedure

For individual complaints:
Individual complaints can be sent only to the European Commission, not to the other bodies enforcing the European Convention. Countries must explicitly accept the right of individual petition (Article 25) before petitions can legitimately be filed against them. As of 1994 all contracting states to the European Convention had accepted the right of individual petition, although most had invoked Article 25(2), which allows countries to do this for limited periods. However, so far all of these states have regularly renewed their declarations of acceptance.

So long as a state has accepted the right of individual petition, a petition may be filed against it by "any person, non-governmental organization or group of individuals claiming to be the victim of a violation of one of the High Contracting Parties [i.e., parties to the Convention] of the rights set forth in [the] Convention...." (Article 25(1)).

Under the terms of the European Convention, the applicant must be a "victim." However, the Commission has heard claims from both "direct" and "indirect" victims, such as relatives or others with a close connection to the direct victim. If the alleged victim is an NGO or group of individuals, the application must be made by persons competent to represent the organization. Anonymous applications are inadmissible.

Also, the mechanism is available only for violations that result from action or inaction by the state or by agents of the state, such as state employees. And the alleged violation must be of a right protected under the European Convention. Nationals and foreign citizens alike may have access to this mechanism as long as they reside within the jurisdiction of the state.

For inter-state complaints:
States can bring complaints under the European Convention either to the European Commission (Article 24) or to the Court of Human Rights (Article 48(b) and (d)). States rarely invoke this mechanism; they have never specifically done so in instances concerning women's human rights. Since the primary focus of this manual is on complaints by individuals, not states, the rest of this section will deal primarily with individual complaints.

Getting access to the process

Complainants must first exhaust domestic remedies, including extensive administrative appeals (Article 26). When complaints are turned away, it is usually because they fail to satisfy this requirement.

The complaint must be filed within a period of six months from the date on which the final decision was made at the

domestic level. The relevant date for the purposes of this rule is normally the date on which the European Commission on Human Rights first receives a communication about an application.

The complaint should be addressed to the Secretary-General of the Council of Europe. All subsequent communication in the case is conducted with the Secretary of the European Commission on Human Rights. The Secretariat will supply an application form on request. However, applicants need not use this form provided that their submission contains all matters required by the Commission's Rules of Procedure. Complaints can be made in French or English or the language of a state that accepts the right of individual petition.

Rule 38 of the Rules sets forth the requirements for applications. In addition to proving exhaustion of domestic remedies, the complaint must contain identifying information about the individual, her representative, the name of the state party against which the complaint is filed, a summary of evidence of the human rights violation, the specific provision of the European Convention alleged to have been violated, the nature of relief sought (i.e. monetary damages, injustice relief, etc.) and any relevant documents, particularly any judgments or decisions relating to the substance of the application.

While the European Commission cannot hear anonymous petitions, the applicant can indicate that he/she does not want to be identified to the respondent government.

Complaints ordinarily are considered in the order in which they become ready for a hearing. However, the Commission can give priority to cases of emergency. A request for priority treatment can be made in a cover letter to the complaint explaining the nature of the emergency and the need for an urgent hearing.

The European Commission can reject a petition under Article 27(2) of the European Convention if it finds that the accusations are unfounded. The Commission is particularly wary about petitions submitted to generate publicity and/or for "political ends." Advocates should bear this in mind in planning any publicity around their cases. The fact that the petition has been filed can be released to the press, but after that time, the process is confidential and media inquiries should be referred to the appropriate office at the Council of Europe.

Women alleging violations may represent themselves or may be represented by attorneys, or by others who have powers of attorney. Appointed representatives must submit a form stating that they are acting on someone's behalf. Legal aid is available where the cost of counsel may be prohibitive. Applications must be signed by the applicant or the representative.

How the system works and the role of advocates

The procedure before the European Commission on Human Rights is divided into two stages: Pre-Admissibility Procedures and Post-Admissibility Procedures (including attempts to reach a settlement).

Pre-Admissibility Procedures:

A complaint that satisfies all admissibility requirements is filed and registered by the Secretariat.

The complaint is examined by a rapporteur who then reports to the Commission. The Commission may rule to:
1. Declare the application inadmissible;
2. Strike it off the list;
3. Ask the accused government for observations on admissibility; or
4. Adjourn the application.

Most applications are rejected at this stage.

The minimum goal of advocates should be to get beyond this early stage, which means persuading the Commission on Human Rights to communicate the application to the government in

question. At the very least, this puts the government on notice of a human rights complaint and forces it to participate in the Commission process. The government normally is given eight weeks to reply.

The Commission forwards this response to the applicant(s), who may then respond. After both sides respond, the rapporteur prepares a second report which is discussed by the Commission.

If the application is not rejected, the Commission may either immediately declare the application admissible or schedule an oral hearing. To streamline the process, during the oral hearings the Commission usually considers both questions of admissibility and the merits of the case.

Post-Admissibility Procedures

Once an application has been admitted, both the applicant and the government have an opportunity to submit a written argument and other documentation. Oral hearings may be called by the Commission, although they are rare at this stage. The Commission is not guided by formal rules of evidence and often it admits evidence that would not be permitted under domestic law.

The Commission may call witnesses to its seat in Strasbourg, or delegates may travel to the site of the alleged violation to hear and examine evidence. Article 28 obligates the state to furnish "all necessary facilities" for the Commission's investigations.

Remedies

Parallel to its investigative function, the Commission attempts to facilitate a friendly settlement (Article 28). A successfully friendly settlement brings the case to an end.

Should a settlement not be reached, Article 31 of the Convention obligates the Commission to draw up a report stating the facts and giving an opinion on the violations alleged. This report is submitted to the Committee of Ministers and the state concerned, but not to the applicant.

After a three-month interval, the Committee of Ministers decides whether a breach of the Convention has occurred. The Ministers have the discretion to publish the Committee's report.

The concerned state, the Commission or individuals (under Protocol No. 9) can also refer the case to the European Court of Human Rights, provided that the state has accepted the Court's jurisdiction (see below).

Weighing advantages and disadvantages

Advantages:

The system under the European Convention (including not only the European Commission on Human Rights but also the European Court of Human Rights and the Committee of Ministers) is one of the most established in the world. The scope of possible violations it recognizes on account of civil and political rights is extremely broad. Member states of the Council of Europe and the European Community/ European Union respect the system, and human rights activists around the world often look to decisions rendered under the Convention for models and precedents (although they are not binding on other regions).

Disadvantages:

Many applications are found to be inadmissible. The victim of a violation has to be willing to pursue the case in her own name (although the Commission can be asked not to disclose the applicant's identity to the state). The system is over-burdened and cases are often delayed. Proceedings often extend over five years and the Convention provides no interim measures in the meantime. However, the implementation of the streamlined provisions under Protocol No. 11 (see below) may help untangle the process.

The Convention is not directly applicable in all member states of the Council of Europe. Furthermore, although generally broad in scope, the Convention is short on economic, social and cultural rights and, while Article 14 prohibits the denial of other rights granted in the Convention on the grounds of sex, the Convention includes no "stand alone" non-discrimination provision. In other words, Article 14 must always be read in conjunction with a substantive provision of the Convention.

Finally, advocates should keep in mind that many states have ratified the European Convention with reservations and not all states have ratified all of the protocols. Advocates should assess their own country situation before proceeding. In addition, advocates are warned that Protocol 11, if ratified by all parties to the European Convention on Human Rights, will drastically change these procedures.

Mechanism Overview	THE EUROPEAN COMMISSION ON HUMAN RIGHTS
WHAT IT COVERS	Administers the European Convention on Human Rights.
RELEVANT ORGANS	The Commission works in conjunction with the European Court of Human Rights and the Committee of Ministers of the Council of Europe.
TYPE OF PROCEDURE	Interstate and individual complaint-recourse.
AVAILABILITY OF PROCEDURE	Available to "any person, NGO or group of individuals claiming to be the victim of a violation by one by the Contracting parties of the rights set forth in the Convention", provided that the relevant state has accepted the right of individual petition.
ADMISSIBILITY REQUIREMENTS	Complainants must exhaust domestic remedies. Complaints must provide relevant data regarding the applicant, evidence of the violation and the provision that was violated, the party against whom the complaint is filed, etc. Anonymous complaints will not be received, but an individual does not have to be identified to the respondent government. Requests for priority treatment can be made.
PROCEDURES AND HOW THE SYSTEM WORKS	*Pre-Admissibility* A complaint is filed and registered by the Secretariat. The Commission decides whether to proceed and often does not.

continued

THE EUROPEAN COMMISSION ON HUMAN RIGHTS *continued*

PROCEDURES continued

The government is notified and asked to respond, then the applicant responds.

The Commission decides whether to continue with the application.

Post-Admissibility
Both parties (applicant and government) submit written arguments.

Witnesses are called or delegates may travel to examine evidence.

Commission attempts to facilitate friendly settlement.

If no settlement occurs, Commission prepares a report for the Committee of Ministers and the state concerned but not the applicant.

After three months, the Committee of Ministers decides whether a breach of the Convention has occurred.

The state, the individual or the Commission can refer the case to the European Court of Human Rights as an appellate tribunal.

ROLE OF ADVOCATES

Advocates play major roles in initiating cases, in settlement attempts, in referring the case to the Court and in communications.

REMEDIES

The Commission attempts to facilitate a friendly settlement. If such a settlement cannot be reached, then the Commission reports to the Council of Ministers or may refer the case to the Court.
The Committee of Ministers cannot issue binding decisions, but it can sanction the offending state by expelling it from the Council of Europe, although this is unlikely.

Expected Changes to the European Convention

A wholesale revision of the procedural system was ultimately approved as Protocol No. 11 in May 1994, yet it will not enter into force until one year after all parties to the European Convention on Human Rights have ratified it. Protocol 11 does not affect the substantive rights protected by the Convention and its protocols, but it does restructure and streamline the system. Like the present Convention, the Protocol includes both an individual complaint procedure and a state complaint procedure. However, unlike the present convention, recognition of the competence of the Court to receive individual petitions is compulsory, as is acceptance of the jurisdiction of the court.

Under Protocol No. 11, the Commission and the Court are to be replaced by a new permanent Court, located in Strasbourg, which will handle

both the admissibility and merits stages of all applications. The Court will also have a fact-finding role and will be at the disposal of the parties to assist in friendly settlement. The new Court shall consist of a number of judges equal to that of the state parties to the convention. Judges will be elected for a period of six years (as compared to nine under the present system), with the possibility of re-election.

Cases will be distributed among Committees of three judges, Chambers of seven judges, and a Grand Chamber of seventeen judges. Three-judge Committees will have the power to rule applications clearly inadmissible according to the same criteria for admissibility as under the present procedure. If the Chamber declares the application admissible, it shall pursue the examination of the case and try to secure a friendly settlement. Negotiations are to be confidential. The procedure may include oral hearings as well as written submissions.

Seven-judge Chambers will deal with all contentious matters whether on admissibility or the merits. In addition, where a serious question affecting the interpretation of the Convention is raised or where the resolution of a question is likely to produce a result inconsistent with the Court's earlier jurisprudence, the regular Chamber may relinquish jurisdiction in favor of a Grand Chamber of seventeen judges. Relinquishment of jurisdiction to the Grand Chamber cannot take place without the consent of the parties. The Grand Chamber will also have jurisdiction where advisory opinions are sought.

In addition, an aggrieved party may request referral of a decision of a regular Chamber to a Grand Chamber for review. Leave for such a referral may be granted by a panel of five judges of the Grand Chamber.

Under the revised system, the role of the Committee of Ministers is restricted to requesting advisory opinions and supervising the execution of judgments. Thus, apart from supervision, the entire process takes place in front of only one body, the Court.

Non-state intervention is permitted under a new Article 36, which allows for "third-party intervenors." Intervenors are not parties to the proceedings, but more akin to "amici" (friends of the court). Amici face several disadvantages. For example, unlike parties, amici are not entitled to compensation or legal costs and they cannot control the direction and management of the case; they are generally not served papers in the case; they cannot offer witnesses or evidence; and they cannot be heard without permission of the court.

The new procedure, however, grants a right to intervene only to the state in which the victim is a national. This contrasts with the more generous European Community law, which permits any member state to submit observations when the Court of Justice is called upon to interpret the content of Community law.

The European Court Of Human Rights

The European Court of Human Rights ("the European Court") is a judicial body composed of a number of judges equal to the number of states that are current members of the Council of Europe. These judges serve in their individual capacities. The European Court helps implement and enforce both the European Convention on Human Rights and the *European Social Charter* ("Social Charter"). As the European Convention was discussed above in reference to the Council of Europe, this section introduces the Social Charter before explaining the Court's role in enforcing both the Social Charter and the European Convention.

Given the failure of the European

Convention of Human Rights to address social and economic rights, the Social Charter was adopted and entered into force by the Council of Europe in 1965. The Social Charter was to be the Convention's counterpart with respect to such issues. The operations of the Social Charter, however, could not even begin to compare with the elaborate, time-tested machinery of the Convention. There was neither judicial supervision of the Charter nor an individual complaints procedure.

In addition, the reach of the Social Charter was limited by its unique "cafeteria" nature. While signatories to the Social Charter agreed to certain core principles as a matter of policy, they could pick and choose among specific rights to which they might agree in whole or in part (so long as they agreed to a set minimum number). States were only required to abide by the provisions to which they explicitly agreed.

Since the end of the 1980s, the Council of Europe has undertaken a number of activities to breathe new life into the Charter. Additional Protocol No. 1 was adopted in May 1988, guaranteeing four new rights; Amending Protocol No. 2 was adopted in October 1991, revising the supervisory system; and Additional Protocol No. 3 was adopted in November 1995, providing for a system of collective complaints.

Then, in May 1996, a thoroughly Revised European Social Charter was opened for signature. The new version guarantees additional rights—a total of thirty-one, including the following rights not previously included: the right to protection in cases of termination of employment, the right to dignity at work, the right to protection against poverty and social exclusion and the right to housing.

At the same time, the nature, scope and wording of the previously established rights were changed considerably, updating the provisions in line with current social trends. For example, Article 15

used to proclaim the right of disabled persons "to vocational training, rehabilitation and social resettlement." The same article now guarantees persons with disabilities the right "to independence, social integration and participation in the life of the community."

Ratification of the Revised Charter does not automatically imply that state parties are immediately bound to all of the new Charter provisions. Each party agrees to the thirty-one rights and principles listed in Part I "as a declaration of aims which it will pursue by all appropriate means." At the same time, the Revised Charter preserves the old "cafeteria approach" whereby parties agree to be bound by at least six of nine articles specified in Part II. The nine articles are: the right to work; the right to organize; the right to bargain collectively; the right of children and young persons to protection; the right to social security; the right to social and medical assistance; the right of the family to social, legal and economic protection; the right of migrant workers and their families to protection and assistance; and the right to equal opportunities and equal treatment in matters of employment and occupation without discrimination on the grounds of sex. A state may also agree to be bound by "an additional number of articles or numbered paragraphs...which it may select, provided that the total number of articles or numbered paragraphs by which it is bound is not less than 16 articles or 63 numbered paragraphs" (Part II, Article A).

Of particular interest to women's human rights advocates:
The provision prohibiting discrimination in employment on the grounds of sex still is not mandatory; although this provision is included among the nine provisions suggested as mandatory, states need agree to only six of these nine.

The Revised Charter contains an explicit non-discrimination provision,

stating that "the enjoyment of the rights set forth in this Charter shall be secured without discrimination on any ground such as... sex..." (Part V, Article E). Yet the new Charter maintains some of the protectionist provisions, which arguably constitute discrimination against women. For example, Article 8(5) (which is not mandatory but to which states may agree to bind themselves) prohibits pregnant women and women who have just given birth from working in underground mines. Given that the jobs in mines underground often are the highest paid, women may want to seek these positions despite their apparent danger.

Type of procedure

European Convention: Complaint-recourse. The Court contemplates both individual and inter-state complaints under the European Convention.
European Social Charter: Monitoring and reporting; collective complaints.

Availability of procedure

European Convention: The Court primarily considers cases already heard by the European Commission and/or those referred to it directly by the Commission, member states or individuals (under Protocol No. 9). A state must agree to submit itself to the compulsory jurisdiction of the Court (Article 46). The Court's decisions are legally binding (Article 53).

European Social Charter: Individuals cannot instigate the monitoring and reporting mechanisms, although employers' and trade union organizations may. The mechanism operates mainly through periodic reviews of government self-reporting. The Social Charter covers a social and economic right only if the country in question has agreed to the substantive provisions covering that right.

Getting access to the process

European Convention: Women's human rights advocates can play a major role at initiating a case, in settlement attempts and in communications throughout the process. Under Protocol No. 9, which was opened for signature in 1990, the applicant in a case admitted by the European Commission also has the right to refer the case to the Court for decision. In addition, advocates can have input through amicus curiae briefs.

European Social Charter: The Social Charter is not applicable for individuals; the new system of collective complaints is possibly open to employers' and trade union organizations.

How the system works and the role of advocates

European Convention: Once a case is referred to the Court, the Court's Registrar makes public the report of the Commission on Human Rights about the case. If the Commission is divided in opinion, both views may be represented. The Commission often invites the applicant or lawyer to assist in the preparation and presentation of the case before the Court. Both the applicant and the government may file written memoranda.

The Court functions primarily as an appellate tribunal, but it may also engage in additional fact-finding. While the Court tends to defer to the Commission's findings of fact, it is not bound by the Commission in reaching its judgment on either the law or the facts. Unless exceptional circumstances exist, the Court hears cases in public. Court deliberations, however, are private. Decisions of the Court are made by majority vote.

While applicants may represent themselves (both before the Commission and the Court), if the case appears to involve complicated issues the Commission advises representation by legal counsel. Unless exceptions are granted, the representative should reside in a country that has ratified the Convention. Also, the Commission now tends to be quite open to individual applicants' participation in preparing

cases before the Court and, since 1983, the Court has permitted NGOs and individuals to submit amicus curiae briefs (briefs submitted by NGOs with an interest in the case.)

European Social Charter: Part IV of the Revised Charter sets out the system of supervision and enforcement, providing for both a monitoring and reporting procedure and a system of collective complaints.

The monitoring procedure operates like an "honor system." Every two years, state parties to the Social Charter must submit periodic government reports on their adherence to the rights of the Social Charter to which they agreed. These reports are reviewed first by a Committee of Independent Experts, which, if the application is incomplete, "may address requests for additional information directly to the Contracting Parties" (amended Article 24(3)). Under the revised supervisory system, the Committee of Experts may "hold, if necessary, a meeting with the representatives of a Contracting Party either on its own initiative or at the request of the Contracting Party concerned" (new Article 24(3)). The Experts make a legal determination on the submission and then submit their report for review to a Government Committee.

Since the 1991 Amending Protocol, the responsibilities of each of these bodies has become more clearly delineated. The Committee of Experts is charged with "assess[ing] from a legal standpoint the compliance of national law and practice with obligations arising from the Charter ..." (amended Article 24(2)). For its part, the Government Committee will accept the Expert findings and not re-interpret the Charter or re-determine whether the reporting parties have complied with their obligations. Rather, the Government Committee will advise the Committee of Ministers "on the basis of social,

economic and other policy considerations" of the cases in which the latter should exercise its power (amended Article 27(3)). In addition, the Government Committee may propose to the Committee of Ministers that studies "be carried out on social issues and on articles of the Charter which might possibly be updated" (amended Article 27(3)).

The Government Committee reports to the Committee of Ministers of the Council of Europe, the body ultimately charged with making recommendations. Under the old procedure, the Committee of Ministers would have to take into account the view of the Parliamentary Assembly in considering claims. The revised system removes the Assembly from the regular supervisory process. In addition, the contracting parties must report occasionally as requested on the Charter provisions that they have not accepted. The same procedure is followed in these cases.

The new supervisory system modestly expands the role of NGOs. State parties are now required to submit copies of their reports to "the international non-governmental organizations which have consultative status with the Council of Europe and have particular competence in the matters governed by" the Charter (new Article 23(2)). These organizations may prepare their own comments on the reports and submit them to the secretary-general of the Council of Europe (new Article 23(1)). The Committee of Experts considers such NGO input in making its decision. The state may have an opportunity to respond to NGO submissions.

The system of collective complaints applies only to states that have ratified Additional Protocol No. 3 or states that upon ratification of the Revised Charter expressly agree to collective complaints. Under a system similar to ILO procedures (see below), employers' and trade union organizations may bring claims to the Committee of Independent Experts alleg-

ing breaches of international labor
conventions.

Remedies

European Convention: If a state party is
determined to have violated the
European Convention, and if the
country's domestic laws do not provide
for adequate redress, the Court's decision
"shall, if necessary, afford just satisfaction
to the injured party" (Article 50). The
Court may issue a declaration and/or
award monetary damages, including costs
and expenses or pecuniary and non-
pecuniary damages. Decisions of the
Court are legally binding.

European Social Charter: A state may
be chastised for failing to abide by its
commitments under the charter. If the
State refuses to respond, it can be
expelled from the Council of Europe.

Weighing advantages and disadvantages

European Convention

Advantages:

All state parties have accepted the
compulsory jurisdiction of the European
Court of Human Rights and, in effect,
the Court has become a constitutional
rights court for Europe.

The Court has a long history of
considering women's human rights claims
favorably. Since the adoption of Protocol
No. 9 to the Convention, individuals can
refer a case to the Court after the
Commission has adopted a report. In
addition, advocates can have input
through amicus curiae briefs.

Disadvantages

Disadvantages under the Court system
are the same as for the Commission
process and for the European
Convention generally: many applications
are found to be inadmissible; anonymity
is not allowed; the system is over-
burdened and has a backlog; etc.

European Social Charter

Advantages

For some, the Social Charter, however
weak, is the only source of protection for
economic and social rights. The "cafete-
ria" plan allows states to agree to bind
themselves to a wider array of provisions
than could possibly have been uniformly
adopted by all signatories. The Revised
Charter and the new supervisory system
have streamlined the process and allowed
greater NGO input. In addition, states
now must make their national reports
under the monitoring procedure available
upon request.

Disadvantages:

Only a few European states have ratified
the Social Charter. The reporting mecha-
nism remains cumbersome and relies
unrealistically on the good faith of states.

Mechanism Overview	THE EUROPEAN COURT OF HUMAN RIGHTS
WHAT IT COVERS	The European Court implements both the **European Convention on Human Rights** and the **European Social Charter**
RELEVANT ORGANS	*For the Convention*–the Court works in conjunction with the European Commission on Human Rights and the Committee of Ministers. *For the Social Charter*–the Court utilizes a Committee of Independent Experts and a Government Committee.
TYPE OF PROCEDURE	*For the Convention*–Complaint recourse. *For the Charter*–Monitoring and Reporting; collective complaints.
AVAILABILITY OF PROCEDURE	*For the Convention*–the Court primarily hears cases referred by the Commission and/or member states or individuals. *For the Charter*–individuals cannot instigate the monitoring mechanisms. It operates through review of government self-reporting.
ACCESSIBILITY REQUIREMENTS	*For the Convention*–Advocates can play a major role in initiating a case, settlement attempts, and communication throughout the process. They can also have input through amicus curiae briefs. *For the Charter*–Not applicable for individuals, only for employers and trade union organizations.
PROCEDURES: HOW THE SYSTEM WORKS	*For the Convention*–Once a case is referred to the Court, the Court's Registrar makes public the report of the Commission about the case. The Court usually defers to the Commission's findings of fact, but may also engage in additional fact-finding. Unless exceptional circumstances exist, the Court hears cases in public. Deliberations are private. The Court decides the case by majority vote. *For the Charter*–Operates on the "honor system." Every two years state parties to the Charter submit a report of their adherence to the rights to which they agreed. The reports are reviewed by a Committee of Independent Experts, then by the Government Committee and finally by the Committee of Ministers of the Council of Europe, the body charged with making recommendations. There is no oral hearing or dialogue between the Committees and the reporting states.

continued

ROLE OF ADVOCATES

For the Convention–Advocates can play a major role in initiating a case, settlement attempts, and communication throughout the process. Advocates can also have input through *amicus curiae* briefs.

For the Charter–Advocates (representing trade unions and national organizations of employers) may submit comments on the report of the Government Committee to the Council of Europe.

REMEDIES

For the Convention–The Court makes legally binding decisions. It may issue a declaration or award monetary damages.

For the Charter–A state may be chastised for failing to abide by its commitments to the charter. If the state refuses to respond, it can be expelled from of the Council of Europe.

ADVANTAGES AND DISADVANTAGES

For the Convention–
Advantages: All state parties have accepted the compulsory jurisdiction of the Court and, in effect, it has become a constitutional rights court for Europe.
The Court has a long history of considering women's human rights favorably.

Since the adoption of Protocol No. 9, individuals can refer a case to the Court after the Commission has adopted a report. Advocates can also have input through *amicus curiae* briefs.

Disadvantages: (same as those for the Commission) Many applications are found to be inadmissable.

Anonymity is not allowed.

The system is over-burdened and backlogged.

For the Charter–
Advantages: For some, it is the only source of protection for economic and social rights.

The "cafeteria" plan allows states to agree to bind themselves to a wider array of provisions than could possibly have been adopted by all signatories.

Disadvantages: No individual complaint or judicial review mechanisms exist for social and economic rights.

The reporting mechanism relies on the good faith of states.

The outcome has little force and recommendations are rarely harsh.

Only a few states have ratified the charter and many of them with reservations.

3

The Committee Of Ministers

The Committee of Ministers ("the Ministers") is the political arm of the European Convention and the final authority on the European Social Charter. The Ministers represent the governments of the states in the Council of Europe. Today the role of the Ministers is being reconsidered. Individuals and advocates have little access to this part of the process.

If the European Commission on Human Rights finds a violation of human rights under the European Convention, it may refer the case either to the European Court or to the Ministers. If it is referred to the Ministers, they can then either refer the case to the Court or decide themselves whether a violation has occurred and, if so, what effect should be given to its decision. The Committee of Ministers also supervises the implementation of judgments of the Court.

While the Ministers cannot issue binding decisions, they can decide to sanction an offending state by suspending or expelling it from the Council of Europe. The Committee may also make public the reports of the Commission which would otherwise not be publicly available, unless they are published by the Court.

When states do not comply with their reporting obligations, the Ministers can only issue a warning. Although the Committee of Ministers is the ultimate supervisory body for the Social Charter, it has never exercised its power to make recommendations to a party found in breach of its obligations. When the Ministers take a role in adjudicating issues under the Social Charter, the ultimate outcome generally has little force since the Ministers in practice rarely issue harsh recommendations.

European Committee for the Prevention of Torture

The European Committee for the Prevention of Torture was established by the Council of Europe to administer the European Convention for the Prevention of Torture and Inhuman and Degrading Treatment or Punishment ("ECPT"). The ECPT is similar in some respects to the United Nations Convention Against Torture. However, unlike the UN Convention, the ECPT does not allow individual communications and periodic reports from the state parties.

The ECPT, which came into force in February 1989, seeks not to establish any new norms but rather to "strengthen by non-judicial means of a preventative nature" the realization of the obligations contained in Article 3 of the European Convention on Human Rights, which states: "No one shall be subjected to torture or to inhuman or degrading treatment or punishment."

Of particular interest to women's human rights advocates:

Advocates for women's human rights may find that the ECPT has particular impact in cases of gross mistreatment of women in all types of detention, including prisons, interrogation cells, refugee camps and psychiatric hospitals.

Type of procedure

Monitoring and reporting, which can be triggered by an "application" (i.e. a communication about an alleged incident, akin to complaint-information).

Availability of procedure

Every citizen of the Council of Europe and/or members of the Council which have ratified the ECPT can invoke it. They need not themselves be victims of torture, degrading treatment or punishment.

Getting access to the process
The complainant must be a citizen.

How the system works and the role of advocates
The European Committee for the Prevention of Torture, essentially a fact-finding and reporting body, is composed of one representative from each ratifying state. The Committee conducts both regularly scheduled and ad hoc visits to detained persons in psychiatric hospitals, police cells, prisons, etc., and to any other person who might provide information. Article 2 of the Torture Convention provides that "each party shall permit visits, in accordance with the Convention, to any place within its jurisdiction where persons are deprived of their liberty by a public authority."

Countries which have been selected for the regular visits are notified a year beforehand, and the public is notified. Individuals and advocacy groups can participate at this point by providing additional information to the Committee about the country to be visited. Two weeks before the visit is to take place, the country is informed of the exact dates and duration, and only a few days before the visit commences the state is given a provisional list of places to be visited. This system is designed to balance the need of states to prepare legitimately for visits and the need to include some element of surprise so that abuses cannot be hidden.

Ad hoc visits depend greatly on evidence submitted to the Committee about alleged abuses. Individuals and women's human rights advocacy groups are free to submit such evidence to the Committee at any time, with the hope of prompting and guiding an investigation. The Committee may, on its own initiative, call on any advocates who could provide information about allegations of torture.

After all interviews have been done, the Committee writes a confidential report including its recommendations.

The report is submitted to the state concerned.

Remedies
The Committee's report to the state is non-binding and confidential. However, if the country ignores the report or fails to take action to address the violations, the Committee may make the accusations public. The state itself also may request that the report be made public. In practice, both the report of the Committee and the response by the state have been made public.

Weighing advantages and disadvantages
Advantages:
The system is flexible. Emphasis rests on finding the facts related to gross mistreatment in confinement. Reports of such mistreatment from a neutral body like the Committee are usually accorded great weight. Should the Committee make its confidential report public, the resulting political and media impacts on the accused state can be substantial.
Disadvantages:
The results are non-binding. The ad hoc nature of the ECPT system and limited resources available to it, constrain its ability to monitor all of Europe. The Committee makes an average of eight regular visits annually.

3

Mechanism Overview	THE EUROPEAN COMMITTEE FOR THE PREVENTION OF TORTURE
WHAT IT COVERS	Primarily the right of a person not to be subjected to torture or to inhuman or degrading treatment or punishment.
OF INTEREST TO WOMEN	Useful for impact cases of gross mistreatment of women in all types of detention.
TYPE OF PROCEDURE	Monitoring and reporting.
AVAILABILITY OF PROCEDURE	Every citizen or person subject to the Council of Europe. They need not themselves be victims.
ACCESSIBILITY REQUIREMENTS	The complainant must be a citizen. The application must be based on European Community law.
PROCEDURES: HOW THE SYSTEM WORKS	The Committee conducts regularly scheduled and ad hoc visits to detained persons in prisons, psychiatric hospitals, jails, etc. States are required to permit the visits. States are informed in advance, but not told of the exact locations of the visits to prevent cover ups of abuse. Ad hoc visits are also conducted based on evidence submitted to the Committee.
ROLE OF ADVOCATES	Advocates can provide additional information on regularly scheduled visits and evidence of abuse to prompt and guide an investigation.
REMEDIES	The Committee's report to the state is non-binding and confidential. The state may disclose the content of the report if it so wishes. If a state fails to comply with the recommendations, the Committee may make the report public.
ADVANTAGES AND DISADVANTAGES	*Advantages:* The emphasis is on finding the facts related to mistreatment in confinement. Reports are usually given great weight by all involved. If the Confidential report were to be made public by the Committee, the impact could be substantial. *Disadvantages:* The procedure is mainly confidential and the results non-binding. The Committee makes only about 8 visits per year and cannot cover all of Europe.

Organization on Security and Cooperation in Europe

The Conference on Security and Cooperation in Europe (CSCE) emerged out of the 1975 Helsinki Accords which, in response to human rights violations in central and eastern Europe, established the 1975 Helsinki Final Act. The Helsinki Act sets forth basic principles for cooperation between states and respect for human rights (Part VII).

For fifteen years, the CSCE consisted mainly of yearly "review" meetings of the Helsinki Act. While motivated in part by Cold War politics, the CSCE did serve to support a wide array of dissidents in central and eastern Europe. Since the Cold War has ended, the CSCE has gone through growing pains of its own, struggling to create monitoring and reporting mechanisms (such as "early warning programs") designed to meet the contemporary security needs of a reconstructed Europe.

The CSCE never was intended to create binding legal obligations; the Helsinki Accords and their subsequent texts are not considered to be treaties. However, since nearly all CSCE decisions are adopted by consensus of its voluntary state membership, no state can claim it has not accepted them. Thus, they can be said to have the impact of "soft law."

In 1989, the CSCE took on new importance as many of the newly emerging countries in central and eastern Europe attempted to show adherence to the "Helsinki principles" and, in doing so, to win acceptance from the West. In 1990, at a meeting in Copenhagen, the CSCE explicitly added "democracy" to its mandate, committing itself in the Human Dimension Document to "full respect of human rights and fundamental freedoms and the development of societies based on pluralistic democracy and the rule of law."

Also in 1990, the first permanent organs of the CSCE were created: a Secretariat located in Prague, a Conflict Prevention Centre in Vienna, and a Warsaw-based Office of Democratic Institutions and Human Rights. At the same time, the CSCE established a series of monitoring and reporting mechanisms, such as specific meetings on security problems and specialized monitoring missions, designed to give more force to its substantive commitments. However, the structure and functioning of these "mechanisms" remains amorphous, their focus still on "security" and their impact dependent largely on the will of cooperating states.

In 1995, the CSCE was renamed the "Organization on Security and Cooperation in Europe" (OSCE).

Of particular interest to women's human rights advocates:

The human rights section of the Helsinki Act does not include a separate provision banning sex discrimination or mandating sex equality, but it does state that "the participating states will respect human rights and fundamental freedoms.... without distinction as to ...sex...". Advocates for women's human rights may find the OSCE most useful with respect to the rights of women belonging to national minority groups, as the enforcement mechanisms for inter-ethnic conflicts within a state are strongest (as explained below). In addition, however, advocates can take advantage of all opportunities to provide information on the status of women's human rights to OSCE monitors and to bring such issues to the attention of OSCE conferences.

Type of procedure

Monitoring and reporting (although individuals can make communications, akin to complaint-information).

Availability of procedure

Any individual, group or state can submit communication to the OSCE. Only

states or groups of states can place potential inter-state conflicts on the OSCE agenda. Participation in the annual conference is limited largely, although not exclusively, to states.

Getting access to the process
Not applicable given the monitoring and less formal nature of the OSCE.

How the system works and the role of advocates
The Committee of Senior Officials, the de facto governing body of the OSCE, normally meets several times a year. Among other duties, the Committee can decide to send out ad hoc human rights fact finding missions. OSCE monitors may make short visits to a country or reside "in-country" for a longer period of time (such as the year-long mission in reduced Yugoslavia, 1992-1993, which the Serbian regime refused to extend). Advocates can attempt to use communications to the OSCE to influence its choice of missions. Women's human rights advocates within countries under investigation can provide useful information during missions, as well as in follow-up.

In addition to sending missions, the OSCE has a Secretariat and Conflict Prevention Centre in Vienna, an office in Prague, and an office for Democratic Institutions and Human Rights in Warsaw. The Warsaw office is charged with assisting in monitoring implementation of the commitments in the 1990 Human Dimension Document. The practical impact of all these endeavors is unclear.

In 1992, the OSCE appointed a High Commissioner on National Minorities to be "an instrument of conflict prevention at the earliest stage." The main function of the Commissioner is to provide an "early warning" and, as appropriate, an "early action" at the earliest possible stage in regard to ethnic tensions which have not developed beyond an early warning stage, "but... have the potential

to develop into conflict within the CSCE area..." The Commissioner considers general "situations" but not violations with regard to an individual. The High Commissioner can collect information from any source, including the media and NGOs, consider written reports from parties directly involved, and visit sites to obtain first-hand information.

Human rights advocates can play a major role in providing the High Commissioner with information. Should the Commissioner conclude, prima face, that there is a risk of conflict, he/she may issue an "early warning" to the Committee of Senior Officials of the OSCE.

Remedies
The monitoring missions and the yearly and periodic meetings of the OSCE and its offices do not result in binding legal obligations. However, the missions can result in influential reports designed to shame offending governments and encourage other governments to take action against violating states. The periodic meetings of the OSCE also can (and have) resulted in "soft law," i.e. quasi-legal standards which guide local practice. The "early warning" system of the High Commission on National Minorities may result in letters to the offending government (which are made public) and in influential reports of actual and potential human rights violations against national minorities. These in turn may influence the reactions of OSCE countries as well as trading partners outside the OSCE.

Weighing advantages and disadvantages
Advantages:
The OSCE is gradually transforming itself from a political institution founded on Cold War values into an effective, apolitical monitoring body. Its most innovative and influential mechanism is the High Commissioner on National Minorities. In addition, the ad hoc

OSCE monitors have proved useful, particularly to human rights advocates in the countries under investigation. The OSCE has worked with the European Community/ European Union and the UN on various initiatives relating to the war in the former Yugoslavia; sponsored a conference on Nagorno-Karabakh; and acted in a flexible, responsive manner to other crises.

Disadvantages:

The operations and influence of the OSCE are still amorphous. In particular, apart from an information-sharing function, the impact of the Conflict Prevention Centre and the Office for Democratic Institutions and Human Rights is unclear. These offices tend to be isolated, understaffed and without significant independent power. In the words of an OSCE self-critique: "a lack of willingness among participating States to maximize the procedures and bodies they have created, and to revise them as necessary to solve problems, has brought OSCE up short time after time" (OSCE, 1990-1992 report). The ad hoc monitoring missions depend upon the consent of the government under scrutiny (at least as to the issuance of visas), thereby allowing governments simply to deny access to areas where violations are most likely to be found. Follow-up to the "early warning" system has yet to be worked out.

Mechanism Overview	THE ORGANIZATION ON SECURITY AND COOPERATION IN EUROPE
WHAT IT COVERS	The OSCE, as established by the Helsinki Act, is committed to cooperation between states and respect for human rights. Today its mandate is expressed as promotion of "full respect for human rights and fundamental freedoms and the development of societies based on pluralistic democracy and the rule of law."
MAJOR ORGANS	The Committee of Senior Officials, the governing body of OSCE. The Secretariat and Conflict Prevention Center (Vienna). Office for Democratic Institutions and Human Rights (Warsaw). High Commissioner on Minorities.
OF INTEREST TO WOMEN	Useful with respect to the rights of women belonging to national minority groups and in general for providing information to the OSCE monitors on the status of women's human rights.
TYPE OF PROCEDURE	Monitoring and reporting (although individuals can make communications, similar to complaint–information).
AVAILABILITY OF PROCEDURE	Any individual, group or state can submit a communication.
PROCEDURES & HOW THE SYSTEM WORKS	The Committee of Senior Officials meets several times a year. The Committee can decide to send out fact-finding missions.

continued

| continued | THE ORGANIZATION ON SECURITY AND COOPERATION IN EUROPE |

The High Commissioner considers general situations but not individual violations.

ROLE OF ADVOCATES

Advocates under investigation can provide additional information during and following up to the fact-finding missions.

Advocates can also provide the High Commissioner on Minorities with information.

REMEDIES

The monitoring missions and meetings of the OSCE do not produce legally binding obligations. However their reports designed to shame offending governments to encourage other governments to take action against those responsible for violations, have resulted in quasi-legal standards.

The early warning system of the Commissioner has potential to influence OSCE states.

ADVANTAGES AND DISADVANTAGES

Advantages:

The High Commissioner on National Minorities appears to be an innovative and influential mechanism.

The OSCE monitors have proven useful to human rights advocates in the countries under investigation.

Disadvantages:

The operations and influence of the new (post Cold War) OSCE is still amorphous.

The impact of the Conflict Prevention Centre and the Office for Democratic Institutions and Human Rights is unclear.

The ad hoc monitoring missions depend on the consent of the government under scrutiny.

Follow–up to the early warning system has yet to be worked out.

The Mechanisms of the European Union

The system of the Council of Europe including the European Convention on Human Rights, the European Commission on Human Rights, and the European Court of Human Rights names as its primary goals the promotion of democracy and human rights. In contrast, the primary aims of the European Union traditionally have been restricted to economic matters. In general, the European Union seeks to coordinate a cohesive European economic and political union, with coordinated markets, financial institutions and trade. Within this framework, however, the promotion and protection of human rights do find a place.

Members of the European Union have used the mechanisms of that system in order to advance women's human rights within the economic sphere, in particular the rights to equal pay and equal treatment in the workplace. In addition, policy developed at the EU level is beginning to transcend the field of public sector employment and influence the "private" spheres of women's lives.

What is the European Union?: A Note on Its Origins

What we today call the European Union was first known as the European Community. The Union has its roots in the European Coal and Steal Community (ECSC), an arrangement that was founded in 1952 between six European nations in order to coordinate and provide a common market for coal and steel resources. Five years later, in March 1957, the ECSC Member States adopted the Treaty of Rome, which created two new communities to facilitate economic cooperation, the European Atomic Energy Community (Euratom) and the European Economic Community (EEC or Common Market).

The EEC sought social and economic integration in order to create a single economic region in which goods and services could freely move. As part of this plan, the Treaty of Rome included not only strictly economic provisions but also social provisions related to the workplace.

Although many provisions of the Treaty of Rome remain in place today, the structure and substantive scope of the community was changed greatly by two acts. First, in 1965, the three communities of Europe merged into a single "European Community." Second, the European Community became the European Union on November 1, 1993 after the coming into force of a complementary treaty, the Treaty on European Union ("TEU or Maastricht Treaty.")

The Masstricht Treaty includes both amendments to the Treaty of Rome and new Protocols applying only to certain governments (in particular the UK). Maastricht pursues the goals of united European markets with even greater ambitions than its predecessor treaties, calling for the establishment of a European citizenship, a single European currency (ECU) and a central European Bank. Moreover, it strengthens the competencies of the Union to pursue social issues.

The Institutions of the European Union

The institutions of the EU have similar names to those of the Council of Europe, described above. Nonetheless, they are distinct. Advocates that live in states belonging to the EU should consider these institutions as alternative and complementary mechanisms for women's human rights.

The Council of Ministers is the primary decision making body of the EU. (It should not be confused with the European Council, the name given to the semiannual meetings of leaders of the Member States.) In general, each

Member State has one delegate on the Council of Ministers. However, the exact composition varies with the topic; thus the different agriculture ministers make up the Agriculture Council, etc. The Council retains the greatest power to make a proposal for new legislation. Yet, as explained below, it usually can only act on a new law after the Commission has made the initial proposal. Decisions of the Council are binding. The body acts on proposals that come from the European Commission and, more rarely, the European Parliament.

The European Commission is the institutional arm of the EU. Each Member State has one commissioner, except for Britain, France, Germany, Italy and Spain, all of which have two. Members are bound to act in the interest of the Community and not in their own state's interest. The Commission, which is located in Brussels, has great discretion in initiating public policy (although the final decision on the policy is left to the Council of Ministers). The law and policy-making procedures of the Commission are relatively open and thus often subject to input from NGOs and other lobbyists. It can also investigate complaints about a Member State and take a Member State to the Court of Justice for failure to implement treaties. The work of the Commission is broken down by subject matter into distinct divisions ("directorate generals" or "DGs"). Policy affecting women is made most often in the Equal Opportunities Unit of the Division of Employment, Industrial Relations and Social Affairs ("DGV").

The *European Parliament*, located in Strasbourg, is comprised of 626 members distributed in rough proportion to the population of the Member States. (Note that the number changes according to the number of Member States.) It meets in Strasbourg each month except August; its administration is based in Luxembourg and meetings of committees and other

entities usually take place in Brussels. Members sit not in national groups but in political alliances. The term "Parliament" is a bit of a misnomer as the body does not make laws, but rather adopts budgetary and policy decisions. On many issues the role of Parliament is only consultative; although the situation has changed somewhat since Maastricht, usually the Council has the last word. The Parliament's permanent advisory body on women's rights is called the Women's Rights Committee. Of the four EU institutions, the Parliament is the least powerful.

The *European Court of Justice*, which is located in Luxembourg, consists of one judge from each Member State. (It should not be confused with the European Court of Human Rights, the Strasbourg-based body established by the Council of Europe). The ECJ is assisted by Advocates-Generals, who often write preliminary opinions which the ECJ then follows. Within the EU system, the *Court of First Instance* considers cases brought by individuals and companies, with a right of appeal to the ECJ on legal points (but not on factual matters). The ECJ interprets and applies EU regulations, directives and recommendations. Its decisions override those of courts in member states. It often functions as a court of appeals for the Union and it can under certain circumstances hear cases from national courts. Any appropriate court of a Member State can ask the ECJ for a ruling on any alleged conflict between national and Community laws. If the ECJ's final decision goes against the Member State, its national legislation must change. The ECJ may fine Member States for noncompliance with Community legislation.

In addition to the above institutions, national courts also act as an important body for the EU. Many kinds of EU legislation (see below) are directly applicable in national courts.

Of Special Interest to Advocates for Women

The main provision of the EU directly applicable to women is Article 119 of the Treaty of Rome, which states that Member states should apply the principle of "equal pay for equal work." This has been interpreted broadly to infer a right to equal pay for comparable worth and, in addition, a general right to nondiscrimination in the workplace has become the norm within the European Community.

Through directives and recommendations, the EU has clarified and progressively enlarged the principle of equal treatment. The EU has issued five directives on women's issues, covering equal pay (making the principle of equal pay apply to work of equal value), equal treatment in working conditions, equal treatment in social security, and the protection of new mothers. Collectively, these provisions are known as the Equality Directives.

While Article 119 is binding upon public and private employers throughout the EU, it is unclear to what degree the Equality Directives have the same effect. In the very least, the directives are binding upon Member States and public corporations, and the private sector must comply once implementing legislation is adopted.

In addition to the provisions of the Treaty of Rome and Maastricht Treaty, the fundamental freedoms set forth in the European Convention of Human Rights (ECHR) have some force in the EU system. Although the ECHR has not been formally incorporated into European Union law, Article F of the Maastricht Treaty requires Member States to respect the fundamental rights guaranteed by the convention. The ECJ has been increasingly willing to take the ECHR into account when making its rulings. Many advocates have long argued that the EU should accede as a body to the convention. EC law and practice is extremely complex and will not be explained in detail here. In cases involving discrimination in the workplace in countries subject to EC law, advocates should consult the guides listed in Appendix 4: Bibliographical Resources.

Type of Procedure

Complaint-recourse (cases can be brought either to the ECJ or to a domestic court).

Procedures other than legal cases, such as investigations or policy actions taken by EU bodies.

Availability of Procedure

Citizens of Member States of the EU have access to the system, either at the level of EU institutions or as EU law is reflected in their own country's law.

Private litigants cannot bring an action against a Member State. However, private litigants have access to their own court systems where EU law is to be applied.

Admissibility Requirements

The right to commence litigation in national courts must be given to private litigants by national law. As Ralph Folsom (1994) explains: "European Union law has not (as yet) been interpreted to create national causes of action. What it does do, according to the 'direct effects doctrine,' is give litigants the right to raise many EU law issues (Euro-defenses and Euro-offenses) in national courts and tribunals."

How the system works and the Role Activists Can Play

There are two primary ways in which the EU system can be triggered in women's rights cases. First, under Article 169 of the Treaty of Rome, the European Commission can bring complaints against members of the EU that it believes are not in compliance with the EU sex discrimination law. Disputes can then be resolved by the European Court

MAKING THE *EU* SYSTEM WORK: THE STEWARDESS CASES

In the early 70's, airline stewardesses in Belgium were forced to retire at the age of forty with minimal benefits because they were deemed no longer attractive for the (mainly male) clientele. Three cases were brought challenging the situation as violating the principle of "equal pay." The cases were brought in Belgian court, but as Belgian labor law allowed equal pay cases to be referred to the European Court of Justice, at the initiative of the private litigants they were sent to the ECJ.

The first case was lost in 1971 when the judges decided that they did not have the competence to hear the matter. The second one, in 1976, was successful. The judges applied a broad interpretation of "equal pay" approaching the concept of "comparable worth"—that is, equal pay for comparable work. The court also ruled that Article 119 was directly applicable and could be used directly by claimants in the national courts of Member States.

See *Defrenne v. Sabena* (1976) Eur. Comm. Rep. 455.

of Justice. Advocates for women's rights cannot bring these cases directly, but they can exercise pressure on the Commission to do so.

Second, EU law becomes domestic law. Thus, a private litigant can raise EU law in domestic court cases. The extent of NGO involvement in such cases is determined by the laws of the particular state. Also, under Article 177 of the Treaty of Rome, a domestic court may refer EU law questions to the European Court of Justice for interpretation.

Not all kinds of EU litigation are directly binding on national courts. In seeking to apply EU law in domestic court, a private litigant must consider what type of legislation is involved. The main ways in which EU laws are expressed is through:

Regulations, binding laws that are automatically incorporated into the national legal systems; in other words, regulations have immediate unconditional legal effect without any need for national implementation; regulations may apply to both public and private activities. Regulations are not widely used in connection to issues that advocates for women's rights may face.

Directives, measures stating broad objectives—they call on Member States to implement them in a fixed time table. Member States usually implement directives by either adopting new laws or amending existing laws. Directives do not become law in Member States until they are implemented or until the ECJ rules that a directive is of "direct effect," but still national law must be interpreted in light of the EU directives even if the directive has yet to be implemented. Directives cannot be used to challenge private activities. The topics discussed by advocates for women's rights are often the subject of existing or proposed directives.

Decisions are binding instructions addressed to a particular government, enterprise or individual.

Recommendations, which can be issued by the Commission alone, are not binding, but generally function as advice to governments. At their own discretion, Member States may revise their laws and policies in line with recommendations.

Resolutions, issued jointly by Member States after agreement by the Council, are nonbinding. They are often significant expressions of intent by Member States on areas not covered by Community law.

Although the effect of the types of legislation are complicated and contested, it can be said that regulations

and often directives can be applied in domestic courts.

Remedies

The European Court of Justice can issue both advisory opinions—for example, interpreting an EU directive for a state–and findings that a Member State is in violation of EU legislation.

When EU law is applied in domestic courts, the remedies are set by national law.

Advantages and Disadvantages

Advantages:

One of the greatest benefits of the EU system is that it has helped to establish transnational links among women's movements in Europe. Moreover, EU policy has helped to establish and enforce equality standards in the workplace. Where EU law automatically applies and supersedes local law, the impact is most evident. However, even the recommendations of the EU, which are nonbinding, have had a major impact on the laws and policies of many of the Member States.

Disadvantages:

The greatest disadvantage of the system is that it traditionally focuses on (un)employment issues and neglects other matters affecting women's lives. As Catherine Hoskyns notes: The European Court of Justice "has been progressive on equal treatment in employment matters and has helped to establish rights for part-time and pregnant workers. But it has held the line very clearly against any move towards extending these rights into the domestic sphere or to unpaid workers. The European Court has made it clear that it does not regard such initiatives as falling within the competence of the European Union." In addition, EU policies are based primarily on notions of formal equality (comparisons of similarly situated groups, not eradication of power imbalances), lumping all women together without accounting for the different challenges faced by such groups as ethnic or racial minority women.

Through other institutions, however, the EU has acted to take on issues broader than traditional equal pay matters. In particular, the European Commission has developed "Action Programs" to promoted women's equality and has pushed for the development of policy and legislation beyond the narrow confines of the labor market. In the early 1990s, a directive was adopted on pregnancy rights, a Commission recommendation on sexual harassment, and a Commission recommendation on childcare. Recommendations of the Commission, however, are nonbinding.

Another disadvantage of the EU system is the substantial confusion regarding when directives will have binding force in national courts. In many cases, when the implementing legislation for EU laws is insufficient, the only remedy is prosecution of the member state by the Commission.

Finally, as Michael Spencer has pointed out, the EU system suffers from a "democratic deficit," that is, a lack of democratic accountability. "A basic problem is that the powers taken away from national parliaments in forming the Union have not been fully transferred to the European Parliament."

The Inter-American System

The Organization of American States (OAS) is a regional, inter-governmental organization which includes all the sovereign states of the Americas. The Inter-American system for protecting human rights has three distinct legal sources: the Charter of the OAS; the American Declaration (which applies by virtue of OAS membership); and the American Convention on Human Rights. While the Charter applies to all members of the OAS, the Convention applies only to those that have ratified it. The two systems often overlap. This section primarily addresses the system under the Convention.

The Inter-American system offers several mechanisms for the enforcement of human rights. These include:

- *The Inter-American Commission on Human Rights,* an organ of the OAS and an implementation organ for the Inter-American Convention. It provides an individual complaint procedure, on-site visits and special protective measures for emergency situations;
- *The Inter-American Court of Human Rights,* which provides for hearings of disputed cases and issues advisory opinions; and
- *The Inter-American Commission on Women,* which recently succeeded in witnessing the adoption of the Inter-American Convention for the Prevention, Punishment and Eradication of Violence Against Women. It helps enforce this Convention.

Some of the prominent attributes of this system for protecting human rights include:
- The Velásquez-Rodriguez norm, uniformly enforced throughout this system, provides that governments have an affirmative legal obligation to investigate, prosecute and punish human rights violators (including persons who are not agents of the government) through their national judicial apparatus. It also provides that governments must compensate victims of human rights violations;
- The right to judicial enforcement of human rights violations. In contrast to other human rights systems, under the Inter-American system this right can never be "derogated from," even in states of national emergency, which means that nothing can excuse the failure to provide for this.

The Inter-American Commission has shown it is willing to enforce these norms in the face of heavy political pressure and litigation by accused governments.

Of particular interest to women's human rights advocates:
The Inter-American Commission and Court are willing to interpret the norms of the American Convention and Declaration according to the new Inter-American Convention on the Prevention, Eradication, and Punishment of Violence Against Women. This measure breaks down the private/public distinction in cases of violence against women: women have a right to freedom from violence in both the public and private spheres of their lives; the state cannot justify failure to address violent acts simply because they take place in the so-called private sphere (such as the family). Thus, the measure codifies the international legal responsibility of governments to take measures to defend women against violations of their fundamental human rights as perpetrated by government and non-government agents.

In 1995, the Commission issued the ground-breaking Report on the Situation of Human Rights in Haiti, where it expressed the opinion that the rape of women constitutes a grave violation of human rights which must be remedied. In previous years, the Commission's attention to women's human rights had

been sporadic and superficial. Its few reports on women's human rights were, for example, not as well-investigated as reports treating other human rights issues. Like other human rights bodies, until very recently its investigations of human rights violations failed to recognize violations of women's human rights.

Inter-American Commission on Human Rights

Members of the Inter-American Commission on Human Rights are independent human rights experts selected by the General Assembly of the OAS and charged with promoting respect for and defense of human rights and with investigating cases of human rights violations. The Commission meets twice a year in Washington, DC.

The Inter-American Commission on Human Rights provides both an individual complaint mechanism and general country reports based on on-site visits to places where human rights violations have been reported. These two functions are discussed separately below.

Individual Complaint Mechanism

Type of procedure
Complaint-recourse.

Availability of procedure
Every individual living in every country in the Americas has the right to access this enforcement mechanism. Groups of individuals and representatives appointed by individuals may also access the enforcement mechanism.

Getting access to the process
The complaint must allege violations of an individual's or group of individuals' rights under the norms of the American Convention for Human Rights and/or the American Declaration on the Rights and Duties of Man (American Declaration). It should state which articles of these human rights instruments have been violated. The complaint may also include a state-ment of what remedies are sought.

The complaint should also show that the matter is not pending before another adjudicatory body and that domestic remedies have been exhausted. Three exceptions to the exhaustion requirement occur when:

- the domestic legislation does not afford due process of law for protection of the right or rights that have been violated;
- the party alleging violation of her rights has been denied access to the remedies under domestic law or has been prevented from exhausting them; or
- there has been unwarranted delay in rendering a final judgment under the domestic procedures.

The petition usually must be filed within six months of the exhaustion of domestic remedies. The Commission may grant an exception to this requirement if the information necessary to bring the complaint had been unavailable.

The complaint must be signed by the complainants or their representative(s).

The complaint must also include the name, nationality, profession and address of the person(s) making the complaint or their legal representative(s). Where security issues and other concerns warrant, the person(s) making the complaint may remain anonymous.

How the system works and the role of advocates
After the Commission receives a complaint, it examines the case to see whether it satisfies all the admissibility requirements.

If it finds the communication admissible, it sends it to the government against which the action has been initiated for its reaction. If the government does not respond, the Commission may make a recommendation. However, such a recommendation does not in reality carry as much weight as if the government

The Inter-American System: Access for Advocates

Human rights norms and procedures are well developed in the Inter-American system. Advocates can access the system in the following ways:

Inter-American Commission on Human Rights. The Commission both accepts individual complaints and conducts its own on-site monitoring. Every individual living in any country of the Americas can access the complaint mechanism.

Inter-American Court of Human Rights. Cases can be brought before the Court after they have been brought through the Commission's individual complaint procedures.

Inter-American Commission on Women. This new mechanism (1995) is devoted to preventing, punishing and eradicating violence against women. Cases can be submitted directly to this Commission for resolution.

were involved in the proceedings.

If the government responds, an attempt is made to reach a friendly settlement. In the Inter-American system, "friendly settlements" must include serious commitments to remedy the human rights violation; otherwise the Commission will reject them.

If a friendly settlement is not possible, the Commission reviews the response of the government and takes it into consideration. The party that brought the complaint also reviews and replies to the government's response, submitting a statement showing why the government's arguments are incorrect or insufficient. Historically, governments often have failed to respond, forcing the Commission to re-contact them and slowing the entire process. Today, however, most governments in the Americas do respond.

After receiving all the submissions from both parties, the Commission conducts an investigation and issues a recommendation stating whether or not a violation of the norms of the American Convention and/or the American Declaration occurred. It may further recommend measures that should be taken to compensate the victim and to ensure that the violation does not occur in the future. New submissions may also be made at the time of the hearing. The Commission decides its findings and recommendations at this hearing and its concurrent sessions.

If a human rights violation is found, the Commission typically recommends that the government should compensate the victim and "investigate, prosecute and punish" the human rights violator. Courts follow the ground-breaking Velásquez-Rodriguez case, in which the Inter-American Court on Human Rights ruled that a nation's judicial system must investigate human rights violations, compensate victims, and prosecute and punish human rights violators. The Commission has been building a progressive jurisprudence (a body of decisions on all kinds of human rights cases) based on this norm, and it almost always recommends that offending governments must follow this norm. The Commission also usually recommends that governments "take whatever measures are necessary to prevent the recurrence of the human rights violation."

Once the Commission makes a

decision, it must publish the results of its investigation in a report which is sent to the government and to the party that made the complaint. The government is given a period of three months to settle the matter and comply with the recommendations of the Commission.

If, after a period of three months, the government has not complied with the Commission's recommendations, the Commission deliberates the matter during one of its sessions. It may choose to publish a second report about its investigation, this time including mention of the government's non-compliance.

The Commission's second report must include its opinion and conclusion about the case. The second report also includes the Commission's recommendations for remedying the human rights violation and may issue a new deadline by which the government must take the measures "that are incumbent upon it to remedy the situation examined" (Article 51.2, American Convention). Typically, this is three months.

At this point, if the government has accepted the jurisdiction of the Inter-American Court on Human Rights, the Commission and/or the advocate may bring a case against the government for a hearing before the Court. The countries that have accepted the jurisdiction of the Court are listed in the next section of this manual, on the Inter-American Court. If the government has not accepted the jurisdiction of the Inter-American Court, however, the Commission can do nothing other than issue a second report.

If after the prescribed period the government still fails to comply with the Commission's recommendations, however, the Commission may publish its report in its Annual Report to the General Assembly of the OAS. This publicity may be a useful tool to pressure the government to implement the recommendations and remedy the violation. The Commission may also address

the government's failure to comply in its later sessions, and issue further reports calling for compliance and the remedy of the human rights violation.

Women's human rights advocates can actively participate in the proceedings before the Commission, taking on various roles at various stages. The advocates representing the woman can make oral representations before the Commission. The Commission also welcomes amici participation. Advocates can seek the assistance of attorneys who specialize in litigating cases before the Commission.

Remedies

As detailed above, the Inter-American Commission can issue a recommendation to the offending party to rectify the human rights situation. One criticism of the Commission is that the only remedy it offers is issuing a report whose recommendations can be enforced only through outside pressure. On the other hand, these reports can lead to the eventual remedy of the violation of women's human rights. The reports call for the government to comply with its international legal obligations to investigate, prosecute and punish human rights violators, to compensate the victim, and to take whatever measures are necessary to ensure that the human rights violation does not occur again. The General Assembly of the OAS may join in bringing public and media pressure to bear upon the government until it complies.

Weighing advantages and disadvantages

Advantages:

The forum is open to receiving complaints and addressing women's human rights cases. Basic human rights norms and procedures are well-developed in this system. The Commission is not hesitant to take a strong stand in favor of human rights, and to issue decisions that criticize governments and pressure them to take concrete measures to remedy human rights violations. As part of the regional system,

the Commission can be a more appropriate and effective vehicle than the UN system for addressing local human rights issues, and its work carries a certain amount of respect in Latin America.

A number of very competent international human rights organizations are willing to assist in the Inter-American Commission litigation process. Some women's human rights organizations also have acquired experience and expertise in bringing women's human rights issues before the Commission. The Commission networks with women's human rights organizations and is open to receiving information and expert opinions from them. In comparison with other systems, the Inter-American system allows for an easier means to break down the public/private distinction and to act in respect of violations of women's human rights that are perpetrated by non-government actors. Over the last several decades, the work of the Commission on individual cases has prompted long-term reforms leading to the establishment of new national systems designed to improve human rights situations at the local level.

Disadvantages:
The Commission's backlog of cases is fairly heavy and hearings may not be held for one or two years after it receives a complaint. Litigation takes at least two years, which represents a significant time and resource commitment. The process can be trying and disheartening for the woman or women who agree to have their cases litigated. The recommendations of the Commission are not always followed by governments and they are not, strictly speaking, enforceable by the Inter-American human rights system unless the government has accepted the jurisdiction of the Inter-American Court. Bringing a case before the Commission does entail a risk that the case will be lost or that a mistake will be made in the law. Advocates will want to be careful that their work establishes a positive, not negative, precedent.

Mechanism Overview	THE INTER-AMERICAN COMMISSION ON HUMAN RIGHTS (COMPLAINT PROCEDURE)
WHAT IT COVERS	The Charter of the OAS, American Declaration, American Convention on Human Rights.
OF INTEREST TO WOMEN	The Commission appears willing to interpret norms of the American Convention according to the new Inter-American Convention for the Prevention, Punishment and Eradication of Violence Against Women. Recent investigations take women's human rights into account.
TYPE OF PROCEDURE	Complaint recourse on-site visits and emergency protective measures.
AVAILABILITY OF PROCEDURE	Individuals and groups living in a number of states of the OAS have the right to access this mechanism.

continued

ADMISSIBILITY REQUIREMENTS

Complainants must exhaust domestic remedies, but mechanism provides for exceptions where due process of law is lacking in the country concerned.

Complaints must provide relevant data regarding the applicant, evidence of the violation and the provision that was violated, the party against whom the complaint is filed, etc.

Anonymous complaints may be received.

PROCEDURES: HOW THE SYSTEM WORKS

After receiving a complaint, the Commission informs the government, requests its reaction and attempts a "friendly settlement."

If no settlement is made, the Commission then investigates and makes a recommendation.
If a violation has occurred, the Commission usually requires governments to compensate victims and prosecute perpetrators.

If the state does not comply, the case may be taken to the Inter-American Court or the report of the Commission may be published as part of its report to the Organization of American States.

ROLE OF ADVOCATES

Advocates can actively participate in the proceedings before the Commission; including making oral presentations or amici participation.

REMEDIES

The Commission can issue a recommendation to remedy the situation.

ADVANTAGES AND DISADVANTAGES

Advantages:
The Commission is open to cases regarding women's human rights.

Human rights norms and procedures are well developed.

The Commission does not hesitate to take strong stands in favor of human rights and to criticize governments.

It is often a more effective vehicle for addressing human rights issues than the United Nations system.

Disadvantages:
Commission has a long backlog and cases take at least two years.

The recommendations are not always followed by governments and are not strictly enforceable unless the government has accepted the jurisdiction of the Court.

On-Site Visits by the Inter-American Commission

Type of procedure

Monitoring and reporting. The Inter-American Commission collects and receives information about human rights violations in the country under study from individuals, human rights groups and other groups, as well as the government.

Availability of procedure

Every individual or human rights group in the Americas has the right of access to this enforcement mechanism. Access is achieved through: participating in one of the Inter-American Commission's on-site visits to a country where it is studying human rights violations; providing information to the Commission during its study; or pressuring the Commission to conduct such a visit.

Getting access to the process

Because the visits are conducted on an ad hoc basis and the Commission's funding and time are limited, the Commission's decision to investigate depends on the its interest in the issue that advocates want to bring to its attention. Advocates should contact the Commission to find out when they are planning an on-site visit to their country. In some countries, the visits occur every year or every couple of years. Next, advocates should write or call the legal officer at the Commission who is charged with review of human rights issues in that country, and offer to provide information documenting human rights abuses. With good contact and the promise of documentation of human rights abuses, the Commission is likely to accept the information.

How the system works and the role of advocates

The Commission prepares for the visit by studying background information. The legal officer for the country, as well as other staff of the Commission and Members of the Commission, schedule meetings and investigations in the country. Visits usually last two weeks. A few days are dedicated to receiving individual complaints or testimony from human rights groups about violations of the American Convention and/or the American Declaration. The Commission operates under a promise of security by the government, and tries to receive testimony under conditions that will not jeopardize the safety of the persons who contact them about human rights violations. The Commission usually sets up meetings with scholars, human rights groups, bar associations, Congress members and other agents and branches of the government.

After returning to Washington, DC, the staff of the Commission may receive follow-up information. Then they prepare a report, identifying the human rights violations uncovered, providing background information about the history and context of human rights in that country, and recommending what measures should be taken to remedy the human rights violations. The report is published and made available to the public as well as the General Assembly of the OAS, which may join the Commission in denouncing the human rights violations and calling for the government to remedy the situation.

The Commission's reports on its on-site visits may broadly address many aspects of the human rights situation in the country, and make more sweeping recommendation about what should be done to both remedy and prevent violations. The Commission may return to the issue in later reports, or conduct further on-site visits that monitor the situation of human rights in the country, noting both the progress made and the measures that still need to be taken.

Advocates can influence both the process and the report by directly contacting the Commission and asking it to examine women's human rights viola-

tions in its forthcoming on-site visits. They may schedule a meeting with the Commission during its visit, where they can present documentation of women's human rights violations and studies about the overall situation of women's human rights in the country. These presentations, whether written or oral, may be broad and address systematic and societal issues, but they should also include an analysis of how the American Convention and/or Declaration could be translated into reforms.

Advocates may also cite other international legal instruments that apply to the country, because the Commission may make recommendations that governments comply with the norms of those instruments. They may also use the opportunity of on-site information gathering to influence the Commission to recommend specific measures to be taken to remedy violations. They may call for further studies or follow-up work in future visits by the Commission.

Advocates can also encourage individual women, who may remain anonymous, or their representatives, to present testimony during the time scheduled by the Commission to receive complaints. Advocates should stay in contact with the Commission after the publication of the report, to encourage monitoring and follow-up of the human rights situation. The report may be utilized to pressure the government, through political and media campaigns, to comply with the Commission's recommendations. Advocates may also encourage the Commission to recommend preventive measures and systematic changes to be incorporated into the legal system, as well as in any part of the government's policy, to advance and defend women's human rights.

Remedies

The report provides a means to advance the recognition of women's human rights violations. It contains specific conclusions and recommendations and calls upon governments to adopt the measures necessary to both prevent and remedy violations of women's human rights. The recommendations of the Commission to governments to make systemic reforms, which are typically part of its reports on on-site visits, are, in practical terms, only enforceable through media and political pressure.

Weighing advantages and disadvantages
Advantages:
The Commission demonstrates willingness to address women's human rights issues. The investigations, conclusions and recommendations of the Commission can broadly address systemic issues and political and social problems that cannot be addressed through the litigation of individual cases. Preventive measures, as well as specific remedies, are recommended to correct human rights violations. Any group, including academics, policy-makers and political advocacy groups, can participate in the proceedings. The Commission can include analyses of human rights instruments other than the American Convention and Declaration in its investigations and reports. Participating in this process is somewhat easier than the litigation of individual cases: the level of legal analysis and documentation required to bring women's human rights to the attention of the Inter-American system, as well as the time, resource and travel commitment, is lower. The reports make for a useful lobbying tool in situations where political, social and legislative remedies are the goals.
Disadvantages:
The Commission does not have the resources to conduct thorough investigations on its own, and advocates have to provide it with information. In addition, they may have to educate the individuals working on the study to recognize and address women's human rights issues. Because the on-site visit is focused on systemic issues, individual women who give testimony can be frustrated that redress of their case is not the highest

priority. The individuals who give testimony are among many from whom the Commission will hear during its visit, and the Commission may not be able to contact them later with results. The process is ad hoc and depends, in practical terms, on the willingness of the government to participate and provide the Commission with safe facilities and the information it needs to conduct its investigation.

The government can frustrate the process and, historically, many have. The staff of the Commission is not always aware of women's human rights groups in the countries they visit, so contact and lobbying need to be initiated by women's human rights advocates.

Mechanism Overview	THE INTER-AMERICAN COMMISSION ON HUMAN RIGHTS (MONITORING PROCEDURE)
WHAT IT COVERS	The Inter-American Commission on Human Rights collects and receives information about human rights violations through site visits.
OF INTEREST TO WOMEN	The Commission appears willing to interpret norms of the American Convention according to the new Inter-American Convention for the Prevention, Punishment and Eradication of Violence Against Women. Recent investigations take women's human rights into account.
TYPE OF PROCEDURE	Monitoring and reporting.
AVAILABILITY OF PROCEDURE	Individuals and groups living in the Americas have the right to access this mechanism.
ADMISSIBILITY REQUIREMENTS	Admissibility depends on the interest of the Commission.
ROLE OF ADVOCATES	Advocates can actively participate in the proceedings before the Commission, including making oral presentations or amici participation.
REMEDIES	Commission can issue a recommendation to remedy the situation.
ADVANTAGES AND DISADVANTAGES	*Advantages:* The Commission is open to cases regarding women's human rights. Human rights norms and procedures are well developed. Commission does not hesitate to take strong stands in favor of human rights and to criticize governments. It is often a more effective vehicle for addressing human rights issues than the United Nations system. *Disadvantages:* Commission has a long backlog of cases and cases take at least two years. The recommendations are not always followed by governments and are not enforceable unless the government has accepted the jurisdiction of the Court.

Inter-American Court of Human Rights

The Inter-American Court, which was established by the American Convention on Human Rights, consists of seven judges who are nominated and elected by the state parties to the Convention. Judges must be nationals of an OAS member state but they need not be nationals of state parties to the Convention. Judges sit for a period of six years; they may be re-elected for another term. The Court, which holds at least two sessions annually, convenes in Costa Rica.

Type of procedure
Complaint-recourse or complaint-information.

Availability of procedure
Only the state parties to the American Convention and the Inter-American Commission have the right to submit a case to the Court (Article 61(1)). The procedure is available only for countries that have accepted the jurisdiction of the Inter-American Court. Only one exception to the above rule exists. If the government makes a special agreement to accept the jurisdiction of the Court for the case at issue, the Court can rule on the case.

With respect to advisory opinions, the procedure is available to governments of member states of the OAS and to the Inter-American Commission on Human Rights.

Getting access to the process

Unless the request is for an Advisory Opinion, the cases must first be brought through the individual complaint procedure of the Inter-American Commission on Human Rights. In addition, the Commission itself may bring a case to the Court (provided that the case is against a country that has accepted the jurisdiction of the Court). Because the case first proceeds through the Commission, the same rules of admissibility apply. The

Court may rule that the case is inadmissible because the Commission has already addressed that issue, or the government may challenge the admissibility of the complaint before the Court. In that case, the Court will evaluate whether domestic remedies have been exhausted or an exception exists, and/or consider and rule on the other admissibility requirements.

How the system works and the role of advocates

For complaints:
Testimony and proof is presented by the advocate and the Commission, and the government presents its defense. The complainant may also testify, but that is not required. If the Court finds a violation of the American Convention, it may direct that the violation of rights be remedied and the injured party compensated.

Once the decision is issued, the government has an international legal responsibility to comply. If the government does not comply with the decision, the Court may hold another hearing on the matter and order that further damages be paid to compensate for the failure to comply with the Court's order.

Advocates may work with the Inter-American Commission on the case. The local advocate can play an essential role because she is familiar with the local problems and the national legal system. Since national courts are charged with carrying out the remedies ordered by the Inter-American Court, the local advocate can help expedite the process by making sure the national court actually hears the matter. This process can be lengthy, and it requires expertise in the national legal and political system. Another role of advocates is to issue press releases about the Court's decision.

For Advisory Opinions:
The Inter-American Commission or a government may ask the Court for Advisory Opinions, especially its interpretation of the norms of the American

Convention on Human Rights or "other treaties concerning the protection of human rights in the American states". "The treaty need not be one that was adopted within the Inter-American system or a treaty to which only American states may be parties. It may be bilateral or multilateral, and it need not be a human rights treaty as such, provided the provisions to be interpreted relate to the protection of human rights." (Article 64)

The Court convenes in Costa Rica, analyzes and decides how the treaty in question should be interpreted with regard to the matter at hand, and issues an Advisory Opinion. The Advisory Opinions are not binding. Advocates can try to influence the Commission or governments to request an Advisory Opinion. If a matter is already being reviewed by the Court for an Advisory Opinion, advocates may present expert opinions to the Court to assist it in its decision-making process about the norms of the American Convention and the issue at hand.

If a violation of the American Convention is found, the Court must rule that the woman injured "be ensured the enjoyment of [her] right or freedom that was violated." In addition, the Court must rule, "if appropriate," that the consequences of the human rights violation be remedied and compensated (Article 63 (1)).

Remedies

The remedies can include whatever is necessary to put the individual back in the position she would have been in if the violation had not occurred. Following the Velásquez-Rodriguez norm, the Court should also order that the national courts investigate, prosecute and punish the human rights violator. Compensation is in the form of monetary payment to the person whose rights were violated. It includes compensation for lost salary and for any other losses due to the injuries, medical expenses, and compensation for pain and suffering. In addition, under Article 63(2), the Court has the power to grant an extraordinary remedy in the nature of a temporary injunction.

Weighing advantages and disadvantages
For Complaints:
Advantages:
In general, states have shown high regard for decisions of the Court, which become precedents that are followed throughout the Americas. The Inter-American Court also enjoys great respect in the broad international human rights community, making it a good tool to increase awareness of the enforceability of women's human rights. At the moment, the Court appears to be favorable to defending and progressively developing women's human rights.

Remedies are broad, as the women whose rights have been violated receive compensation and specific remedies as well as an order for the future guarantee of their rights. The decisions can be used to prompt broader reforms in the national system. Assistance from experts in the litigation process is available.
Disadvantages:
After two or three years of participating in the proceedings of the Inter-American Commission, one must wait another year for a hearing. The individual woman's case is in the public eye for a long period of time, during which the problem may still persist. Preparation and legal arguments are challenging, making outside assistance a necessity, and the process can dominate an organization's resources during the time of the hearing. The Court can only redress human rights violations after the fact; it can only direct its remedies to individual cases. Typically, further work, both on the national level and within the Inter-American system, is necessary

to enforce the Court's orders.

To date, the Court has heard only a few cases involving individual complaints, and none of these cases dealt with issues of women's human rights. However, the historical composition of the judges of the Court has included human rights experts who were either experts in women's human rights or highly favorable to advancing women's human rights.

For Advisory Opinions:

Advantages:

Advisory opinions can be a powerful vehicle to develop the law in favor of women's human rights. The process is easier to participate in than litigation. The Court has issued few Advisory Opinions, but the work it has done over the last ten years has been timely, progressive and effective in advancing and developing human rights law in the Inter-American system.

The procedure has been used effectively to promote women's human rights. For instance, in 1984 the Inter-American Court issued an Advisory Opinion on proposed naturalization laws in Costa Rica, which would have discriminated against women by allowing Costa Rican men to automatically naturalize their foreign-born spouses, but prohibiting Costa Rican women from doing the same. The Court interpreted the norms of the American Convention through use of the CEDAW and other international women's human rights instruments that had been recently enacted at the time of the Court's opinion. The language of the Court's Advisory Opinion is a compelling description of the development of women's human rights, and it provides a useful tool to advance and enforce women's human rights in future cases.

Disadvantages:

Access is limited to the Inter-American Commission and governments. Once the Court addresses an issue, expert legal opinions are welcome but some activists may not have the credibility to have their views heard. The Advisory Opinion does not provide specifically enforceable remedies.

Mechanism Overview	THE INTER-AMERICAN COURT OF HUMAN RIGHTS
WHAT IT COVERS	The Inter-American Court of Human Rights provides for hearings of disputed cases and issues opinions.
OF INTEREST TO WOMEN	The Court appears willing to interpret norms of the American Convention according to the new Inter-American Convention for the Prevention, Punishment and Eradication of Violence Against Women. Recent investigations take women's human rights into account.
TYPE OF PROCEDURE	Complaint-recourse or complaint information.
AVAILABILITY OF PROCEDURE	Only the states parties and the Commission have the right to submit a case to the Court. The Court is available for countries that accepted its jurisdiction and countries that accepted its

continued

continued	THE INTER-AMERICAN COURT OF HUMAN RIGHTS

jurisdiction for a particular case. The advisory opinion procedure is available to governments of member states of the OAS, and the Inter-American Commission on Human Rights.

ACCESSIBILITY REQUIREMENTS

The Court can only accept cases after the cases have been addressed in the individual complaint proceedings of the Inter-American Commission on Human Rights.

PROCEDURES & HOW THE SYSTEM WORKS

Complaint procedure:
The Court holds annual hearings.
The Government presents its defense.
The Court decides whether the government violated the American Convention.
Advisory Opinion procedure:
Inter-American Commission or government requests for an opinion.
The Court issues Advisory Opinion on the interpretation of the American Convention or other treaty concerning the protection of human rights.

ROLE OF ADVOCATES

Advocates and the Commission present testimony and proof during the hearing.
Advocates can present expert opinions to the Court to assist it in its decision-making process about the interpretation of the norms.

REMEDIES

The Court can order protective and preventive measures to protect the rights guaranteed in the American Convention.

The Court can order compensation.

The Court can order the national courts to investigate, prosecute and punish the human rights violator.

The Court can grant a temporary injunction.

ADVANTAGES AND DISADVANTAGES

Advantages:
The decisions become precedents and are highly respected throughout the Americas.
The remedies are broad.
The decisions of the Court can be used to prompt broader reforms in the national system.
Advisory Opinions advance and develop human rights law.
The procedure has been used to promote women's human rights.
Disadvantages:
The process takes a long period of time.
The Court can only redress human rights violations after the fact.
The Court can only direct its remedies to individual cases.

Inter-American Commission on Women

The Inter-American Convention on the Prevention, Punishment and Eradication of Violence Against Women which entered into force in March 1995 provides a new mechanism for women who have suffered from various forms of violence against them. In addition to cases that can be sent to the Inter-American Commission for Human Rights, the new Convention makes provision for cases to be sent to the Inter-American Commission on Women for resolution.

The Convention defines violence against women as:

> any act or conduct, based on gender, which causes death or physical, sexual or psychological harm or suffering to women, whether in the public or private sphere (Article 1).

Type of procedure

Complaint. The Inter-American Commission on Human Rights can investigate cases brought to its attention under the Convention and can make recommendations to address violations against individual women.

Simultaneously, the Inter-American Commission on Women may receive the complaints and participate in their resolution, in cooperation with the Commission.

Availability of procedure

Women in countries that have ratified the new Convention may utilize it. The Convention provides that any person, group of people, and/or NGO may present petitions to the Inter-American Commission on Human Rights to address complaints about violations of Article 7 by a State Party.

Women in countries that have not ratified the new Convention may access its enforcement mechanism through the Inter-American Human Rights Commission. Such petitions must be presented directly to the Commission.

Getting access to the process

Substantive requirements: Women from countries that have signed the Convention must allege a violation of Article 7 of the Inter-American Convention on Violence Against Women, and provide evidence that such a violation occurred. Women from countries that are not signatories to the Convention should state that the American Convention and/or the American Declaration, which are under the jurisdiction of the Commission, must be interpreted according to the new Inter-American Convention on Violence Against Women. They should further allege that the case at hand and the failure of the government to protect the human rights of the women constitute a violation of the norms of the American Convention and/or the American Declaration.

Procedural requirements: Complaints must comply with the same admissibility regulations as any other complaint before the Inter-American Commission on Human Rights. In brief, the regulations require that: the complaint must be presented within of six months after the final action taken by the national judicial system; it must allege that the internal (national) remedies were exhausted or that the internal remedies are ineffective; and it must be signed by a person, a group of persons and/or NGO representing the person(s) whose rights were violated.

How the system works and the role of advocates

Complaints may be sent directly either to the Inter-American Commission on Human Rights or to the Inter-American Commission on Women. Either Commission will investigate the complaint according to its standard procedures for complaints about human

rights violations. Advocates may partici-pate in the proceedings as with any matter before the Inter-American Commission on Human Rights.

Remedies

At the end of the procedure, the Inter-American Commission on Women must either (1) be satisfied that negotiations with the government resulted in a settle-ment that will adequately defend the rights of the woman or women involved; or (2) publish, in its Annual Report, conclusions and recommendations that state whether, according to the norms of the Convention on Violence Against Women, a violation of women's human rights occurred. If a violation of human rights occurred, the Commission must recommend "measures necessary to ensure that the violation does not recur." This includes, in the very least, that the government investigate, prosecute and punish the instigator of the violation, and that it compensate the woman or women for the harm suffered. If the government does not comply with the Commission's recommendations during the period of time fixed (normally three months), the Commission and/or the complainant (the woman or the NGO) may bring the case to the Inter-American Court on Human Rights, provided that the country has agreed to the jurisdiction of the Court.

Weighing advantages and disadvantages

Advantages:

State responsibility under the Convention is defined precisely, which makes the convention an excellent tool to realize and enforce women's human rights.

It is advantageous that the Inter-American Commission on Women is available as an alternative to the Human Rights Commission.

Disadvantages

There is difficulty of enforcement regard-ing countries that have not agreed to the jurisdiction of the Court.

Mechanism Overview	THE INTER-AMERICAN COMMISSION ON WOMEN
WHAT IT COVERS	The Commission on Women creates an additional legal avenue for women to address violations, with the new Convention on the Prevention, Punishment and Eradication of Violence Against Women.
OF INTEREST TO WOMEN	The Inter-American Convention provides a new mechanism for women who suffer from various forms of violence against them.
TYPE OF PROCEDURE	A complaint procedure before Inter-American Human Rights Commission alone or in cooperation with the Inter-American Commission on Women.
AVAILABILITY OF PROCEDURE	Any person, group of people, and/or NGO may present petitions to the Inter-American Commission on Human Rights. In countries that have not ratified the Convention on Violence Against Women, women can still access the enforcement mechanisms with a direct petition to the Commission on Women.

continued

ACCESSIBILITY REQUIREMENTS

All women from countries that accepted the Convention on Violence Against Women can file a complaint.

Women from countries that have not accepted the Convention on Violence Against Women should state that the American Convention and/or the American Declaration should be interpreted according to the new Convention on Violence Against Women.

In addition, they should allege that the case of violence against women and the failure of the government to protect the human rights constitute a violation of the norms of the American Convention and/or the American Declaration.

PROCEDURES & HOW THE SYSTEM WORKS

The complaint must be presented within six months of any action taken by a national judicial system.

The national remedies must be exhausted and/or ineffective.

The complaint must be signed by a person, group of persons, and/or NGO that represents the complainant.

Complaints can be sent directly to the Inter-American Commission on Human Rights or to the Inter-American Commission on Women.

The Commission investigates the complaint.

ROLE OF ADVOCATES

Advocates can participate in the proceedings as with any matter before the Inter-American Commission on Human Rights.

REMEDIES

A settlement with the government.

Published report with conclusions and recommendations.

Recommended measures necessary to ensure that the violation does not recur.

Compensation for the victim.

ADVANTAGES AND DISADVANTAGES

Advantages:
The Inter-American Commission on Women is an alternative to the Human Rights Commission, making it a good additional tool for enforcing women's human rights.

Disadvantages:
Enforcement is difficult, especially with countries that have not accepted the jurisdiction of The Court.

The African System

The African human rights system is the "youngest" regional system. In 1981, the Assembly of Heads of State and Government of the Organisation of African Unity (OAU) adopted the guiding human rights document for the system—the African Charter on Human and Peoples' Rights ("African Charter") which came into force in 1986. The most distinctive feature of the Charter is its recognition of collective rights. It views individual and peoples rights as inter-linked. Other distinctive features are inclusion of the right to development, duties of individuals and its drawback clauses which restrict rights in a broad sense. The African Commission on Human and Peoples' Rights ("African Commission"), the enforcement mechanism for the Charter, was established in 1987.

Article 18 of the Charter makes the elimination of discrimination against women a duty of member states and links the convention to all other international declarations and conventions on women. However, the protection of women under the Charter is ambiguous as the language of the Charter as a whole is oblivious of women, and Article 18 does not confer any rights as such.

The functions of the African Commission are:
- To promote human and peoples' rights and, in particular, to:

 Collect documents and undertake studies and research on African problems in the field of human and peoples' rights; organize seminars, symposia and conferences; disseminate information; encourage national and local institutions concerned with human and peoples' rights; and, should the case arise, give its views or make recommendations to governments.

 Formulate principles and rules aimed at solving legal problems relating to human and peoples' rights and fundamental freedoms upon which African governments may base their legislation.

 Cooperate with other African and international institutions concerned with the promotion and protection of human and peoples' rights.

- Ensure the protection of human and peoples' rights as laid down by the African Charter.

- Interpret the provisions of the African Charter at the request of a state party, an institution of the OAU or an African organization recognized by the OAU.

- Perform any other tasks which may be entrusted to it by the Assembly of Heads of State and Government (Article 45, African Charter).

Type of procedure

Complaint-information and/or monitoring. Three basic types of procedure are available:
- inter-state complaints;
- complaints of individuals and groups against states (complaint-information); and
- studies and other activities undertaken by the African Commission at its own initiative.

The Commission can formulate and lay down principles and rules aimed at solving legal problems relating to human rights. In addition, it can cooperate with other African and international institutions concerned with the promotion and protection of human and peoples' rights.

Availability of procedure

One state may submit communications alleging violations of the African Charter by another state party to the Charter. Both states must have ratified the Charter.

The African Commission is also authorized to receive communications

101

The African System: Access for Advocates

Established in 1981, the African human rights system is the youngest regional system. Advocates can access the system through the:

African Commission on Human and People's Rights. The Commission accepts complaints by individuals and groups against states, as well as inter-state complaints. Individuals and groups submit written communications alleging violation of the African Charter on Human and People's Rights. Members of the Commission have the discretion to decide which non-state communications to consider.

from non-state parties. This has been interpreted to mean that it can receive communications from both individuals and groups, including NGOs. Members of the Commission have the discretion to decide which non-state communications to consider. The African Charter provides that a communication shall be considered if a simple majority of its Commission members so decide.

Getting access to the process

For inter-state communications, the African Charter emphasizes the need to exhaust all domestic remedies unless the Commission decides that local remedies either do not exist or the procedure for achieving them is unduly long.

For complaint-information, a communication must satisfy the following requirements before it can be considered by the Commission:

- It must indicate the identity of the authors even if the latter request anonymity;
- Communications must be compatible with the Charter of the OAU and the African Charter on Human and Peoples' Rights;
- Communications must not be written in "disparaging or insulting language directed against the State concerned and its institutions," or against the

OAU;

- The communications must not be based exclusively on news disseminated through the mass media;
- All local remedies must be exhausted unless it is evident that this process is unduly time-consuming;
- The communication must be submitted within a reasonable time from after local remedies were exhausted or the date the African Commission was first notified of the matter; and
- The communications should not deal with cases which have been settled by the states involved in accordance with the principles of the Charter of the UN, the Charter of the OAU or the African Charter.

How the system works and the role of advocates

For inter-state complaints:

A state can, by written communication, draw another state's attention to the violation of the provisions of the African Charter by that state. Copies of the communication should be sent to the Secretary General of the OAU and the Chairman of the African Commission.

Within three months of receipt of the communication, the defaulting state must give a written explanation of the matter, including relevant information about the

3

laws, rules and procedures which have been applied or are applicable and the redress already given or the course of action available.

The two states then have to attempt to settle the matter by friendly negotiations.

If they cannot settle it within three months, either party then has the right to petition the African Commission, through its chairman, and the Secretary General of the OAU. Notice has to be sent to the other state of this step taken.

The Commission decides whether the admissibility requirements are satisfied and whether any exceptions apply. The Commission then proceeds to hear the matter. It may request relevant information from the state parties. States may be represented before the Commission and may make oral or written submissions.

The African Commission attempts to reach an amicable settlement between the parties. If that fails, the Commission prepares a report stating the facts and its findings and recommendations. The report is sent to the Assembly of Heads of State and Government.

For complaints-information:
Individuals or groups submit written communications to the African Commission alleging violation of the provisions of the African Charter by a state.

The Commission secretariat makes a list of such communications and transmits it to members of the Commission before each session. The members vote on which communications should be considered by the Commission. They may decide by a simple majority which cases should be heard.

If the African Commission decides to hear a case, it first determines if the complaint satisfies the admissibility requirements in Article 56. The communication is then brought to the attention of the state concerned by the chairman of the Commission. The Commission then deliberates on the communication.

If after deliberations the Commission considers that one or more of the communications reveal "the existence of a series of serious or massive violations of human and peoples' rights," the attention of the Assembly is drawn to these cases. The Assembly may then request the Commission to undertake an in-depth study of these cases and make a factual report, accompanied by its findings and recommendations. Emergency situations may also be drawn to the attention of the Chairman of the Assembly, who may unilaterally request an in-depth study.

When the Commission undertakes an investigation, whether of an inter-state communication or other complaint, it has the right to choose any appropriate method of investigation. It may hear from the Secretary General of the OAU or any other person capable of elucidating the matter. This opens a channel for women's rights advocates to educate the Commission on issues relating to women's human rights. All measures taken by the Commission are confidential and it is only the Assembly that can decide whether the report submitted by the Commission should be published.

For monitoring and reporting procedures:
Procedures of the monitoring arm of the African Commission are less clear. Advocates can bring any issue relating to women's human rights to the attention of the Commission and request them to conduct studies into the issue. This may result in in-depth examination of issues relating to women's human rights in a particular country and to recommendations to the government to improve the human rights of women. Advocates can also urge the Commission to lay down principles and rules for promoting women's rights, upon which African governments can base their legislation. For example, it can be urged to lay down rules for dealing with domestic violence as exemplified by CEDAW and other instruments. African governments could then be urged to adopt domestic violence

or other legislation aimed at protecting women.

Remedies

The Commission has no authority to grant a remedy or bind a state to its decision or to any findings made as a result of monitoring. The Commission submits reports of its findings to the Assembly which then determines what action, if any, is to be taken regarding the decision.

Weighing advantages and disadvantages

For complaints:

Advantages:

The procedure allows for groups including NGOs to initiate complaints before the Commission (Article 46). NGOs can also bring an issue before the Commission if it is proven that the individual directly affected is unable to do so.

Under Article 66, special protocols or agreements may supplement the African Charter. These could be used to remedy the situation of women under the Charter. At the meeting in Mauritius in 1996, the Commission passed a resolution to elaborate an additional protocol on women in the Charter. There is also in existence a draft protocol for the establishment of a court.

Article 18 of the African Charter makes the elimination of discrimination against women a priority and links the convention to all other international declarations and conventions on women. Articles 60 and 61 call on the Commission to draw inspiration from international covenants and in such a situation the Commission may be persuaded to interpret Article 18(3) of the Charter with reference to the provisions on women's rights in CEDAW and the Declaration on the Elimination of Violence Against Women. Women's rights advocates can therefore rely not only on the provisions of the African Charter to argue for women's human rights but can also authoritatively cite CEDAW, DEVAW and other instruments with important provisions on women's rights.

Disadvantages:

The individual complainant and NGOs have a limited role in the system. The confidentiality of the complaint mechanism makes it difficult to assess how women have been able to use the system to promote and protect their human rights. Secrecy eliminates the potential for advocates to use publicity to embarrass governments into changing their ways. Cases are also very difficult to prove, as the standard is "serious or massive" violations of human and peoples' rights. Uncertainty exists as to the type of evidence that must be shown to meet this test. Moreover, the African Charter, in contrast to the European and Inter-American systems, does not allow for judicial review of the decisions of the Commission.

The overall effectiveness of the complaint procedure is weakened by the Charter's grant of power to the Assembly of Heads of States and Governments. If actions are brought against governments whose heads have final authority in the determination of the outcome of cases, there is very little likelihood that any effective action will be taken against any state.

For monitoring and reporting procedures:

Advantages:

The mandate granted to the African Commission is very broad, including undertaking of studies and research on human rights issues and the organizing of seminars, symposia and conferences on human rights. The Commission can work with African and international institutions concerned with the promotion and protection of human rights.

Disadvantages:

All these activities require financial resources; this has been a problem for the effective implementation of the mandate of the Commission. Also, the results of

Mechanism Overview	THE AFRICAN COMMISSION ON HUMAN AND PEOPLE'S RIGHTS

WHAT IT COVERS

The African Charter on Human and Peoples' Rights.

The Commission collects studies in the field of human rights; lays down principles and rules regarding human and peoples' rights; spurs cooperation with other African and international institutions; interprets all provisions of the Charter; and performs tasks entrusted to it by the Assembly of Heads of State.

OF INTEREST TO WOMEN

Can be used to promote and protect women's human rights in the Africa region.

TYPE OF PROCEDURE

Inter-state complaints, complaint-information and monitoring mechanisms.

AVAILABILITY OF PROCEDURE

State parties that have ratified the Convention.

ACCESSIBILITY REQUIREMENTS

Inter-state Complaints:
State parties must have exhausted all domestic remedies.

Complaint-information:
All authors must be identified.
Communications must be compatible with the Charter of the OAU and the Charter on Human and Peoples' Rights and cannot be insulting to the OAU. They must be based on information other than mass media; all local remedies must be exhausted and communication must be submitted in a timely manner, and "should not deal with cases which have been settled by the States involved in accordance with the principles of the Charter of the UN, the Charter of the OAU or provisions of the African Charter."

PROCEDURES & HOW THE SYSTEM WORKS

Inter-state Complaints:
A state identifies a violation of another state through written communication. The responding state must respond within 3 months. States must make attempts to settle the matter amicably. If not, the communication is submitted to the Commission to decide if the admissibility requirements are met. The Commission hears the matter and attempts to reach an amicable settlement between the parties. If that fails, a report is prepared and sent to The Assembly of Heads of State and Government with recommendations from the Commission.

continued

For Complaint-information:

The Commission decides which written communications submitted by individuals or groups it will hear. If after considering the communication the Commission determines that it reveals "the existence of a series of serious or massive violations of human and peoples' rights" they will alert the Assembly.

The Assembly will study these cases and make a report.

ROLE OF ADVOCATES

For Monitoring and Reporting:

Advocates can bring issues relating to women's human rights to the attention of the Commission and request an inquiry by the Commission. Advocates can also urge the Commission to lay down principles and rules.

REMEDIES

Non-binding recommendations.

ADVANTAGES AND DISADVANTAGES

For Complaints:
Advantages:

NGOs can bring issues and complaints before the Commission. Women's groups can cite the Charter and authoritatively cite CEDAW and DEVAW and other instruments with relevant provisions.

Disadvantages:

Individuals and NGOs have a limited role in the system.

Secrecy limits the use of publicity to embarrass governments.

Cases are difficult to prove.

There is no judicial review of the decisions of the Commission.

For Monitoring and Reporting Procedures:
Advantages:

The Commission has a broad mandate.

Disadvantages:

The effective implementation of the mandate has been hindered by lack of financial resources.

Monitoring and reporting procedures do not bind states.

NATIONAL HUMAN RIGHTS SYSTEMS

4

National Human Rights Systems

How do national human rights systems work?

Many people tend to associate human rights protection with international human rights law and international relations. This leads them to believe that only international bodies can enforce human rights. This reasoning is wrong on two accounts. First, human rights protections frequently exist in national laws and, second, national bodies often may enforce human rights norms found in international and regional systems.

The first place an advocate or victim of a human rights violation may look for recourse in one's own country of residence, is to the courts, commissions and other investigatory and judicial bodies. The types of mechanisms and procedures vary from country to country. For example, human rights commissions exist in some countries while they are unheard of in others. Similarly, constitutional courts exist in some countries but not in others. Women's rights advocates and/or victims of rights violations should endeavor to understand their legal system so as to identify components of the human rights system in their respective countries.

In some cases, human rights advocates can succeed at the national level. In others, advocates may have to go on with their claim to the regional or international level. Usually, human rights advocates will be required to show that they did everything they could possibly do at the national level before addressing a regional or international mechanism, that is, they must "exhaust" their claims at the national level. In nearly every case then, advocates for women's human rights should consider the national level.

National Laws Protecting Human Rights

Most states have some type of laws protecting human rights guarantees. Countries that are signatory to regional and international human rights documents are obligated to abide by their provisions. Thus, a signatory state may opt to provide more rights than allotted for in the international convention, but not less.

At times, national laws directly refer to human rights, and many states copy international and regional guarantees virtually word for word into their national law. In many places, however, human rights can be seen in national law only under another name. For example, in the U.S., the term "civil rights" is used for many rights that are also considered "human rights."

Many countries create human rights enforcement systems, which may include a human rights commission to investigate claims and special adjudicative bodies (which may or may not be courts) to hear cases. Also,

human rights claims may be heard through the regular course of a civil or criminal case. Finally, ad hoc or permanent commissions may be established to monitor and write reports on immediate and ongoing human rights concerns. For example, following the World Conference on Women in Beijing, many states have committed themselves to writing reports on violence against women and other issues pertaining to women's human rights.

National constitutions increasingly reflect a commitment to human rights. At times the rights are listed in a separate section–a bill of rights. Drafters of recent constitutions often consider the language of international and regional norms in fashioning their guarantees. Some of the possible constitutional provisions that affect women's human rights are the:

- right to nondiscrimination (on the basis of sex, gender and/or child bearing; race; nationality or ethnic group, etc.)

- right to equal treatment of men and women (in specified spheres, such as employment or the court system, or in all spheres of life)

- right to freedom from violence

- other civil and political rights available to all people including, for example, the rights to assembly, to free speech, to worship as one chooses, to privacy, etc.

- right to maternity leave (and/or paternity leave)

- other economic and social rights available to all people, including, for example, the right to health care, housing, and education

- right to equality of men and women

Many constitutions do not include all of the rights. Some include far more. Although many constitutions include nondiscrimination provisions, few include general equality provisions. A guarantee of equality is generally interpreted to be broader, as it refers to equality in fact.

Some countries, such as New Zealand, Canada and Israel, have no written constitution in one single document, but rather a number of Basic Laws, that are primary laws guiding society. Basic Laws may include provisions about women's human rights as well.

In addition to constitutions, other legislation may specifically guarantee women's rights. Aspects of women's human rights may be protected under the criminal or penal code, family law provisions, laws pertaining to ownership of property, employment and citizenship or other laws. Such legislation not only specifies which rights are guaranteed, but also sets up or mandates specific courts or other institutions with the power to handle cases of alleged violations of the rights. The legislation may also specify various forms of redress available to aggrieved individuals.

Of course words on paper do little to advance women's rights. The constitutional provisions and other legislation must be interpreted in a manner that is in line with women's interests and must be enforced for all women.

International Human Rights in National Systems

States follow different practices in "internalizing" treaty norms, that is in incorporating treaties within the state's legal structure so that the provisions can be implemented by state authorities. In some countries, international (and at times regional) human rights law automatically becomes a part of national law. In other words, as soon as a state has ratified or acceded to an international agreement, that international law is national law. Under such systems treaties are considered to be "self-executing."

In other countries, international

National Approaches to Human Rights

National systems consist of:	A set of elements including constitutions, legislation, courts and institutions established for the protection of human rights.
Examples of enforcement mechanisms:	• Human rights commissions • Constitutional courts • Regular courts • Ombudspersons • Offices of civil rights • Permanent and ad hoc commissions

human rights law does not automatically form part of the national law of the ratifying state. The international law is not "self executing," that is it does not have the force of law without the passage of additional national legislation. In these cases, international human rights does not as such form part of the national law.

International human rights law can have a great impact on national systems, regardless of which of the two scenarios described above applies. National courts may look at international and regional human rights norms in deciding how to interpret and develop national law. Although a court may not be required to follow the international law, it could use the law as a guide.

Courts are not the only national bodies that can enforce treaty norms. States may also establish administrative bodies to monitor and carry out compliance with international and regional agreements. For example, CEDAW (the "Women's Convention") requires states to take positive action to improve the status of women. The political and administrative bodies entrusted with carrying out these steps are an important component in the enforcement of human rights. So too are the local NGOs that monitor state leaders to ensure that they hold true to their agreements.

Finally, courts and administrative bodies may internalize and enforce customary international law. Customary international law about the fair treatment of prisoners, for example, often has a great impact on the treatment of prisoners on a national level. Customary international law may find its way into the national law books. For example, in the U.S., the Alien Tort Claims Act codifies international norms pertaining to genocide, torture, piracy and other grave wrongs against the "law of nations." This Act permits U.S. courts to hear claims by a victim of any nationality, against a perpetrator of any nationality, regardless of where the crimes occurred. Advocates for women's rights used the Alien Tort Claims Act to sue Radovan Karadzic, a Bosnian Serb leader, for ordering rape, torture and other crimes against women and men in Bosnia.

Are there strategies for using international law nationally?

International and regional human rights law can be used in national human rights mechanisms in different ways including:
• Basing the human rights claim on international or regional law, where such law is part of national law or has otherwise been incorporated into national law.

- Using the international and regional human rights law as an aid to the interpretation of national law provisions. Judges in many countries can and have been guided by international law in their interpretation of specific legal provisions.

- Reminding the state that if it has, through ratification of a treaty, freely assumed an obligation (e.g. to eliminate discrimination against women), national enforcement mechanisms should be under a duty to interpret national law so as not to conflict with the state's international or regional obligations.

- Using international human rights law as the minimum standard of protection which national law should attain. Advocacy for law reform and responsive judiciaries can endeavor, in the first instance, to bring national law in line with internationally accepted standards for the protection of women's human rights.

of women's human rights establishes law which can, in turn, be used by other women whose rights are violated. This is the doctrine of judicial precedent—a common law, rather than a civil law, approach.

A successful claim may lead to the reform of legislation or policies found to violate women's human rights. Women's rights advocates can thus take test cases to court to challenge policies or laws which are discriminatory to women as part of an overall law reform strategy.

National human rights systems bring the concept of women's human rights closer to the people. Advocacy groups are able to show through public education how women's day to day experiences of domestic violence, discrimination on the job or denial of a right to inherit are violations of fundamental rights.

National human rights systems make it easier for women's human rights activists to press for greater accountability by government. This can be done by

Using International Law in National Courts

In deciding the Unity Dow case* the High Court of Botswana relied on a number of international instruments even though Botswana was not signatory to them. The judges noted that they were entitled to take judicial notice of the instruments because Botswana is a member of the community of nations through the UN. They also relied on the African Charter of Human and People's Rights, to which Botswana is a signatory.

*See "Case Study of an Advocacy Strategy from Africa" in Chapter 5.

What are the benefits of national human rights systems?

National human rights systems can be important for the two reasons:

- they are more easily accessible to large numbers of women and advocacy groups in each country;

- where jurisdiction for human rights claims lies with a superior court (such as the High Court, Court of Appeal, or Supreme Court) a decision in favor

calling for legal reforms or more systematic enforcement of existing legislation. Advocates can also aim to promote greater gender sensitivity and human rights awareness among law enforcement agencies and the courts.

Most human rights systems at the regional and international level require that before a claim for redress for an alleged violation of human rights is entertained at those levels, national

remedies must be exhausted. The use of national human rights systems enables women victims of violations to satisfy this requirement.

What are the drawbacks of national systems?

National human rights systems can also have significant limitations. These exist in varying degrees of seriousness in many countries. Common limitations of national human rights systems include:

- Dependency on the political environment. In countries where the government of the day is oppressive and does not protect human rights, it is unlikely that the national human rights mechanisms will effectively protect such rights;

- Reliance on national laws. Where national laws are discriminatory or do not protect other aspects of women's human rights, the national mechanisms may offer no redress for the violation;
- Reliance on local personnel. Where local political, administrative and judicial personnel are hostile to women's human rights, they may be unwilling to enforce national, regional and international laws;
- The socioeconomic environment. Where courts or other agencies do not function properly, are corrupt and/or where officers are not gender sensitive or are hostile to women's rights, there may not be any redress for women at the national level.

4

Using National Laws & Mechanisms to Advance Women's Human Rights

Some questions to guide your process...

Which provisions of the constitution or basic laws protect women's fundamental rights and what provisions of other legislation are important for women's human rights?

Are there special constitutional or other legal provisions covering the right to nondiscrimination and/or to equality?

Which human rights conventions has the country agreed to enforce? When did the convention come into force in the country?

Are human rights treaties "self-executing? That is, do they automatically form part of the local law as soon as they are signed or must supplemental legislation be passed?

What direct mechanisms exist to protect human rights: constitutional courts, offices of civil rights, human rights commissions, ombudspersons, etc.? Do any of these bodies have officers focusing specifically on women?

Have advocates raised international human rights claims in national courts in the past? If yes, how did the judges respond? If no, why not? Would your local judges take notice of international norms even though they may not be directly applicable?

If the country is party to CEDAW, what mechanisms have been established to report the state's progress on the convention?

Constitutional Provisions Pertaining Specifically To Women

The selection below was chosen to illustrate some of the many ways constitutions address women's human rights. For other countries, see http://www.uni-wuerzburg.de/law/home.html

The Netherlands
(Adopted: 17 Feb 1983).

Chapter 1 Fundamental Rights Article 1 [Equality]

All persons in the Netherlands shall be treated equally in equal circumstances. Discrimination on the grounds of religion, belief, political opinion, race, or sex or on any other grounds whatsoever shall not be permitted.

Namibia
(Adopted: Feb 1990).

Article 10 [Equality and Freedom from Discrimination]

(1) All persons shall be equal before the law.

(2) No persons may be discriminated against on the grounds of sex, race, colour, ethnic origin, religion, creed or social or economic status.

Cambodia
(Adopted: 21 Sep 1993)

Article 31 [Human Rights, Equality, Restrictions]

(1) The Kingdom of Cambodia recognizes and respects human rights as stipulated in the United Nations Charter, the Universal Declaration of Human Rights, the covenants and conventions related to human rights, women's and children's rights.

(2) Every Khmer citizen is equal before the law, enjoying the same rights and freedom and fulfilling the same obligations regardless of race, colour, sex, language, religious belief, political tendency, birth origin, social status, wealth or other status.

Article 36 [Work]

(1) Khmer citizens of either sex have the right to choose any employment according to their ability and to the needs of the society.

(2) Khmer citizens of either sex receive equal pay for equal work.

(3) The work by housewives in the home has the same value as what they can receive when working outside the home.

(4) Every Khmer citizen has the right to obtain social security and other social benefits as determined by law.

(5) Khmer citizens of either sex have the right to form and to be members of trade unions.

[note that the Cambodian constitution contains many provisions that specify application to "either sex"]

Article 45 [Gender Equality, Marriage]

(1) All forms of discrimination against woman are abolished.

(2) The exploitation of women in employment is prohibited in marriages and matters of the family.

(3) Marriage is to be conducted according to conditions determined by law based on the principle of mutual consent between one husband and one wife.

Article 46 [Women]

The commerce of human beings, exploitation by prostitution and obscenity which affect the reputation of women are prohibited.

A woman may not lose her job because of pregnancy. Women have the right to take maternity leave with full pay and with no loss of seniority or other social benefits.

The State and society provide opportunities to women, especially to those living in rural areas without adequate social support, so they can get employment, medical care, send their children to school, and have decent living conditions.

Eritrea
(Draft: July 1996)

Article 5 Gender Reference

Without consideration to the gender wording of any provision in this Constitution, all of its articles shall apply equally to both genders.

Article 7 Democratic Principles

(1) It is a fundamental principle of the State to guarantee its citizens broad and active participation in all political, economic, social and cultural life of the country.

(2) Any act that violates the human rights of women or limits or otherwise thwarts their role and participation is prohibited.

continued

113

(3) There shall be established necessary institutions to encourage and develop people's participation and initiative in the areas where they reside.

Article 14 Equality under the Law

(1) All persons are equal before the law.

(2) No person may be discriminated against on account of race, ethnic origin, language, colour, sex, religion, disability, political belief or opinion, or social or economic status or any other factors.

(3) The National Assembly shall, pursuant to the provisions of this Article, enact laws that can assist in eliminating inequalities existing in the Eritrean society.

Romania

(Adopted: 8 Dec 1991)

Article 4 [Unity, No Discrimination]

(1) The State foundation is laid on the unity of the Romanian people.

(2) Romania is the common and indivisible homeland of all its citizens, without any discrimination on account of race, nationality, ethnic origin, language, religion, sex, opinion, political adherence, property, or social origin.

South Africa

(Adopted: 8 May 1996 / Amended: 11 Oct 1996)

Section 1 Republic of South Africa

The Republic of South Africa is one sovereign democratic state founded on the following values:

(a) Human dignity, the achievement of equality and the advancement of human rights and freedoms.

(b) Non-racialism and non-sexism.

Section 9 Equality

(1) Everyone is equal before the law and has the right to equal protection and benefit of the law.

(2) Equality includes the full and equal enjoyment of all rights and freedoms. To promote the achievement of equality, legislative and other measures designed to protect or advance persons, or categories of persons, disadvantaged by unfair discrimination may be taken.

(3) The state may not unfairly discriminate directly or indirectly against anyone on one or more grounds, including race, gender, sex, pregnancy, marital status, ethnic or social origin, colour, sexual orientation, age, disability, religion, conscience, belief, culture, language and birth.

(4) No person may unfairly discriminate directly or indirectly against anyone on one or more grounds in terms of subsection (3). National legislation must be enacted to prevent or prohibit unfair discrimination.

(5) Discrimination on one or more of the grounds listed in subsection (3) is unfair unless it is established that the discrimination is fair.

4

HUMAN RIGHTS ADVOCACY

5

HUMAN RIGHTS ADVOCACY

Previous chapters introduced some of the mechanisms that can be used to seek redress and/or call attention to violations of women's human rights. This chapter provides an overview of human rights advocacy. It places the use of human rights mechanisms and other activities in the context of advocacy strategies and it examines the key components and characteristics of effective advocacy.

What is advocacy?

Advocacy is a political process designed to influence policy decisions at national and international levels. Advocacy is citizen-initiated and aimed at changing popular interests/needs/desires into definable policies, practices or even rights. Advocacy consists of actions designed to draw a community's attention to an issue and to direct policy-makers to a solution. It consists of political and legal activities that influence the shape and practice of laws or public policies. Successful advocacy often results in the recognition and greater respect of citizen rights.

Advocacy initiatives require organization, strategic thinking, information, communication, outreach and mobilization. Achieving a policy solution to a given issue means that advocates must:

- identify a clear issue, concern or problem that citizen action can play a role in resolving;

- investigate the nature and extent of the problem/concern;

- define a clear position and desired outcomes (e.g., articulate the entitlements or the rights desired and offer policy or legislative proposals, etc.);

- articulate the strategy (goals, target and actions to be taken);

- build alliances in support of the proposition;

- educate constituents, allies and the public about the issues; and

- lobby for the changes needed or litigate test cases to clarify the content of the rights or achieve the desired judgment.

There are many examples of advocacy in which an organization took the initiative to define a problem, propose a remedy and then draw in large numbers of people to support their position and lobby for the necessary changes. Consumer advocacy in many countries transformed people's concerns for product safety into sets of consumer rights to safe products, standards and

Examples of Women's Human Rights Advocacy

International-level advocacy strategies:
The worldwide initiative by women to add women's human rights to the agenda of the World Conference on Human Rights held in Vienna, Austria, in 1993.
The effort of human rights advocates to make human rights the framework for the entire Platform for Action adopted at the Fourth World Conference on Women in Beijing, China, in 1995.
Regional efforts to establish the Inter-American Convention on Violence Against Women.
Campaigns to expose rape as a war crime in Bosnia and Rwanda.
The campaign to compensate the "comfort women" who suffered systematic sexual abuse by the Japanese military during World War Two.
Elaboration of additional Protocols on Women to the African Charter.
National-level advocacy strategies:
Efforts in Ecuador, Peru and other Latin American countries to bring national laws into conformity with the new Inter-American Convention to eliminate violence against women.

enforcement mechanisms. Concern about the tragic deaths of people caused by auto drivers under the influence of alcohol sparked advocacy initiatives in several countries that changed the way the law, the police and the public view and deal with drunk drivers. The mobilization of communities to defend their land in the face of destructive practices by industry or government helped build the environmental movement and change ecological practices globally.

What is human rights advocacy?

Human rights advocacy and women's human rights advocacy use this same basic approach but their goals focus on human rights and their methods are framed by the human rights system. *Human rights advocacy* responds to citizen interest in transforming *formal* human rights into *genuine* and *effective* human rights. It uses constitutional guarantees and international norms, standards and mechanisms to hold governments accountable for their actions, to expand the core content of the guaranteed rights and to make the system itself more responsive and effective. In the same context, *women's human rights advocacy* aims to assure respect for and protection of

women's human rights and in particular to:

- *amplify the definition and understanding* of human rights to cover abuses of women that are not yet generally acknowledged as human rights violations;
- *expand the scope of state responsibility* for the protection of women's human rights in both the public and private spheres; and
- *enhance the effectiveness of the human rights system* at both national and international levels in enforcing women's rights and holding abusers accountable.

Within the framework of promoting and protecting women's human rights, advocacy initiatives vary widely because they are always grounded in particular circumstances, issues, opportunities and constraints. They tend, however, to focus on a few key targets within the human rights system at national, regional and international levels, particularly on:

- the laws and policies that define how women's human rights are interpreted;
- the institutions at national, regional and international levels charged with upholding these rights; and
- the attitudes and behaviors of officials and ordinary citizens (including

Making Formal Rights Real Rights

Type of Right		Advocacy goals:
Rights found in the general human rights instruments intended to apply to both men and women.		To assure that these apply to women consistently.
Rights found in specialized instruments, such as CEDAW intended to cover rights specific to women, (such as freedom from sex discrimination).		To assure that these rights be treated with the same seriousness as the general human rights.
Evolving rights (such as reproductive and sexual rights) that are not yet in any instrument.		To make explicit the identification, definition and protection of these rights.

women) about women's rights. One advocacy initiative may aim to ensure that governments and human rights bodies take women's human rights more seriously, while another may seek to bring violations to the attention of monitoring bodies, governments or human rights organizations with the political influence and credibility to take up or remedy the cause of the victims. Still another may aim to achieve a definite decision or action with regard to a specific case. Another yet may seek to bring state law into compliance with human rights standards by pushing for reform of national laws. Each of these initiatives, in one way or another, contributes to *expanding the scope of rights, holding states accountable for violations and assuring that abusers are punished and remedies provided.*

What makes human rights advocacy effective?

Successful human rights advocacy presupposes a dynamic interaction between the issues to be addressed and the skills of the organizers. Conceptual clarity on the issue, strategic thinking in the design of the strategy and patience, energy and drive in carrying it out are all needed for a successful advocacy endeavor. The following section examines some key characteristics of effective advocacy:

- strong organization and leadership,
- a compelling human rights issue,
- a clear analysis of the issue,
- a dynamic strategy,
- an appreciable constituency or support group,
- effective communication and education, and
- visible mobilization and action.

Strong organization and leadership

Organization and leadership are among the most critical elements in advocacy. An advocacy initiative only happens when someone makes it happen. Moreover, a complex advocacy strategy requires careful management of various elements, including information-gathering, communication, education and mobilization.

In the field of women's human rights, the people and groups best positioned to initiate and carry out advocacy strategies are those who know the women's human rights issues in their area, what the government has or has not done and

what women want. Often this is a local or national group; sometimes it is a regional or international group; sometimes it is a coalition of national and international groups collaborating to achieve a specific goal. Irrespective of the level, if the lead group is democratic, participatory, open to new ideas, flexible, and disciplined, it is even better positioned for the exacting work of advocacy.

Leadership inspires its own members as well as others to join in the process. Leadership knows how to build alliances, when to invite broader participation, when to seek expert input and obtain international support. It engages women and men to take the "right" kind of action at the "right" time in pursuit of the desired change. Initially, leadership provides the vision needed to frame the goals and recognize what needs to be done. In the course of the campaign, leadership contributes to the coordination, drive and continued inspiration required to press toward the achievement of the goal. Leadership with organizational capacity is thus the first pillar of advocacy.

A compelling human rights issue

The next characteristic of an effective strategy is a compelling human rights issue. That is, one that has a clear human rights content and a potentially positive impact on women. The starting point for this kind of advocacy is often the violation of a right, generally an act of gender-specific violence suffered by women or a law or practice that discriminates against women. Sex or gender-specific women's rights violations take place where the abuse constitutes a type of harm particular to the person's sex, such as rape, genital mutilation or pregnancy-related employment discrimination. There are also abuses that occur as the result of discrimination based on socially defined gender roles, as for

example, when women (but not men) are denied the freedom to choose whether, when and whom to marry.

Human rights issues can be identified through various means. Victims of abuse may seek help directly from advocates or advocates may learn through their own or other research about widespread violence against women or about laws that discriminate against women. Press or media reports disclosing abusive practices which can be connected with violations of women's human rights are also common sources.

Another source of information about abuses of women's human rights–or at least a point of reference for framing them–is the UN human rights system itself. The limitations and challenges to women's human rights emanating from official intergovernmental pronouncements, such as the Vienna Declaration, resolutions passed at CEDAW, CSW and the Commission on Human Rights, among others, offers fruitful ground for identifying issues suitable for advocacy. As explained in Chapter One, the dynamics of human rights are such that gaining consensus about the meaning of a right is an on-going process and often needs the extra push of advocacy to mature. Also, if governments, or even the UN are not in the habit of regarding women's human rights as authentic human rights–and therefore are failing to fulfill their obligations to protect all human rights–they also need the nudge of advocacy to become more consistent and responsible.

Whatever the nature or source of the advocacy issue, another consideration is the impact the issue will have on women and the community. Finding an issue that inspires people to active interest and commitment to action is also important. The "comfort women" advocacy issue, for example, (see case study on page 130) is powerful and engaging because of the number of abused women who might

directly benefit from a legal resolution, but also because of the way in which it has engaged various communities in Asia and the rest of the world. The "citizenship" issue (see case study on page 133) served a similar function in Africa because of the number of women affected and because of its relevance to women in many other parts of the continent and the world. Because of the blatant brutality embedded in the comfort women case and the unfairness in the citizenship case, these issues have the capacity to touch the sensibilities of people, helping them to reflect on and internalize the underlying human rights values and principles involved, thus consolidating a legal and personal culture of respect for human rights. The establishment or enforcement of legal principles that will make it more difficult for the same type of abuse to recur is one likely outcome of these efforts. A change in attitude about the status of women is another. The issue itself, thus, has potential impact on the women who were victims but also on human rights and on society as a whole.

Clear analysis of the issue

In addition to a compelling issue, effective advocacy presupposes a strong human rights "case," clearly defined, documented and analyzed. Three elements go into building a strategic human rights case:
- showing that a right exists,
- proving that a violation of the right occurred, and
- demonstrating that the state was responsible for the violation.

Due to the fact that considerable ambiguity about women's rights still exists, arguing the existence of a right is not always simple. As noted above, major aspects of women's lives, such as reproductive and sexual freedom, are not yet fully recognized as being crucial to women's human dignity and therefore do not receive full protection as human rights. Demonstrating state responsibility for a violation when the perpetrator of the violation is a private actor and not a direct agent of the state poses another challenge due to the same underdevelopment of human rights with regard to women and the fact that women routinely suffer abuse at the hands of non-state actors.

Confronting state impunity and inertia with regard to women's human rights and the place of women's human rights within religious or customary legal regimes likewise looms as a formidable task.

Fact-finding and analysis with regard to women's human rights contribute to overcoming conceptual problems in these areas. By revealing the link between women's day-to-day experience and human rights regimes at national, regional and international levels, investigation and documentation can contribute to expanding advocates' and governments' understanding of human rights as they apply to women. This process involves not only field research by women's human rights activists, but also academic inquiry and research. Publishing articles in scholarly journals or disseminating reports meant for broad consumption both have their place. Such efforts articulate perspectives that can influence the development of human rights law in favor of women's human rights and help assure that the treatment of women is consistent with international human rights standards.

Research and fact-finding around specific human rights abuses can thus serve an essential purpose in building a powerful case. Moreover, they can foster the development of human rights as a whole by clarifying and exposing inadequacies in the human rights system with respect to women.*

*Fact-finding is so important to the advocacy process that Chapter Six of this manual is dedicated entirely to data gathering, investigating and documenting violations of women's human rights.

Critical Components of the Advocacy Process in Action

PROGRESS TOWARD GOAL
Achievement of Objectives

COMMUNICATION & EDUCATION
Message reaches public
Message reaches policy makers
Necessary training and
skills obtained
Political alliances formed

MOBILIZATION & ACTION
Plan Implemented
Legal and political action undertaken
Interested and affected groups take
action to secure change
Process monitored/evaluated

STRATEGY
Clear Objectives & Demands
Activities Organized
Plan of action and schedule

KNOWLEDGE OF THE ISSUE
Clarity about the human rights violation
Analysis of the political and legal context
Cases articulated
Remedy selected
Strategy designed

LEADERSHIP & ORGANIZATION
Ability to identify & initiate advocacy effort
Ability to inspire and attract interest
Ability to manage process
Ability to mobilize support

A dynamic strategy

In addition to a compelling human rights issue and a strong human rights case, an effective advocacy initiative has a dynamic advocacy *strategy* based on a clear set of goals and objectives. The architects of effective strategies know what they want to achieve and what they have to do to get there. Effective advocates for women's human rights understand the remedies and the mechanisms offered by the human rights system at the local, as well as regional and international levels. They evaluate and select the most appropriate approach available, given the nature of the issue, the behavior of the state, and other relevant local circumstances. The advocacy groups with the most clarity on the issues involved and the possible actions that can be taken will be in the best position to be successful in their endeavors.

There are three parts of the advocacy plan that need to be in place: 1) goals and objectives, outlining what will be achieved; 2) a strategy design, outlining the type of actions to be carried out; and 3) a plan of action, defining the structure and sequence of activities, when they will be carried out and by whom.

Goals and objectives

The nature of the violation identified, the context of the abuse and the availability of remedies will shape the objectives and demands of the advocacy process. The objectives define what the advocacy strategy proposes to achieve, what its desired outcome will look like and what it will accept as "victory." Broad, generalized or abstract goals may provide worthy ideals, but do not necessarily translate into the concrete tactics necessary for a successful advocacy campaign.

While the goals of all advocacy efforts relate to expanding the scope of recognized rights, asserting state responsibility for violations of women's human rights and/or seeking remedies for individual violations, for a given initiative objectives must be concrete and specific. For example:

- If it is a gender-specific abuse directed against a woman or group of women, obtaining a legal remedy to stop the violation, punish the violators or compensate the women may be an appropriate objective.

- If the violation is the result of the application of a discriminatory law or

Some Human Rights Advocacy Strategies

Objectives to be Achieved	Legal Strategies	Political Strategies
Recognition of women's rights as human rights	Bring case on specific issue(s) to establish right(s) in domestic courts and ultimately to an international tribunal. Collect evidence and send it to an international monitoring body.	Awareness-raising campaigns, e.g. media campaigns, legal literacy programs. Letter-writing campaigns.
Stopping widespread and systematic violations of women's human rights	Identify victims and file cases in court. Prepare a "shadow report" and send it to any international body to which the offending government already sends periodic official reports. Send the shadow report to any domestic administrative human rights body.	Advocate for law reform, if existing laws are inadequate. Advocate for the passing of relevant legislation if none exists. Conduct investigations, write a report and send it to international NGOs so they may also pressure the government to take action.
Protection of individual rights	File a case in court for a remedy to stop the violation.	Raise public awareness about the case. Lobby parliamentarians.
Protection of women's human rights in emergency situations	File a case in court and apply for interlocutory measures to stop continued violation. Use emergency procedure to access international forum.	Publicize the situation using media campaigns, solidarity campaigns and alerts.

customary practice, or of the absence of a law which is needed to defend women's human rights, then a possible objective may be to seek legal reform or the passage of a new law to improve women's rights.

- If the violation is system-wide and government assistance is unlikely, then the appropriate objective may be

simply to raise public awareness about the issue or to report it to inter- or non-governmental organizations, which may be able to influence the government in question to take action to improve women's rights.

Effective advocacy presupposes that objectives be defined in *very clear and manageable terms* at the start. For

example, in the "comfort women" initiative, the overarching goals of "holding the government accountable for its actions" was translated into an unambiguous requirement that the government pay compensation to each of the survivors, and a demand to include in Japanese school text books the history of the sexual enslavement of women by the military during World War II. This is certainly more powerful than a vague goal of "raising awareness" about the issue. Goals and objectives that are defined in both short and long-term timeframes are also useful. The final outcome sought by the group may be the culmination of a series of small victories. Getting the government of Japan to pay compensation to the comfort women, for example, cannot happen without a long string of victories, including non-binding recommendations by various human rights entities, a strong support group formed in Japan and other countries in Asia and the world, etc. Each of these victories represents a worthy interim objective.

Targeted objectives answer clearly such questions as: Is the government being asked to reform a particular law? Is it being asked to stop specific actions constituting a violation of women's human rights? Is it being asked to ratify a treaty guaranteeing women's human rights? In an effective strategy, specific objectives and demands are understood by everyone involved.

Dynamic advocacy allows for growth and refinement of objectives as the process develops. Initial objectives are usually based on good hunches but incomplete information. They allow the process to move forward, but objectives and targets often change or become more specific as the plan unfolds. Additional data-gathering and documentation help refine the understanding of the chosen human rights issue and the legal and political context in which the advocacy

strategy will be carried out. As the research process deepens the analysis and understanding of the violations, objectives may need to be modified to assure that the strategy has maximum impact.

A strategy design
The second part of the strategic plan defines the political and legal actions that participants will undertake to achieve the objectives of the advocacy initiative. Women's human rights advocacy is essentially a political process because it seeks to influence policy decisions and conduct in favor of women's human rights. Yet, because it rests on the bedrock of national and international human rights law and enforcement mechanisms, human rights advocacy work often includes legal action. To achieve their objectives, advocacy strategies combine legal action, which directly engages the law, and political action, which mobilizes constituencies to pressure governments or institutions for change in both law and practice.

Recognizing the distinction between legal and political action is useful conceptually for planning and organizing purposes. However, human rights advocacy is hardly ever purely legal or purely political. The most effective strategies combine political action with legal action. The previous chapters detailed some of the judicial actions that advocates can initiate in favor of women's human rights, such as: bringing a test case to court (litigation); filing a complaint with a regional or UN human rights mechanism; or establishing a state's accountability for a violation of a specific human right which it is legally bound to uphold. Taking a government to court or submitting a complaint to an international body (legal actions) exert pressure and publicize a given issue (political actions). Lobbying, legislative advocacy and monitoring, the most directly political part of advocacy, are often essential

to the success of the more legally oriented advocacy efforts. The dynamic character of international law, and the fact that its remedies are fragile at best, requires human rights advocacy to include sustained political pressure. On the other hand, political pressure absent the weight of human rights law has less effect on governments than political pressure that invokes legal standards.

Ultimately, legal and political actions are mutually reinforcing and work together to shape more equitable policies, standards and attitudes and assure that governments and citizens comply with international human rights law. In the last analysis, effective strategies have a ratio between political and legal action that is appropriate to the nature of the issues, the political situation in the country and the human and material resources available to the group. In addition to reflecting the necessary balance between legal and political activities, the selection of activities is also based on efficiency and other criteria to be developed by the group. These criteria include, for example:

- Activities that are efficient and cost effective, .i.e., that have a high results ratio for the effort involved.

- Actions that will best enable the involvement of all or most of the participants.

- Activities that will best publicize the issue and demands involved.

- A sequence best suited to achieving short-term and long-term goals.

A plan of action

The plan of action consists of *the type and sequence of steps necessary to be undertaken* given the activities that have been identified as essential to achieving the initiative's objectives and goals. Building on the strategy design, the plan of action simply spells out what will be done, when and by whom and criteria by which to measure progress. The plan also corre-

sponds to the short- and long-term goals of the advocacy effort.

An essential part of the plan defines how the work will be divided and who will take the lead on which activity. A clear division of roles and responsibilities among the participants is essential in order to prevent contradiction and confusion in the message being put across and to maximize efficiency and effect. When each participating organization or individual takes charge of a specific aspect of the strategy, it ensures that all aspects will be covered and that different skills/expertise will be used appropriately.

Maximum sharing of information among participants (about the strategy's progress, problems, need for further information, etc.) will empower all participants to execute their roles effectively as the strategy unfolds. Therefore, participants should understand and agree on the coordination of roles and activities and on how information is to be shared.

Finally, a plan should include evaluative criteria and a plan for evaluation. The plan should spell out:

- How achievements will be measured.

- How the lessons learned will be used.

- How the analysis of what works and what does not will be incorporated into the ongoing planning.

- How the advocacy process will be tracked and documented.

- The means that will be used to evaluate and monitor the effort in the interim and at the end of the process.

Effective advocacy requires a well thought out, strategic plan that is focused and targeted, but also flexible. Such a plan is the product of good organization and leadership.

An appreciable constituency or support group

The next element to be considered in an effective advocacy initiative is partici-

pation and support. Indeed, success in advocacy depends on popular support. This is particularly true in women's human rights advocacy. Women are at such a disadvantage in most societies that it requires the strength of numbers to make an impact on governments and other human rights actors.

Law-making bodies, government agents (including judges) and international agencies whose decisions affect women's rights respond to political pressure. If no one pushes them, the inertia of the status quo will rule the day. The effectiveness of an advocacy initiative will depend on the number and range of people involved and how they target their efforts.

All effective advocacy strategies include outreach or constituency-building activities. The advocacy issue itself often points to potential participants. Those already working on the issue or whose work might be significantly affected by the success or failure of the advocacy effort are potential participants and activists.

All women are affected by discrimination, violence and other forms of human rights abuse and they all can play a role in advocacy at the different levels of state power. Women, like other disadvantaged groups, can and will fight to end their own oppression when they recognize it and when they feel there is a clear solution or possibility of change. In addition, there are men who would like to promote social justice across gender divisions and be involved in advocacy to promote women's human rights. In short, anyone concerned about justice can be involved in advocacy.

The sooner such people are invited to join the effort, the more of a stake in the effort they will have and the more important they will become to it. Of course, not everyone will participate at the same level. Besides those who will cooperate actively in the organization and imple-mentation of the strategy, there are individuals who will form opinions and support the initiative in less perceptible ways on a daily basis. They also form part of the support group or stake-holders.

The stronger and more vocal the support group, the better poised the advocacy strategy will be for success. An organized, diverse and articulate constituency, exerting influence on decision makers is a powerful engine for change in favor of women's human rights. When entire communities join women in mobilizing to demand their rights, their voices cannot be ignored.

Effective communication and education

The next characteristic of an effective strategy is a strong communication and public education program, a necessary condition for building citizen support for the advocacy initiative. People cannot support a cause if they don't know about it. Organizations with effective advocacy strategies understand the power of communication and public education and know how to use the media well.

In most countries, few people or organizations have experience working on issues of women's human rights. National laws remain discriminatory or silent on many aspects of women's human rights. Customary and religious laws, where applicable, often reinforce the systems that violate women's human rights. Under these circumstances, consciousness-raising, education, training and media strategies are important tools for developing a constituency of individuals committed to respecting women's human rights.

Public education and media

For affecting public opinion, nothing equals positive media coverage as a tool for publicizing the issue, getting the message out and influencing policy makers and the general public. Public opinion, educated by media reports, can

Working with the Media: Building a Strategy

"Think about media coverage as a water faucet. When the systems are turned on, water pours through the faucet. When the systems are turned off or left dormant, the water stops.... Likewise, if an organization aggressively works at getting news coverage...then good press coverage will become routine. Waiting passively for the media to call you may mean that your group stays invisible to the outside world. If the leaders of your group decide media coverage is a top priority, they must be prepared to allocate resources accordingly."

(from Strategic Media: Designing a Public Interest Campaign (Communications Consortium Media Center, 1994)

be powerful in swaying states to redress internal violations of women's human rights.

Media strategies can range in sophistication from minimal (e.g. one or two press conferences advertising the launch and the successful conclusion of an advocacy effort) to full-blown campaigns that include an in-house media relations office and ongoing relationships with national and international media contacts. Those groups that use media effectively have several practices in common.

- Early in the project, they decide where media coverage fits into the overall priorities of the advocacy effort. Media planning is thus incorporated into the initial blueprint for the project. This approach helps prevent tensions later over the use of valuable time and resources.

- The organization's top leaders and spokespersons get involved early in the process and are responsible for planning media coverage.

- Public opinion is periodically measured and tracked. Different approaches are used to change public opinion on the issue and to mobilize the people who already support the issue. Polling data can be enormously helpful in illuminating where the public stands on the issue. In many countries, polling sources are available to the public for little or no money.

- Past press coverage is charted. Reviewing previous press coverage of the issue, if any, helps assess how it might have been more accurate, who was quoted and what arguments were put forth by representatives from all sides of the issue.

- Creativity among people involved in the advocacy initiative is encouraged. By brainstorming strategies for achieving the best possible press coverage and how issues should be presented to reporters, results can be visualized and tracked over time.

- The message is periodically reviewed, revised, repeated. The media strategy is systematically evaluated throughout the advocacy campaign and revised as needed.

Education and training

Not all awareness-raising and educational goals associated with an advocacy initiative can be achieved through the media. A variety of educational activities are needed to reach specific individuals who have the capacity to play important roles in the success or failure of the effort and who may become either allies or opponents.

Most individuals interested in promoting greater respect for women's human rights need assistance in understanding how human rights systems work. Because of their long exclusion from the

127

human rights field, women's rights activists particularly require training. Police, judges and lawyers are also prime targets for training since their concepts of human rights are often biased or incomplete when it comes to women. People working with human rights bodies at all levels need training to build their capacity to protect women's human rights, as do human rights activists working in national or international human rights organizations that do not routinely address the rights of women.

In providing more in-depth training to judges, law enforcement agents, journalists, other NGOs, etc., effective advocates know that exposure to new thematic areas might make the critical difference in winning them over. Key themes, in addition to the specific content of a given advocacy initiative, include:

- The concept of human rights and the place of women's human rights in the human rights system and movement;

- How to investigate and document violations of women's human rights;

- How to push for legal reform aimed at bringing national laws in line with international human rights standards; and

- How to access and use to the best advantage national, regional and international human rights enforcement mechanisms.

Empowering women through advocacy
Training can be very limited if approached only as a technical exercise to help women understand the human rights system. What is also needed is an educational process that fosters a deeper

understanding of women's status as expressed in law and practice and the development of women's capacity to take action for change. Rights education in the context of advocacy should be aimed at facilitating the involvement of more women in exercising their human rights and demanding accountability for violations of those rights.

In the context of creating and defending rights, education plays an important role. Through empowering rights education the structures of the system can be exposed, challenged and pressed to be responsive to gender issues. In the final analysis, it is not changing the law or getting the favorable judgment that defines the value of women's human rights advocacy, it is the process by which women not only activate the rights they do have, but also redefine and reshape inadequate laws and human rights standards and ensure their full and fair application. Rights education in this context is about helping women to use the law, rights and the human rights system as a political resource to gain the power needed to effect change.*

Visible mobilization and action
The final element in an effective advocacy strategy is its capacity to mobilize groups and individuals to take action in support of the desired change. Successful advocacy has both depth and breadth among it supporters. In addition to counting on expertise to build the case in legal terms, shape arguments, draft legislative proposals, document and verify abuse, etc., effective advocacy counts on ordinary people to stand up and defend or promote the issue from their own experience and perspective. Mobilization

*It is beyond the scope of this book to explore rights education in depth. See, Schuler, Margaret., and S. Kadirgama-Rajasingham (eds.) *Legal Literacy: A Tool for Women's Empowerment* for a fuller exploration of the methodology of rights education as empowerment. See also, Mertus, Julie, with Mallika Dutt, and Nancy Flowers, *Local Action/ Global Change: Learning About the Human Rights of Women and Girls* (New York: United Nations/ UNIFEM, forthcoming 1997) for a specific examination of how women can develop an understanding of their human rights.

5

activities that call on supporters for different inputs might include:

- Meetings with decision-makers and other persons who have influence over the violators;
- Meetings with the violators themselves;
- Media interviews to publicize the issue;
- Public hearings in which victims of the human rights violation narrate their experiences;
- Public meetings rallying the communities of the victims;
- Parliamentary hearings considering the merits of a law reform initiative;
- Court testimony;
- Turnout at the electoral polls;
- Petitions calling for specific reforms;
- Boycotts;
- Protest marches to highlight and oppose abusive practices;
- Letter-writing or email campaigns targeting officials responsible for abuse

The final test of advocacy is measured by the effective support it can muster.

In sum, advocacy is a powerful tool in the hands of citizens and particularly of non-governmental organizations. History shows us that the mechanism pushing forward the human rights process–from the articulation of basic human rights to their consistent application–has been the organized groups around the world willing to press for the definition of new or unrecognized rights and to hold governments and the human rights system itself to account. There is a current trend among some governments to view NGO's as obstructionist in the process. There is also a move to limit access of NGO's to the human rights system. It is essential, therefore, for women's rights advocacy groups to become proficient in human rights advocacy and to be astute and intelligent strategists. Much is riding on their success.

Women victims of wartime rape in the Philippines: The Malaya Lolas

By Lourdes Indai Sajor

The Issue

It was in 1991 that we first heard about the comfort women. Women's organizations in Korea had shocked the world with revelations that women from Korea, Philippines and other Asian countries had been victims of sexual slavery by the Japanese Imperial Army during World War II. Understanding that rape in war is a war crime and a crime against humanity, that the issue of the "comfort women" had long been buried in the hearts and minds of the victims, and that the Philippines was one of the countries victimized by Japan's military aggression during WWII, we decided to look for women survivors in the Philippines.

Considering that most of these women were of advanced age, we decided to use the radio to look for survivors, encouraging them to come and tell us their stories. After the first interviews with survivors of wartime rape, we recognized that these rapes exemplified the historical phenomenon of rapes perpetrated with impunity on a massive scale against women during armed conflicts. When the first Filipino comfort women came forward we knew that we had a powerful issue and that we had to start a campaign for justice.

Research on the Human Rights Issue

A major part of the research work involved documenting the cases of the victims, most of them already in advanced years. Since the violations occurred fifty years ago, corroborating evidence was hard to find except for the fact that some former military garrisons and comfort stations still exist and the elder people in their communities testified to their existence. The research involved identifying the circumstances of each of the former comfort women and calling upon the women themselves, their families and their communities to tell their stories. It also involved documenting or verifying each case through war documents, most of which were uncovered by support groups and scholars in Japan. The research in Japan greatly strengthened the value of the research in the Philippines, because it provided access to war documents detailing the existence and rules governing the comfort stations inside the military garrisons. Using interviews, public forums, speak-outs, press conferences, radio and TV interviews we sought to highlight the issue of wartime rape and to demand justice and accountability from the Japanese government. The lawyers we consulted briefed us on the statutory limitations for rape cases in our country and in Japan and on relevant international humanitarian law, specifically, the convention on wartime rape. We also studied our international capabilities to sustain the campaign and the strength of the solidarity work in Japan among the support groups.

Objectives and Demands

Assessing the impact of the campaign and the research and documentation of the issue, we decided to target specific demands to the government of Japan:
- a sincere apology from the Prime Minister,
- recognition of the war crime,
- direct compensation from the

Japanese government to the victims
and

- adding the issue of comfort women
 to the school curriculum.

The Strategy

Over time, the campaign developed
into a movement for justice for victims
of war, which also came to include
forced laborers and victims of torture,
massacre, racism and genocide. Due to
this momentum, the demand for
compensation became a pivotal issue.
We decided as part of our strategy to
file a case in the Tokyo District Court.
A panel of lawyers was formed in Japan
with assistance from the support groups
in Japan. A court case was selected in
order to legitimize the struggle of the
survivors and more importantly to
educate a new generation to recognize
the military rape of women as a grave
violation of human rights.

Later in the process, it was decided
to bring the issue to the international
level at the Human Rights Commission
in Geneva, where we demanded an
investigation and resolution through an
apology from the Prime Minister of
Japan and direct legal compensation
and recognition of the war crimes.
Cases of the former comfort women
were also brought to the Permanent
Court of Arbitration (PCA) in The
Hague in order to keep up the pressure
on the Japanese government to
compensate the victims and officially
recognize the war crimes.

Considering the magnitude of the
work, we needed to constantly fine
tune our working relations and
advocacy work. The lawyers' groups in
the Philippines took up the documenta-
tion to assist the Japanese lawyers in
filing the lawsuit in Japan. At the local
level, the strategy would rely on
pickets, rallies, symposia and fora initi-
ated on all fronts from different

victimized countries. Local women's
organizations would picket the Japanese
embassy in Manila. Regional women's
human rights networks would take up
the issue on the international level by
lobbying continuously at the UN
Commission on Human Rights and
other UN bodies. A solidarity meeting
in Japan helped to consolidate the
efforts initiated by different sectors of
Japanese society.

Public Education and Support

Appreciating the gravity of the issue of
wartime rape and military sexual
violence, the women's movement in
the Philippines took up the issue with
great sympathy. Initially, we organized a
meeting of women's organizations in
the country to discuss how we could
assist in documenting the cases of
former comfort women and speak out
in various forms on the issue. A series
of meetings gave momentum to our
campaign as the numbers of supporters
grew. Also, it strengthened the resolve
of the survivors, who could see for
themselves the growing numbers of
women supporting them. Interest
groups in other sectors, most especially
the mainstream human rights organiza-
tions, also showed support.

Due to an outpouring of support for
the victims in the Philippines and
other parts of Asia, individuals and
human rights groups in Japan also
started to organize in support of the
former victims and their quest for
justice. A Japanese solidarity commit-
tee formed as a result of these
spontaneous reactions among progres-
sive sectors in Japan.

On a regional level we convened a
conference of organizations throughout
Asia which were advocating on the
comfort women issue, to discuss and
coordinate our strategies in demanding
compensation from the government of

Japan. We also had forums to share the stories of former comfort women from victimized countries like Korea, China, Philippines, Taiwan, Indonesia and Malaysia.

Financing the Campaign

Because of the demands of the campaign and the movement, a campaign fund was initiated by advocates' organizations, including the support groups in Japan whose commitment to the issue continued. The need for resources continues today, not only for the campaign initiatives but more importantly for medical and health assistance for the former comfort women.

Mobilization and Action

With women's organizations and support groups in many countries actively advocating for the victims of wartime rape, we developed a broad, loose coalition. When our demands were clear, we launched our initiative with a press conference to take advantage of the wide support and to increase our visibility and exposure of the violence done against women in war time. The press launch also gave a base to the issue, which was already beginning to receive a lot of media play. Women's organizations also expanded the issue to including modern-day sexual slavery in the form of trafficking in women.

The Philippine government at first responded with great interest and a congressional and senate hearing transpired on the issue. We brought the comfort women to testify during the hearing in order to elucidate the issue. A presidential resolution was issued to the relevant ministries, such as the Ministries of Justice, Foreign Affairs and Health and the Commission on Human Rights, ordering them to assist in the investigation and documentation.

Although the case was well received by the public in Japan, by the time a lawsuit was filed at the Tokyo district court with former comfort women as the plaintiffs, some rightist groups started to question the existence of comfort women, saying that they were paid prostitutes. These false assertions angered women's organizations, and new strategies for combating the allegations were launched by the victims themselves. A case was filed by the former comfort women before the Japan Federation of Bar Associations against the Diet members who had uttered these vicious accusations, charging them with grave slander and malicious intent.

Assessment of Results

New twists to the issue continue to unfold, but the successful exposure of these women's human rights violations is undeniable. Monitoring the strategy became a very important factor in the development of the issue. New issues have emerged as the government of Japan, although forced to formally acknowledge the war crimes, still continues to evade responsibility for it. The government started a new scheme to give women some kind of moral damages reparation, but this move has been rejected by a majority of the comfort women as they continue to demand official recognition of rape in wartime as a war crime and crime against humanity and a violation of international human rights law. Thus, the legacy of the former comfort women and women victims of wartime rape continues to unfold.

5

Discriminatory citizenship laws in Botswana: Emang Basadi

By Athaliah Molokomme

The Issue

In 1986, a number of women's rights activists in Botswana were concerned about the existence of laws and customs which directly and indirectly discriminated against women. Because none of the existing organizations at the time addressed these issues, and did not seem prepared to do so, these women decided to establish an organization which would do so. Emang Basadi Women's Association was therefore established and legally registered, with the aim, among others, of working towards the removal of all laws which discriminated against women in Botswana. The issue of the Citizenship Act, which denied women the right to pass their Botswana nationality to their children and foreign husbands, was chosen because it was one of the most glaring examples of discrimination against women.

Research on the Issue

The members of Emang Basadi recognized that in order for our strategy to succeed, we needed to know more about the background of the Act, the official justification for the relevant provisions, the arguments for and against it, and the women who were affected by it. Research on the background, official justification and precise implications of the Act was carried out by individual members. This research revealed that the Act was officially justified by reference to the location of Botswana at the center of Southern Africa, where it is surrounded by hostile and racist neighbors and is

faced with an influx of refugees.

We also found out that there was official concern about the seeming ease with which foreigners could obtain Botswana citizenship, and the implications of allowing dual citizenship to Botswana's citizens. The government also argued that there was a universal move away from citizenship by birth towards citizenship by descent, which led us to research the legal provisions addressing this question in other countries in the region, the commonwealth and internationally. Some of these provisions were recommended as solutions to Botswana's problems at various national and international fora.

Research on the precise numbers of women in Botswana who were affected by the Act was difficult to pursue due to a shortage of time and resources, although it was crucial for the success of our strategy. The prevailing view was that the Act affected only a small minority of elite urban woman who were married to foreigners. We were keen to show that this was not the case, and that ordinary rural women on Botswana's borders were the most affected.

Another organization, Women and Law in Southern Africa, came forward to assist us with research. They identified a number of ordinary women living along Botswana's borders who were affected by the Act. Their profiles were published in the press; this went some way toward demonstrating to the public that the problem was real.

Objectives and Demands

Having researched the issue, we decided that the immediate remedy or solution would be to amend the Act. Because the citizenship issue was politically sensitive, it was decided that the

initial objective would be to make the public, especially women, aware of the discriminatory provisions of the Act and its violation of the rights of women and children. In 1986, it was decided to make a submission to the Parliamentary Law Reform Committee detailing the history of the Act, pointing to its discriminatory provisions and recommending a number of options for its reform. By 1988, the citizenship issue had become well publicized and a heated debate was underway in official circles, the press and nationally, with most people taking a position against women's right to pass on their Botswana citizenship to their children. It was at this time that the idea of a test case to challenge the constitutionality of the Citizenship Act was first considered, but not pursued.

The Strategy

Emang Basadi initially decided on a lobbying and information dissemination strategy to bring to the attention of lawmakers the fact that the Act violated women's human rights. In June 1990, a Botswana women lawyer named Unity Dow, who is married to an American citizen, decided to pursue the test case strategy. She brought litigation before the High Court challenging the constitutionality of the Citizenship Act on the basis that it discriminated against her by denying her the right to pass on her Botswana citizenship to her children(a right which is granted to male Botswana citizens).

At this point, the strategy had to change somewhat since the test case was taken on by an individual woman, and no collective decisions were made about who was responsible for what aspects of the overall strategy. This led to some confusion and contradictions in the women's movement about

whether this was an individual case or a collective one. Once it became clear that this was an individual case, Emang Basadi and other organizations decided to play a supportive role The understanding was that a win by Unity Dow would be a win for all women and their human rights. Thus, the strategy evolved to include:

- a court case,
- lobbying lawmakers to amend the Citizenship Act, and
- concerted public education and media coverage.

Public Education and Support

The initial participants were the women who started the organization, with the intention of involving others once the issue became better understood and publicized. As time went on, consultations were held with other women's organizations and the issue was explained to them in a manner which would make them understand that it violated the human rights of all women, not only those married to foreigners. Emang Basadi also kept the issue on the national, and later international, agenda by writing to the press, publishing in academic journals and conducting workshops on this issue and on other laws which discriminate against women. Public mobilization took many forms, from attending court sessions and press conferences, printing bumper stickers and wearing T-shirts with supportive messages.

Financing the Initiative

From the beginning of the Emang Basadi campaign, the organization lacked the human and financial resources to conduct a consistent campaign, apart from sporadic grants to run workshops on women's legal rights generally. Members contributed their

5

spare time and financial resources to hold meetings and other activities.

During the test case, Unity Dow secured the assistance of Women and Law in Southern Africa to raise funds for the case from the Swedish Agency for International Development (SIDA). She also obtained the assistance of international organizations such as International Women's Rights Action Watch (IWRAW) and the Urban Morgan Institute of Human Rights to find required precedents for the court case.

Mobilization Action

Unity Dow was successful in her case against the government, with the High Court deciding that the relevant provision of the Citizenship Act discriminated against women and violated the constitution of Botswana. The court also relied on a number of international instruments which Dow had invoked, even though Botswana was not signatory to them. The judges pointed out that they were entitled to take judicial notice for these as Botswana is a member of the community of nations through the UN. They also relied on the African Charter on Human and People's Rights, to which Botswana is a signatory.

The government appealed this decision to the final court of appeal, which dismissed the appeal partly based on the same international standards. The government's response was to ignore the court's decision. There were rumors that the issue would be put to a referendum.

Emang Basadi, Women and Law in Southern Africa and a newly formed NGO Network for Women's Rights took the lead in convening a well-attended public press conference at the city hall in the capital. They called together other human rights organiza-

tions and the national and international press to inform them of the implications of a referendum.

The objective was to bring national and international attention to the issue and put pressure on the Botswana government to abandon the idea of a referendum. The response to this campaign from national, regional and international organizations was positive and supportive, with a number of organizations appealing directly to the Botswana government on the issue.

The organizations also wrote to Botswana government officials demanding that they come out in the open about their intentions, and pointing out that should a referendum be held, it would be a negation of the concept of the rule of law and judicial independence. The government responded by saying that they did not respond to rumors.

Pressure was maintained, and the advocacy organizations seized every opportunity to lobby lawmakers directly on the issue and keep the regional and international community informed.

Outcome and Results

The preparations for the international women's conference in Beijing provided an excellent opportunity to step up pressure on the government. Just before the Beijing conference, the Citizenship Amendment Act was passed with provisions complying with the court decision and enacting gender-neutral provisions going even beyond the requirements of the court decision.

INVESTIGATING VIOLATIONS

6

Previous chapters explored various strategies for promoting and protecting women's human rights. All strategies—from the submission of complaints before national, regional and international human rights mechanisms to legal reform initiatives and public education campaigns—have a role and may be preferable depending on the issue, political environment and goals to be achieved. However, irrespective of the objectives sought or the strategy selected, accurate information on the human rights abuse in question will always be necessary. If an advocacy strategy is to be effective, certain basic steps must be taken to investigate and document the violations on which it is built.

In documenting abuse, it is very important that the information gathered and presented be accurate, valid, reliable and, to the extent possible, timely. As in any research project, challenges to the worthiness of the research can call its conclusions into question. In an academic setting, the damage caused by sloppy research may have significant consequences for the scholar. In the context of human rights activism, challenges to the accuracy of the research can undermine the entire advocacy effort.

Documentation can take various forms. Evidence may be written or printed, oral or audiovisual. In addition, types of documentation may vary, ranging from individual testimony to statistical evidence to other secondary research. Advocates need to determine the form and type of documentation necessary to pursue their campaign objectives.

This chapter presents a step-by-step guide for planning a women's human rights investigation and a methodology for documenting abuses. It suggests how to build arguments and demonstrate state responsibility for women's human rights abuses. Finally, it suggests steps for presenting the findings, evaluating potential solutions and incorporating the information into the overall advocacy strategy.

Why investigate and document

There are many reasons why thorough investigation and documentation is important for women's human rights. Here are just a few:

To expose abuse

Most women's human rights violations are hidden or actively ignored. Exposing the types of human rights abuse that women suffer, and doing so in reliable detail, can shatter the myth that such abuse does not occur or that it does not constitute abuse. This effort can be an important public education tool and also can provide a powerful basis for legal and political advocacy.

To seek accountability

Documenting women's human rights abuses helps pressure states and human rights bodies to protect women's human rights. Such pressure can embarrass recalcitrant states and compel them to stop or reduce violations. Such publicity may also influence local and international allies to support the advocacy effort and/or the victim(s) of the abuse. Moreover, all human rights mechanisms require a certain minimum of detail regarding an allegation of abuse before it is ruled admissible. (Chapters Three and Four indicate some of these requirements.)

To secure a remedy

Exposing women's human rights abuses demonstrates the need to remedy them. In addition, documenting human rights abuses can obligate governments to implement clear legal and other remedies. Detailed documentation can help in the development of these remedies and ensure that they respond to the exact nature of the problem.

To plan an effective advocacy strategy

Human rights activism is most effective when driven by indisputable evidence of abuse. Successful advocacy thus depends, in no small part, on advocates' being fully informed about the violations they denounce, the government obligations they assert and the remedies they demand. Investigation and documentation also can reveal patterns of abuse if they exist.

Step-by-step guide for investigating and documenting violations of women's human rights

The steps below are meant to guide advocates in planning and conducting investigations and/or documentation of women's human rights abuses. Although the steps are presented in a logical sequence, advocates may want to adapt the process to suit their particular circumstances. The steps are presented under three broad headings: steps to be taken before the investigation, steps during the investigation and steps subsequent to the investigation.

1 *Preparation*

Preparation Step 1:
Set investigation objectives
Before setting out on any effort to document abuses of women's human rights, the investigation's main objectives need to be identified. Although these objectives will change as the effort unfolds, it is wise to begin with a clear sense of the issue under investigation, why it is being investigated, what the investigation aims to accomplish and what advocacy strategies might ensue from the investigation's findings.

In setting objectives, it is useful to keep two things in mind:

- **Focus:** The objective of a given investigation or related advocacy effort may be very general or very specific. That is, one might seek to document and remedy the abuse of an individual woman or one might set out to assess a given country's overall women's human rights record. It perhaps goes without saying that a narrower objective is easier to achieve and also can bring attention to much broader issues. Thus, for example, a group may choose to investigate only one case of sexual abuse in prison in order to highlight the more general issue of custodial abuse. Another might focus on the specific issue of discrimination against pregnant women workers to raise the problem of women's reproductive rights more generally. Sometimes however, a narrow focus is neither possible nor desirable. Just keep in mind that the broader the objective, the more expansive the investigation will have to be, which will affect the time allotted to do the work, the human and financial resources necessary and, finally, the ability to determine a clear and achievable remedy. Less can sometimes be more.

- **Consultation:** In determining an investigation's initial focus and objec-

A Word to the Wise…Write a pre-mission memo…

Some human rights organizations use pre-mission memoranda to set forth a given investigation's initial scope and purpose. Such memoranda can be useful for investigators because it prompts them to be clear about what they seek to accomplish before they set out to accomplish it. In addition, pre-mission memos can be circulated to people not directly involved in the investigation who may have information or suggestions. Again, this initial memo is not nor should it be conclusive; it is designed to ensure that the initiators of the investigation have a shared sense of its objectives and potential advocacy value and to be a reference point for thinking out the actual field work.

Where written memos are not desirable or possible, investigators should make a concerted effort in some form to establish a clear and shared objective and to formulate some initial advocacy ideas.

tives, it is important to consult with those likely to be most directly affected by it. Thus, for example, if the investigation's chief objective is to publicize a particular woman's case, it would be important to know in advance that she or her representative consider such publicity desirable. Absent such advance consultation, an effort can easily and painfully backfire. Consultation should involve, at a minimum, discussion with victims and survivors of abuse, or their representatives, and groups already working on the issue. Such prior consultation not only helps to clarify the investigation's objectives but also lays the groundwork for further cooperation as it unfolds.

Preparation Step 2:
Identify the violation

Identifying the violation to be investigated can sometimes be more difficult than it first appears. Investigators need to keep in mind that in most cases states, not individuals, are the entities legally bound by international human rights law. Thus, for any particular abuse to constitute a human rights violation investigators must connect the abuse to some form of state action, whether by commission or omission. If, for example, the abuse to be investigated is domestic violence, investigators will have to show not only that private individuals are committing such abuse, but also that the state is routinely failing to do something about it. The actual human rights violation, therefore, is not only the domestic abuse itself but also the state's failure to prevent or punish such abuse or to guarantee women equal protection under the law.

Obviously, proving state action with respect to a given practice is especially difficult in advance of conducting an actual investigation into the abuse. Nonetheless, a rough idea of the alleged

violation must be clear in advance because it will dictate the main focus of the investigation. Defining the nature of the violation at an early stage can help advocates ask questions and be alert for information that either confirms or denies that initial definition.

Preparation Step 3:
Identify key actors

The process of setting objectives, including advance consultation, will help to identify key actors in the situation. These will usually include the following:
- Women victims and survivors of abuse;
- Their families and/or representatives;
- Other activists working on the issue;
- The person(s) or entities suspected of the abuse;
- Those with direct knowledge of the abuse or responsibility for addressing it.

Relevant actors should be identified in advance as much as possible. Identifying key actors after the investigation has begun can add time and stress to the process; meanwhile, failing to identify the key actors at the outset may result in a less thorough investigation. Identifying key actors in advance also will help advocates determine which language(s) to use in the interviews, the most appropriate interviewers and the resources required.

Identifying the alleged perpetrator(s) of the abuse is also crucial to advance planning. As noted above, governments may be directly accountable for a given abuse or they may be indirectly accountable thanks to their failure to prevent or punish abuses by private actors. In each case, as discussed in more detail below, different types of information may be needed and different types of people will have to be interviewed.

If a woman allegedly has been raped by a police officer, for example, demonstrating state responsibility may require interviewing the officer's superior or the

government official in charge of the police force. If, on the other hand, a woman has been raped by a partner or acquaintance and received no protection or response from the police, it may be necessary to interview not only local police and their superiors but a range of other actors. To fully demonstrate the government's accountability, advocates may need to show that the rape was not an isolated incident and that police often or routinely fail to assist women victims of spousal or acquaintance rape. This will require a broader set of interviews than those needed to establish that an individual officer abused a particular woman.

Preparation Step 4:
Create an information checklist

In most cases, it will be impossible to determine in advance all the information the investigators will need to obtain. However, a clear sense of the investigation's objectives, of the abuse to be investigated and of the key actors can help identify likely informational needs.

In addition, virtually every investigation must cover some basic factual ground:

- The nature of the violation;
- Whether the violation is an isolated incident or part of a pattern;
- The violator(s);
- Those affected by the violation;
- Steps, if any, taken by those affected by the violations;
- State action or responses; and
- Actions by any third-party governments or institutions.

Advocates are encouraged to obtain as much information on the alleged violation and surrounding circumstances as they can.

As this factual information is gathered, other information needs usually become apparent, such as: the relevant local or national laws and procedures; the common practice with respect to these laws and procedures; the human rights law guaranteeing the right(s) allegedly violated; and the government's obligations (if any) under that law.

One useful way to ensure that all necessary information is collected during an investigation is to create a checklist of the types of information investigators are most likely to need. This will help guide them not only in planning the investigation, but in allotting their time as they carry it out. One of the most difficult problems for all investigators, particularly those who do not come from the area relevant to the investigation, is *time management*. An information checklist can help investigators stay focussed on their priorities while in the field, ensure a more valuable investigation and reduce the need for follow-up investigatory work, which can be very costly.

If the investigators reside in the place where the investigation is to occur, conducting such advance research is obviously easier. Nonetheless, for both internally and externally based investigators, such research is time-consuming. All investigations need to build in time purely for document collection and,

A Word to the Wise...Anticipate research needs...

To the extent that investigators can anticipate their factual or research needs in advance, they will greatly reduce the demands on themselves during the course of the investigation. Thus, for example, if the relevant local laws and procedures can be obtained and researched in advance, it will reduce the time spent gathering such information in the field. Advance research also will help to clarify the types of questions that should be asked, both of those who suffered the violation and of those charged with upholding the law. The more specific the investigators' questions, the more valuable their information and, ultimately, their recommendations will be.

where necessary or possible, duplication of materials.

Preparation Step 5:
Identify likely sources of information
Determining what information to gather can be much easier than determining from whom that information can be obtained. Thus, in the acquaintance rape example mentioned above, the investigator may know that she needs to uncover the exact details of the abuse and to interview as many of the key players as possible, but she may not know how to contact these persons or other crucial sources that may exist. As human rights abuses against women are often quite hidden, identifying and accessing these sources can be difficult and in some instances dangerous.

Nonetheless, in every investigation some likely sources of information do exist. Again, the more clearly and specifically they can be identified in advance, the more efficiently investigators can use their time during the actual investigation. Some likely sources of information include: those directly affected by the violations; women's human rights groups or other groups in the locality or country who may have documentation based on preliminary or local investigations; and libraries, lawyers, courts and government officials who may have information about applicable laws and state actions or responses to the violations.

Preparation Step 6:
Agree on a research methodology
All of the steps suggested above form part of a general human rights research methodology. However, each investigation will need to adapt these steps to conform to its particular research needs. This adaptation will be influenced by many factors, including the circumstances under which the investigation is to occur. For example, is it in a war zone or in a small community? Is it an issue that has never been documented before,

or is it widely known? Is it safe to investigate or potentially dangerous? Do the investigators speak the same language as their likely interviewees?

Assessing all these factors and arriving at a research methodology is one of the most important steps in preparing an investigation. The research method will guarantee not only that all the necessary information is gathered, but also that it is collected in a manner that is appropriate to the circumstances and therefore most suited to ensure the investigation's ultimate value and effect. In this sense, agreeing on a research method is a highly strategic act that reflects an informed assessment of what needs to be accomplished and of the most effective way to accomplish it. Even choosing the order in which interviews will occur, for example, can make all the difference in the effectiveness of the investigation. If one speaks to the relevant government officials before interviewing those most affected by the abuse, key questions that should have been asked of the officials may be missed.

While all human rights research methods need to be flexible and adaptable, advocates should follow three basic principles:

- **Impartiality:** A sound research method should guard against potential bias by the researchers. It should ensure, to the extent possible, that all the facts are compiled and all the relevant parties heard. An investigation that becomes too one-sided can lead to conclusions that are ill-founded and, therefore, all too easily challenged and dismissed.

- **Accuracy:** The strength of any human rights campaign ultimately depends on the accuracy of the facts on which it is based. Investigators should agree on a research method that guarantees accuracy by building in the steps and time necessary to ensure it. The failure to do so can have disastrous results not

only for the overall advocacy effort but also for those who, perhaps wrongfully, were its targets.

- **Specificity:** The more specific an investigation's findings, the more useful they will be.

Preparation Step 7: Make logistical and other arrangements

Identify and obtain necessary resources

Before actually setting out to do the field work, investigators or the group(s) initiating the investigation need to make an inventory of the human, financial and material resources the investigation will require. Human rights investigations and documentation require knowledge of human rights law, some measure of writing and research skills and an even larger measure of interpersonal skills. Questions of language and awareness of the culture and values of the community may also be relevant, especially if the investigation is to be done by a person not belonging to the same community. In addition, investigations of some types of abuse may require medical or other specialized expertise.

The planning process must address the question of whether or not the advocates initiating the investigation have the appropriate *human resources* to do the work. If not, planners will need to locate those with the appropriate expertise or secure training and other assistance to develop these skills themselves. Decisions made at this stage are crucial. On the one hand, employing investigator(s) not directly affiliated with the group sponsoring the investigation can mean that resulting skills and experience leave the group when the investigator(s) do. On the other hand, an independent investigator with the needed expertise can greatly relieve the burden on the investigation's sponsors. Either scenario has profound implications in terms of the time and financial resources needed to complete the investigation.

Sponsors must consider in detail the time, financial and technical resources that will be required to cover the investigators' travel and subsistence costs and to gather the information. Do the investigators require cameras, video equipment or voice recorders? Will travel to or within a given country be necessary? Once the entire inventory is made, advocates can decide whether or not they need to raise funds and go about doing so.

Select fact finders

This is one of the most important steps in planning an investigation. The fact finders will carry out the investigation's objectives. They will also be seen to represent the group(s) that initiated the investigation and be responsible for interacting with survivors, rights activists, government officials and many others. The investigation's success rests largely on their ability to carry out these tasks in an informed, focused and respectful manner. Guiding principles for the selection and support of fact finders include the following:

- Fact finders should be *objective and impartial* in the sense that they have not taken a political stance or exhibited a bias against the government, private entity or issue being investigated—except for a bias in favor of human rights. For this reason, it may be valuable in some circumstances to enlist investigators who are not from the area under investigation, to help avoid any undue challenge to their credibility and independence.

- Fact finders should be *trained in interviewing and data collection,* as well as having relevant expertise on the geographic location and/or subject matter to be investigated. If the end product is to be a written report, writing skills are also desirable. For particular abuses, *medical or legal expertise* may need to be included in the fact-finding team.

- Fact finders also *should be chosen strate-gically*. For example, well-known experts may enhance the investigation's credibility but may draw inopportune attention to it.

- Where women are to be interviewed about rape and other acts of violence against women, *an all-woman fact-finding team* (translators and interviewers), specifically trained in listening to women victims/survivors of violence, may be necessary.

- Any person appointed as a member of the fact-finding mission *should not be replaced* during the term of the mission except for reasons of incapacity or gross misbehavior.

- Information gathered by the investigators *should be for the use of the investigation only*, and not for independent use without prior agreement.

- Initiating organizations should be responsive to the *physiological and emotional needs of fact finders*, providing counseling and allowing them time and space to process psychologically what they have seen and heard.

Select interpreters

While language skills are an important consideration, the neutrality and fact-finding expertise of the mission should not be sacrificed in favor of finding someone who speaks the language. Interpreters may be employed to assist fact finders, given certain criteria:

- Interpreters must have the requisite skill to translate accurately and sensitively from the language of the interviewee.

- Interviewers and interpreters should be culturally appropriate. Where interpreters or interviewers of a certain background would be unlikely to elicit a full and honest answer, others should be assigned. For example, the presence of interpreters who are perceived to be from an "enemy" group might intimidate the witness.

Establish security measures

Nothing is more important than your own security, and that of the people you interview and with whom you work. In planning any investigation, security precautions should be a key element of your advance preparation. Considerations include:

- Plan security precautions in advance. These include regular commitments to "phone home," methods by which you will protect your notes (e.g. keep them with you at all times) and methods for protecting the identity of your contacts. Decide in advance whether you should code the names of your contacts and, if so, how. If you type up your notes on a computer each day, learn how to lock a file for password-only access.

- Err on the side of caution. If an area is deemed unsafe, don't go. If you cannot get facts you need because of safety risks–to you or others–let the facts go.

A Word to the Wise...Some tricks of the trade...

Type or write up detailed interview notes on the day the interview occurred. Include, with appropriate security precautions, the date, time, place, exact name and, where necessary, title of the interviewee. This saves a lot of time that otherwise would be spent later on in trying to piece together notes or remember the precise circumstances of an interview.

Plan time to relax. Investigations can be very fast paced and stressful. Taking a little time off during the investigation can help investigators maintain perspective on their work and ensure that they stay focussed on its objectives.

Carry snack food. Investigations are often hectic and schedules frequently shift. It is not unusual for investigators to miss a meal. Snack food helps bridge the gap.

Remember, few investigations go exactly as planned. Stay flexible.

2 Fieldwork/ Investigations

Fieldwork Step 1:
Decide on the type of evidence to be gathered

The type of evidence to be gathered depends on the investigation's objectives. If, for example, material is being gathered for a specific court case, the evidentiary requirements will be different from that being gathered for a more general report. Investigators must be clear in advance about exactly what type of evidence they will need in order to ensure that they focus on obtaining that information while in the field. In general, the evidence needed for a human rights investigation falls into two main categories:

Direct evidence

Whatever the investigation's objective, the *testimony of the victims* of the abuse is very important. Such direct testimony will have to be gathered in some detail. In addition, the testimony of other witnesses or persons who have first-hand knowledge of the abuse will also be relevant.

Investigating a representative number of cases can demonstrate the seriousness of the problem. For example, even in instances where investigators are not attempting to show a pattern or practice of abuse and are focusing exclusively on one case, direct testimony about other similar cases can help strengthen the human rights argument and underscore the need for remedial action.

Other forms of evidence

Direct testimony can be supplemented with *secondary information*. Depending on the type of advocacy effort likely to result from the investigation, supporting evidence may be obtained through legal means such as depositions, subpoenas, etc., or from informal sources like reports from local women's organizations or newspaper clippings. Other secondary sources, such as medical reports, the opinions of local attorneys, public records, court cases and statistical evidence, are also important and can be used to confirm and supplement direct testimony.

Where safety concerns (of either the interviewers or interviewees) rule out on-site visits or where the government denies entry, testimony still may be gathered from refugees and others who have left the country. This can be achieved through telephone calls (although these are less reliable because the interviewer has less ability to judge the credibility of the speaker) and from signed statements of witnesses and victims (again, much less reliable than direct testimony).

Fieldwork Step 2:
Establish the parameters for interviews

Conducting interviews is perhaps the most crucial stage of the fieldwork process. If the interviewer is not well-prepared, the interviewee not fully informed or the conditions of the interview not appropriate, the results can undermine the entire investigation. Interviewing is not easy; it is a skill that benefits from a long period of practice and experience. The next two steps are some general guidelines for setting-up and conducting interviews. Each fieldworker, while sticking to the basic principles of consent, confidentiality, impartiality and security, should adapt these guidelines according to her own skills and judgement.

- Be clear about who you are and what you are doing. Interviewees should be told in advance the nature and purpose of the mission, including information about the sponsoring NGOs, whether and when a report will be written and how it will be available and to whom their interview

Gathering Evidence: Some Key Criteria

The value of the evidence depends on its accuracy, reliability and specificity. This can be assured if investigators follow some key criteria, including the following:

1. Document evidence from all sides

It is important to collect evidence from all sides. This assures balance and impartiality and provides a more thorough representation of what occurred. If legal action is being contemplated, knowledge of any possible evidence that could be used by the defense is important in building a case for victims. For example, if rape is perpetrated against refugee women by the police or warring factions, it is important that testimony be collected indicating clearly the level of responsibility by various perpetrators. If there are allegations of police abuse, a researcher should notify the police and attempt to interview them to hear their response.

2. Double-check the facts

Investigators should check and double-check their facts and seek ways to corroborate evidence gathered through direct testimony This will ensure that where any charge of human rights abuse is made, it is well-founded and provides a strong basis for the overall advocacy effort. Sources of corroboration may include credible reports of other governmental and non-govern-

mental organizations; interviews with other witnesses; complaints by others about similar forms of abuse (thus demonstrating the likelihood of a pattern and practice of abuse); and physical evidence such as documentation of physical abuse (photographs, videotapes, direct examination of bruises, etc.). Corroboration also may include on-site inspection of a building or the digging up of a grave site.

3. Represent only what can be verified and acknowledge limits of the research

In situations where it is difficult to come to firm conclusions, it is important to state that this is so. For example, in many countries statistics on domestic violence are estimates because women rarely come forward to report abuse to the police. Therefore, in stating the levels of domestic violence in such countries a researcher must take care to qualify figures and give reasons why estimates are the only information available.

4. Be specific

In the early stages of any investigation, allegations can be very general and can therefore lack weight. Specific information helps to reveal whether allegations are unfounded and to uncover valid ones. One of the best methods to secure specific information is to keep asking for it.

may be made public unless they request otherwise.

- Seek clear agreement to conduct the interview.

- Interviews should be conducted in private and one at a time.

- Ask interviewees in advance whether they wish to remain anonymous.

- Guarantee that the interview is confi-

dential and that you will not share its contents without express permission. However, explain that choosing to be anonymous will preclude their participation in systems that require a named complainant.

- Ensure in advance that witnesses will be comfortable with the interviewer.

- Consider carefully whether photography, a tape recorder or other recording

Conducting Interviews: Some Basic Guidelines

1. Be Prepared
The most important criterion for an investigator is to be prepared. Conducting interviews without advance preparation can greatly diminish their value; specific information can be missed or key issues overlooked. Investigators can prepare in advance by writing up interview protocols that set forth in detail the types of information they will need to obtain from each interviewee. When there is more than one investigator, it can be useful to split up interviews so that each investigator has primary responsibility for a given set of interviews.

2. Be Informed
Investigators must be sensitive to the context in which they operate. When conducting interviews regarding women's rights violations, for example, investigators must be aware of the fact that stigma and fear of reprisal often accompany these abuses. As a result, women affected by these abuses are deterred from coming forward. Raped and battered women are often ostracized by their families and communities once they report these issues. Particular care should be taken to reflect these considerations in the interview process, including respect for confidentiality, anonymity and personal security.

3. Be Courteous
Never miss an opportunity to thank an interviewee. The investigation depends on their cooperation, which may at times entail personal risk. Do not be a prosecutor. Always be polite and allow the interviewee to finish his or her sentence or explanation.

device may intimidate witnesses, violate their privacy or cultural norms or cause them to "perform."

Fieldwork Step 3:
Conduct the interviews
Conduct interviews through a series of *open, non-leading questions* (questions that don't suggest an answer). For example, instead of asking "When were you beaten?" ask "What happened?" and "What happened next?" and "Describe that...." Leading questions are generally only appropriate when dealing with hostile interviewees (i.e. people on "the other side," such as government officials). For example, after a government official refuses to tell you anything about a case, you may begin with "Isn't it true that...?" or "Are you denying that...?" When a cooperating witness has difficulty speaking because of fear, lack of verbal skills, reluctance to remember,

etc., more pointed questions may be needed to discover what happened. However, never put words in an interviewee's mouth.

Make careful notes of all interviews, including general impressions of the demeanor and credibility of witnesses and the circumstances in which the interview was conducted (which investigators may not remember later). With appropriate safety precautions, a careful list of sources and contact information should be maintained.

Devise an *indexing system* in order to compare the comments of different interviewees regarding the same incident.

Keep a *reminder list* to track additional information you may need to collect as you go along.

Ask for any *documents* you may need for substantiating information gleaned from the interview.

Use *interview protocols* (see

"Conducting Interviews: Some Basic Guidelines," above). Interviews can produce an overwhelming amount of new evidence. Reference to a protocol can help interviewers to stay focussed and obtain all the necessary information.

Compartmentalize. Never tell one witness what another one has said. This would not only break your promise of confidentiality to a prior witness, it would indicate to your current witness that you cannot be trusted with sensitive information.

Use judgment to *withhold information* that may jeopardize the safety or well-being of those giving testimony or of third parties.

End every interview with an open question. For example, "Thank you. Is there anything else you think I should know?"

Investigators of women's human rights abuse should keep in mind two key points:

- Where it is clear in advance that questioning a witness, victim or family member would cause grave injury (psychologically or physically), and that protection, social services or other needed care would not be available, that person should not be questioned.

- Women who may talk about rape or other forms of violence against women should not be interviewed unless appropriate social services are available to them. If an interviewer finds that her questioning has (re-)traumatized the interviewee, she should ask the interviewee's permission to refer her to social services.

Fieldwork Step 4: Gather secondary data

All supplemental information from public records, medical reports, newspaper accounts, etc., should be gathered before the end of the fact-finding mission to supplement the direct evidence gathered during the interviews.

3 Follow-up and Analysis

To a certain extent, pre-investigation planning will have indicated the nature of the abuse to be investigated, the alleged perpetrator and the obligation of the relevant government to account for and remedy the abuse. However, a successful investigation will usually challenge and refine these initial premises and allow for much more precise, reliable and defensible conclusions regarding all three concerns. This post-investigation analysis can and should be a very rigorous process. Its aim is to examine closely and assess the facts, demonstrate that a violation of protected human rights has occurred, assert that the state, whether by commission or omission, is accountable for the abuse and set forth required and recommended remedies. A clear and valid argument along these lines will greatly facilitate the overall advocacy effort.

Follow-up Step 1: Show that there is a protected right

Advocates should demonstrate that the abuses investigated violate a right that the relevant government is bound to uphold under national or international human rights law. Where the right violated is guaranteed by regional or international instruments, advocates must show that the state concerned has ratified the instruments and is consequently legally bound to uphold them. Where several rights are involved, advocates must indicate each respective violation and show that the state was under an obligation in each case.

Many women-specific abuses may not be specifically mentioned in human rights instruments. However, they may, through the interpretation of particular rights, be shown to fall under the guaranteed human rights. For example, rape in war has been interpreted to amount to

torture, although it is not always explicitly designated as such in the law. Other forms of violence against women may be shown to amount to cruel, inhuman and degrading treatment or to violations against the security of the person or of privacy. Women's rights advocates need to develop analytical skills so that they can show the link between women's experiences and guaranteed human rights which may not explicitly reference those experiences.

This can be a challenging and informative process. Because human rights are defined and secured though a dynamic and often lengthy process of legal codification and interpretation, investigators should become familiar with the history of the particular right(s) they seek to invoke. If these materials (see Appendix 4: Bibliographical Resources) are not readily available, efforts should be made to contact other activists with relevant background knowledge and expertise. While advocates may wish to move beyond the existing interpretations of a given right, the strength of their argument will depend on a sound understanding of its evolution and a well-defended argument as to why it can and should be interpreted more broadly.

Follow-up Step 2:
Show that a women's human rights violation occurred

Not all human rights violations are sex or gender-specific or motivated by gender. To demonstrate not only that a human rights violation has occurred but that the abuse is gender-based, advocates need to construct an argument to that effect. In order to make this argument, the facts collected during the investigation will have to be analyzed to determine whether or not the abuse was gender-specific in character. For example, a given investigation may determine that in the course of a police raid, women and men were arrested and, in some cases,

arbitrarily detained. However, while detained, the women were subjected to forced gynecological exams, but the men were not. One human rights abuse was arbitrary detention, which did not appear to be sex-specific in character. Another was torture or cruel and inhuman treatment that took a gender-specific form. Both elements of the argument need to be identified and defended.

Follow-up Step 3:
Clearly demonstrate state responsibility

Having shown that a human rights violation has occurred, and having indicated its gender or sex-specific character, it is now necessary to demonstrate clearly the state's responsibility—whether by commission or omission for what occurred. This, too, can be a challenging and enlightening process.

Where the state actually committed the abuse through one of its agents, e.g. a police officer or soldier, it is necessary a) to demonstrate that this is the case and b) to show that the state is bound under national, regional and/or international law to refrain from such conduct. This involves researching the state's national, regional and international rights obligations; determining the exact nature of those obligations; and then arguing the state's specific responsibilities with respect to them. At times this can be a fairly straightforward task. More often, however, the exact nature of the state's obligation may be difficult to determine, either because in ratifying the relevant treaty or instrument the state has filed a reservation with respect to the relevant right (see Chapter One) or because that right is not usually understood to encompass the abuse being investigated. (This underscores the need to ensure that any new interpretation of a right is well-informed and defended.)

Where the state has not directly committed the abuse but instead has failed to prevent, punish or remedy it, the

argument for state responsibility can be somewhat more complex. In this case it is necessary to show first that the state knows or can be reasonably expected to know that the abuse occurred; second, that the state has failed to take the appropriate steps to redress the abuse; and third, that this failure is related to the victim's sex or gender. It may not be necessary to show that an abuse was reported to the police to demonstrate that the state knew about it, but such information would be very useful. Where it is not available, either because the women were afraid or unable to report the abuse or because no such mechanism was available for them to do so, other credible means of demonstrating the state's knowledge of the problem must be found.

Once this knowledge has been shown, it is then necessary to *analyze in detail the nature, scope and explanation of the state's inaction.* Obviously this information will have to have been gathered during the investigation, but at this point it will have to be carefully analyzed to ensure that the charge of state omission is well-founded. Supporting such a charge may involve showing a pattern of reports to the police of abuse that were not acted upon, the failure of the state to prohibit certain types of abuse, or the state's failure to take certain positive steps to eliminate a given abuse as required by its obligations under international law.

Once the state's failure to act has been established, it is crucial to demonstrate the extent to which that inaction is based on the sex or gender of the victim. Sometimes this is very clear. For example, a judge who fails to prosecute crimes of domestic violence may argue that they do so because all women are undisciplined and should be controlled by their partners. This indicates a discriminatory attitude that may contribute to the state's failure to act. At times, however, the gender-related dimension of the state's inaction may be

more difficult to uncover. It may require uncovering gender bias embedded in the law itself, it may require a substantial number of interviews with state actors to show a discriminatory pattern or practice and it may benefit from statistical analysis of the differential way in which the state has, for example, addressed crimes of violence against women and men over time.

Follow-up Step 4:
Identify and evaluate potential solutions

During the investigation and documentation stage, it is extremely important to begin to identify means by which the abuse can be stopped and to have concrete recommendations for all the various parties responsible for or in a position to address the violation—governmental and nongovernmental. The appropriate solution(s) will depend on the violation, the violator and, at least in part, the government's legal obligations.

In some cases, solving the problem will require governments to stop actions that constitute or contribute to the abuse. For example, if women in prison in a particular country are frequently raped by prison guards, the government of that country has to take steps to stop this practice as it is a violation of women's rights to liberty and security of person. Advocates should analyze possible solutions and recommend the most appropriate remedies. In some countries, for example, a recommendation that women prisoners should always be under the care and control of female prison guards may be appropriate. In others it may not.

In other cases, governments will be required to take positive action to end an abuse. For example, Article 23 of the ICCPR requires states to take appropriate steps to ensure equality of rights and responsibilities of spouses during marriage and at its dissolution. If a country's customary practice on child custody gives

151

fathers of children born during a marriage automatic custody of those children at divorce, the state has a duty to pass legislation to stop this practice.

In attempting to identify a range of solutions to a given problem, investigators should *consult thoroughly with those most likely to be affected by any given step*, both in terms of whether that step is appropriate and in what manner it would best be carried out.

Follow-up Step 5: Report the findings

A key component of any human rights advocacy strategy is deciding how best to "package" a given investigation's findings. This decision will depend in large measure on the objectives of the overall advocacy strategy; the findings should be presented in a manner tailored to that strategy. One possible format is a written report. Other options include memos, open letters, newspaper articles and public fora. Where the investigation's aim is general public education, for example, a public forum might be appropriate. Where the aim is to get witnesses and facts to support a human rights case in court, only those admissible facts will be used. Where the purpose is to support a complaint to be submitted before a human rights mechanisms (at any level) the report should be structured to give the information required by the particular body or mechanism. Where the documentation is to be used for political action (advocacy) at the national, regional or international level, a formal report with detailed information on the violation can be published and widely disseminated. Below are some key points to keep in mind when compiling a women's human rights report.

Writing a Report

Members of the mission should prepare a final report or designate one of their members to do so. If the members are split on issues, this should be noted. In addition, they should provide details regarding the goal of the mission, the methodology and circumstances under which facts were collected and the sources and methods used to check information.

- The report should *detail the evidence collected*. Where possible, direct quotes from those interviewed should be used and the demeanor of the interviewee should be noted.

- The report should *vary sources of evidence* if possible, and specify each source (unless the source is protected on the grounds of secrecy, in which case this fact should be noted).

- The evidence should then be used to *make a clear human rights argument* using the investigator's analysis of the right(s) violated, the gender or sex-specific nature of the abuse, the suspected or known perpetrator (although not necessarily by name) and the government's local, regional and international obligations with respect to the abuse. To the extent possible, this argument should be well defended using authoritative sources such as local court decisions, international human rights instruments and government position papers or statements.

- The report should include *conclusions and recommendations*, including where possible recommendations to the responsible government(s) and the international community. Whenever possible, the report should link its conclusions to specific international obligations. In crafting recommendations, investigators should seek to make them as specific as possible. In addition, efforts should be made to identify remedial steps that are well grounded in national or international law and that are more or less achievable. Finally, all recommendations should be reviewed by those most

6

likely to be affected by them.

- If an advance copy of the report has been sent to the government for comment before publication of the final report, *the government's response (or failure to respond) should be included* in the final document.

- The final report should be sent to those interviewed or their representatives, the government concerned, cooperating human rights groups within the country (if doing so does not place them in danger), other interested or implicated governments, relevant national, regional and international governmental and non-governmental organizations and activists and the press.

Using the Media

The more public attention given to a human rights report, the more likely that its findings will generate public pressure in favor of its recommendations. Attracting media coverage is one important way to garner broad public exposure. Key steps in attracting such coverage include the following:

- *Identify potentially interested journalists* very early in the planning process. Work with them to get them informed about the issue and committed to investigating it or, at minimum, to covering your group's investigation.

- *Send key journalists advance copies of the report.* Follow up with calls urging them to cover the story or do an investigation of their own.

- When you release the report, *include a press release* summarizing the report's key findings and conclusions (and the human rights basis for them) and its main recommendations.

- *Hold a press conference* or event to celebrate and draw attention to the report's release.

In dealing with the media, it is important to a) identify your main message, b) find a clear and concise way to communicate it and c) be sure to say explicitly which parts of any interview are on the record and which are off the record or for "background" only.

On-Going Monitoring and Follow Up

The purpose of the investigation, of course, is to inform and support the broader advocacy strategy. Once the investigation is complete and its findings are released, the advocacy work begins. This is the most important part of the overall process, although by the time it arrives the investigators and all others concerned may be fairly exhausted. This underscores the need from the very beginning to keep the investigative effort in the context of the broader advocacy campaign, so that advocates can pace themselves for the entire effort and dedicate appropriate financial and human resources to it. However, even as the advocacy effort unfolds, its efficacy will depend on the investigators' maintaining an up to date understanding of the situation in the field so that any deterioration in the situation or any positive steps taken by the government or others to address it can be incorporated into the advocacy campaign. Here are some suggested steps toward ensuring on-going monitoring:

Monitor the response of the state to the report, with particular regard to whether the state initiates reprisals. against petitioners, witnesses or their relatives and associates.

Monitor how or whether the state responds to the recommendations of the report and whether human rights conditions have improved.

Establish and maintain contact with partners in the field who will monitor and report any relevant developments.

Evaluate the need for a follow-up investigation.

Consider additional follow-up, such as: writing letters to responsible officials about non-compliance with international

norms; sending "action alerts" to private individuals and organizations, encouraging them to write letters to specified individuals; monitoring trials and/or elections; visiting prisons; providing technical assistance in implementing recommendations for improving human rights conditions; and/or enforcing human rights through national, regional and international systems and mechanisms (such as bringing individual complaints before commissions and court-like bodies and triggering monitoring mechanisms).

6

STEP-BY-STEP GUIDE TO
HUMAN RIGHTS ADVOCACY

7

*T*he following section examines the key elements of an effective advocacy strategy, drawing on all previous chapters. Each "step" points to an issue or set of issues that need to be considered and resolved.

The steps are organized in a common-sense sequence, but the sequence of the steps is less important than their content. During the course of planning— which is a dynamic, interactive process—certain steps may need to be revisited or reworked more than once. Because of the interrelationship between the choices made in designing a strategy and the information needed to make ongoing decisions, advocates must continually bring their cumulative understanding of the issues and the context to bear on the process. In this way choices made at the start can be reinforced or modified appropriately as the plan unfolds.

STEP 1 Choose the Issue

The first step in the advocacy process is to choose an issue. Organizers should satisfactorily answer or resolve these questions:

- Is the issue a women's human rights issue?
- Does it affect only a few women or many?
- Will the resolution of the issue have an impact on only a few or on many?
- Does the issue have potential to educate a wide audience and engage them in support activities?
- Will the issue contribute to amplifying the understanding of women's human rights, expand the scope of state responsibility or enhance the effectiveness of the human rights system?

Remember, the issue will have to be studied further to have a definitive answer to these questions, but initial analysis should point the way to an issue with potential to make a real difference in the lives of women.

STEP 2 *Research the Human Rights Issue and Explore solutions*

The next set of questions the organizers of an advocacy effort must resolve relate to the nature and extent of the human rights issue they have chosen.

- Is there a protected right that is being violated?
- What is the nature of the violation?
- How will the violation be proven? Are there documented cases that can be used to demonstrate the violation?
- Who is the violator? Can the state be shown directly or indirectly to be responsible for the violation?
- Is the rights issue clearly defined in the constitution, in human rights treaties or through common practice?
- Do national laws conform to international human rights standards? If so, why are they being violated?
- Does the public understand that the issue involved violation of human rights? Does the public tolerate the existence of the abuse or just not know about it?
- Have violations been challenged through courts or national level human rights mechanisms? Is it possible to use these for this case/issue?
- What is the probability of satisfactory resolution at the national level?
- Is there the possibility of using international mechanisms to address the issue? Is there direct access to these mechanisms or is it necessary to put pressure in other ways?
- What kind of remedies do these mechanisms offer and what is the probability of satisfactory resolution at the international level?
- For each of the mechanisms considered, what are the advantages and disadvantages of using them? Is there a direct role for advocates and what is the likelihood of advocates contributing significantly to the resolution of the issue?

STEP 3 *Set Objectives and Demands*

The next step in the process is to decide definitively what the strategy will be about and what the strategy will achieve.

- What is possible to achieve with this issue?
- Are the advocacy objectives related to expanding the understanding of the rights involved or assuring the application of the rights?
- Does some practice need to be stopped or does some positive action need to be taken to comply with human rights standards?
- Is there a demand on the government? What exactly and specifically

must it do? What will constitute satisfactory action?

- Is there an objective to pursued at the national level? Does it involve legislative reform or litigation?

- Is there an objective to pursue at the international level? Does it involve a remedy provided by one of the official human rights mechanisms or some alternative approach?

- Is it possible to spell out both final and interim objectives?

STEP 4 *Design the Strategy*

With clarity about the issue, the possible solutions and the objective the advocacy effort will pursue, the next step is to lay out the strategy, that is, the type and sequence of actions that must be undertaken to achieve the goals. Again, a set of questions must be resolved as a precondition to assembling a strong, potentially effective approach.

- Given the goals and demands of the initiative, will the strategy rely heavily on legal actions? If so, what is the sequence of actions that need to be taken? Who is taking on the legal work? The NGO, an international human rights group, someone else?

- Does additional research need to done? Who will do it?

- Does the strategy involve legislative work? Does a legislative proposal need to be drafted? How (by what process and by whom) will it be drafted and presented to the appropriate legislative body? Who will follow up with it?

- What will be done to educate the public about the issue, the litigation or the legislation?

- At what point will lobbying be needed? When will the public be drawn in?

- Will the strategy be primarily an awareness raising campaign? What methods and approaches will be used? Will there be a full-blown media campaign? Will there be face-to-face educational work with communities and potentially interested groups?

- Whatever the goal and actions devised as a strategy, is there a clear division of roles and responsibilities among the participants? Who will take charge of each aspect of the strategy?

- Are all aspects of the strategy covered and are the different skills/expertise of the groups being used appropriately and efficiently? Do participants understand and agree on the coordination of roles and activities and on how information is to be shared?

- Are all the activities spelled out in sequence on a calendar of events, charting the targets and long-range and interim goals to be achieved?

STEP 5 *Educate the Public and Gain Support*

In addition to the general plan, special attention should be paid to public education and constituency (support base) building. To do this effectively, organizers need to do a thorough analysis of who is involved at various levels, who can be won over and what kind of information or participation they need.

- Who are the advocacy initiative's potential allies? Supporters? Opponents?
- Where are they found? In institutions, communities, professional associations, in public places, etc.?
- Who/what are the main targets? What can be done to educate it/them?
- What means will be used to educate and organize support? Will the media, symposia, marches, protests, hearings etc. be used?
- Will a "launch" be used as a significant occasion for publicity?
- What will be done to gain supporters and maximize their influence?
- What will be done to neutralize the influence of opponents?
- Are there different messages for different audiences? How will the media be managed?
- What will be done on an on-going basis to keep pressure on the violator, disseminate crucial information about the issue and invite people to help?

STEP 6 *Secure Required Resources*

It is also a good idea to assess the resource needs of the initiative and determine when and under what conditions it is useful to begin.

- How much will the advocacy initiative cost? Media? Meetings? Consultants?
- Besides the organizers and direct participants in the initiative, are there others who can provide volunteer or pro bono assistance?
- Are the human and material resources needed to carry out the strategy available?
- Which of these still need to be assembled before implementation starts?
- If financial resources are needed, how can they be acquired? Is it possible to begin without the full amount needed or will it be better to wait until all the resources are available before commencing?
- Do any of persons involved require training in aspects of women's human rights relevant to the advocacy effort or in other skills, e.g. mobilization? How will this be done?

- What other preparation is needed for the participants or any of the principles involved? Training in fact-finding, etc?

STEP 7 — Mobilize for Action and Implement the Strategy

Once the plans and resources are in place, the only thing left to do is to implement the strategies.

STEP 8 — Evaluate the Advocacy Effort

Both during the course of the advocacy effort and at the end, advocacy strategies require ongoing monitoring of their progress and effectiveness. The purpose of monitoring is to enable the organizers of the advocacy initiative to decide whether they need to modify the strategy or to strengthen particular aspects of it. Any aspect of the initiative is open to assessment and adjustment. Some of the questions that might be addressed are:

- What is the state of progress toward the goals?
- Are the plans working well or do they need adjustment?
- What's working; what's not?
- Is the information being received and disseminated accurate?
- Is the information reaching its target?
- Is the issue being kept sufficiently alive and visible to keep pressure on the violator?
- How is the violator responding?
- Is there any backlash to the advocacy effort that has developed?
- Are opponents organizing to counter it?
- Are the targeted decision-makers becoming sympathetic to the demands?
- What was the final result and what does it mean for women or survivors of human rights violations?
- How did their involvement assist the outcome of the advocacy initiative?

7

GLOSSARY OF TERMS: A-1

HUMAN RIGHTS INSTRUMENTS: A-2

STATUS OF TREATY RATIFICATIONS: A-3

BIBLIOGRAPHICAL RESOURCES: A-4

NGOS RESOURCES: A-5

ADDRESSES OF HUMAN RIGHTS OFFICES: A-6

INDEX: A-7

APPENDICES

1503 Procedure: limited procedure that allows a *claimant* to bring a human rights case directly to the Secretary General of the United Nations; addresses situations which appear to reveal a widespread pattern of gross human rights abuses.

Admissibility Requirements: The initial prerequisites that an individual, group or state must fulfill before "getting in the door," that is before being able to present their *claim* to a particular *Treaty-Monitoring Body* or other human rights fact-finding or judging organization or court.

Adoption: Process by which a law-making body of an international organization or a diplomatic conference approves the final text of an instrument (agreement); with regard to treaties, adoption usually refers to the diplomatic process through which a treaty is accepted; in order to become effective for the signatories, the treaty usually must be ratified by the legislative body of the state.

Advisory Opinion: Opinion of a court that provides an interpretation of a law or norm; advisory opinions differ from other forms of opinions in that a concrete case (one presenting actual parties claimed to be harmed and entitled to a *remedy*) need not be present.

Advocacy: a political process consisting of actions designed to transform citizen or popular "interests" into rights; a process aimed at influencing decisions regarding policies and laws at national and international levels; actions designed to draw a community's attention to an issue and to direct policy makers to a solution.

African Charter on Human and People's Rights (adopted 1981, entered into force 1986): Establishes human rights standards and protections for the African region; notable for addressing community and group rights and duties.

American Convention on Human Rights (signed 1969, entered into force 1978): Convention providing human rights protections in the Americas and establishing the *Inter-American Court of Human Rights*.

American Declaration on the Rights and Duties of Man (1948): Non-Binding declaration of regional human rights standards; it has evolved into an influential document as the *Inter-American Court of Human Rights* has given normative value to the Declaration and the *Inter-American Commission on Human Rights* applies it to all OAS members.

Beijing Declaration and Platform for Action: Consensus document adopted by the 1995 Fourth World Conference on Women in Beijing, reviewing and re-affirming women's human rights in all aspects of life; signed by representatives at the Conference and morally but not legally binding.

Cairo Programme of Action: Consensus document adopted by the 1994 International Conference on Population and Development in Cairo, affirming women's reproductive health and rights; signed by representatives at the Conference and morally but not legally binding.

CEDAW: See *Convention on the Elimination of All Forms of Discrimination Against Women*.

Centre for Human Rights in Geneva: Part of the UN Secretariat under the administration of the *UN High Commissioner for Human Rights* that acts as a secretariat and clearing house for several types of human rights complaints, including those issued through the *1503 Procedure*.

Charter of The United Nations: Constituent document of the United Nations Organization which spells out the structure, goals and competence of the UN and restates some of the basic principles of international law.

Charter-Based Bodies: Bodies created directly and indirectly through the *Charter of The United Nations*.

Claim: Allegation by an individual or state that it is entitled to a *remedy* for an injury caused by an offender (usually the state).

Claimant: One who brings a *claim*.

Codification of International Law: Process of transforming customary international law to written form.

Collective Rights: See *Peoples' Rights*.

Commission on Human Rights: Body formed by the *Economic and Social Council (ECOSOC)* of the United Nations to address human rights; one of the first and most important international human rights bodies.

Commission on the Status of Women: Body formed by the *Economic and Social Council (ECOSOC)* of the United Nations to deal with issues facing women in the *Member States*.

Committee of Ministers of the Council of Europe: The political arm of the *European Convention on the Protection of Human Rights and Fundamental Freedoms*; the Committee can refer cases to the *European Court on Human Rights* and supervises implementation of the judgments of the Court.

Committee on Economic, Social and Cultural Rights: Treaty monitoring body charged with enforcing the *Covenant on Economic, Social and Cultural Rights*.

Committee on the Elimination of Discrimination Against Women: The *Treaty-Monitoring Body* created by the *Convention on the Elimination of All Forms of Discrimination Against Women* to monitor state compliance with that Convention.

Committee on the Elimination of Discrimination Against Women, General Recommendation 19, Violence Against Women (Eleventh Session 1992): Influential *Recommendation* of the *Treaty-Monitoring Body* charged with enforcing the *Convention on the Elimination of All Forms of Discrimination Against Women*; defines violence as a form of discrimination against women.

Communication: See *Complaint*.

Complaint: In legal terms, the initial document that begins an action; a complaint sets forth a brief summary of what happened and argues why relief should be granted; in a human rights case, the complaint (or *Petition*, or *Communication*) alleges that the government, or another individual or institution that must answer to human rights standards (such as a surrogate of the government) has violated the human rights of specific individuals or groups of individuals.

Complaint-Information Procedures: Under complaint-information procedures, the goal is not to redress individual grievances but to identify broad human rights violations affecting a large population; petitions are received only as part of the information before the body considering the matter; authors of petitions have no right to a remedy, and may not even have a right to be informed about the disposition of the case.

Complaint-Recourse Procedures: Under complaint-recourse procedures, the goal of the procedure is the redress of specific grievances; A successful complaint in this case may result in enforceable legal remedies, orders that force the government to compensate a victim, reprimand the perpetrator, or even change government policies and practices.

Conference on Security and Cooperation in Europe (CSCE): See *Organisation on Security and Cooperation in Europe (OSCE)*.

Convention Against Torture and other Cruel, Inhumane or Degrading Treatment or Punishment (adopted 1984, entered into force 1987): UN Convention defining and prohibiting torture.

Convention: Binding agreement between states; used synonymously with *Treaty* and *Covenant*; Conventions are stronger than *Declarations* in that they are legally binding for states that are party to them and governments can be held accountable for violating them; the United Nations *General Assembly* creates international norms and standards when it adopts conventions; *Member States* can then ratify the UN conventions, signifying acceptance of the obligations under the treaty.

Convention Concerning Equal Remuneration for Men and Women Workers for Work of Equal Value (adopted by ILO in 1951, entered into force 1953): Convention of the *International Labour Organisation* declaring that men and women should have equal wages for equal work.

Convention for the Suppression of the Traffic of Persons and the Exploitation and the Prostitution of Others (adopted 1949): Convention prohibiting forced prostitution and sex-trafficking in women and girls.

Convention on Consent to Marry, Minimum Age for Marriage and the Registration of Marriages (1962): Convention recognizing the right of women and girls to be free from forced marriage and child marriages.

Convention on the Elimination of All Forms of Discrimination Against Women (adopted 1979, entered into force 1981): The first legally binding international document prohibiting discrimination against women and obligating governments to take affirmative steps to advance the equality of women; draws no distinction between public and private life; establishes the *Committee on the Elimination Discrimination Against Women* as the *Treaty Monitoring Body* for the Convention; there are more *Reservations* to the Convention on the Elimination of All Forms of Discrimination Against Women than to any other convention.

Convention on the Political Rights of Women (opened for signature 1953, entered into force 1954): Early convention re-affirming women's rights in the political sphere.

Convention on the Punishment and Prevention of Genocide (opened for signature 1948, entered into force 1951): International convention defining and prohibiting genocide; first human rights *Treaty* of the United Nations.

Convention on the Rights of the Child (adopted 1989, entered into force 1990): UN Convention setting forth a full spectrum of civil, cultural, economic, social and political rights of children.

Convention Relating to the Status of Refugees and Protocol Relating to the Status of Refugees (adopted 1951, entered into force 1954): Main conven-

tion establishing the definition of *Refugee* and stating the rights of refugees and obligations of receiving states.

Council of Europe: Regional organization that acts as an umbrella organization for regional cooperation on political, social and economic matters; note that the Council should be distinguished from the *European Union*, an economic coalition.

Covenant: Binding agreement between states; used synonymously with *Convention* and *Treaty*; the major international human rights covenants are the *International Covenant on Economic, Social and Cultural Rights* and the *International Covenant on Civil and Political Rights*.

Customary International Law: Law that becomes binding on states although it is not written, but rather adhered to out of custom; non-treaty rules that have attained the status of Customary International Law have done so as the result of consistent state practice accompanied by a sense of obligation; when enough states have begun to behave as if something is the law, it indeed becomes law; one of the main *Sources Of International Law*.

Declaration on the Elimination of Discrimination Against Women (1967): *Non-Binding* declaration of the *General Assembly* on the rights of women; precursor to the *Convention on the Elimination of All Forms Of Discrimination Against Women*.

Declaration on the Elimination of Violence Against Women (1993): *Non-Binding* declaration of the *General Assembly* on the right of women to be free from violence and the obligations of governments to take steps to eliminate violence against women.

Declaration: Document represents agreed upon standards, but is not legally binding as such; United Nations conferences usually produce two sets of declarations: one by government representatives and one by *Nongovernmental Organizations (NGOs)*; the *General Assembly* often issues influential but legally *Non-Binding* declarations.

Displaced Person: A person who flees her or his homeland due to political persecution or war, but does not cross state borders; displaced persons can be used as a "catch all" phrase to refer to many people that may consider themselves to be *refugees* but who do not qualify for official refugee status.

Domestic Systems: Legal systems of a particular country; used synonymously with *National Systems*.

Economic And Social Council (ECOSOC): United Nations council comprised of 54 members and concerned primarily with the field of population, economic development, human rights and criminal justice; high-ranking body that receives and discharges human rights reports in a variety of instances.

Enforcement Mechanisms: *Reporting, Complaint* or other procedures at the national, regional or international level that place obligations on states to ensure respect for human rights.

Entry Into Force: The day on which a treaty becomes effective; the point at which enough parties have ratified (signed on to) an agreement to make it effective.

European Commission on Human Rights: Body established by the *European Convention on Human Rights* to investigate grievances of human rights and brings charges of violations; the Commission consists of a number of members equal to that of the number of contracting parties to the convention.

European Committee for the Prevention of Torture or Inhumane or Degrading Treatment or Punishment: *Treaty-Monitoring Body* set up under the *European Convention for the Prevention of Torture or Inhumane or Degrading Treatment or Punishment;* Each party to the Convention is obligated to permit visits by the Committee to investigate complaints.

European Convention for the Protection of Human Rights and Fundamental Freedoms (signed 1950, entered into force 1953): Regional document which guarantees civil and political human rights and establishes machinery for their supervision and enforcement; see *European Social Charter* for complementary document pertaining to social and economic rights.

European Court of Human Rights: Court established by the *European Convention on Human Rights* to hear allegations of human rights violations; the Court consists of a number of judges equal to that of the Members of the *Council of Europe;* note that this is distinguishable from the European Court of Justice and European Court of First Insistance, a body that hears economic complaints.

European Court of Justice: Judicial organ of the European Union originally created in 1952 as part of the European Coal and Steel Community and European Court of First Instance; Court hears economic claims under the Treaty of the *European Union* and related agreements.

European Economic Community: Established in 1958 to develop a common European market free of trade barriers and to promote harmonization of laws and practices.

European Parliament: One of the four institutions of the *European Union*, the Parliament adopts budgetary and policy decisions; on many issues the role of the Parliament is only consultative; has a permanent advisory body on women's rights called the Women's Rights Committee.

European Social Charter (signed 1961, entered into force 1965): Regional document concerned with developing and protecting social and economic rights; intended to be complementary to the *European Convention on Human Rights and Fundamental Freedoms;* Revised charter signed in 1996.

European Union: Also called *European Community* ("EC" or "EU"); founded by the 1957 *Treaty of Rome* and primarily concerned with economic issues, especially the creation of a single European market; its various organs consider human rights issues, in particular the question of discrimination in the workplace; prohibits discrimination between EC citizens and provides that men and women shall receive equal pay for equal work (Article 7 of *Treaty of Rome*).

Exhaustion of Local Remedies Requirement: Requirement that a person, group or state bringing a human rights claim first bring their case before the *National System*.

Gender Discrimination: Discrimination based on socially constructed ideas and perceptions of men and women.

Gender-Specific Claims: Human rights claims relating to abuse women suffer because of their gender; when human rights are being violated due at least in part to a person's gender and/or when women's experience of a human rights violation differs from men's experience due to gender-specific consequences or experiences.

Gender: A social construction often contrasted with "sex" which refers to biological differences between males and females; gender refers to socially constructed differences between men and women as well as socially and culturally constructed perceptions of differences between men and women; a broader term than "sex."

Gender-Based Violence: Violence committed against women as women; violence particular to women, such as rape, sexual assault, female circumcision, dowry burning etc.; violence against women for failing to conform to restrictive social norms; the *Vienna Declaration* specifically recognized gender-based violence as a human rights concern.

General Assembly: One of the principal organs of the United Nations consisting of all member states; adopts *Declarations* and *Conventions* on human rights issues; the actions of the General Assembly are governed by the *Charter of The United Nations*.

General Principles of Law: Principles that appear nearly universally in states' domestic law and, thus, over time become binding on all states; one of the main *Sources of International Law*.

Grassroots Organizations: Nongovernmental groups, usually not-for-profit, formed to mobilize people and communities to address social, economic and political problems; usually this term refers to groups working on *Advocacy* at the local level.

Helsinki Accords: Declaration of principles by the *Conference on Security and Cooperation in Europe* which seeks peace and human rights in Europe; first Helsinki document was called the Final Act of the Helsinki Conference (1975).

Human Rights Committee: The *Treaty-Monitoring Body* created by the *International Covenant on Civil and Political Rights* 1) Examines reports submitted by *States Parties* under the covenant and 2) considers cases submitted under the (First) *Optional Protocol* pertaining to civil and political rights under that *Covenant*; one of six bodies charged with monitoring compliance of member states with UN human rights conventions.

Human Rights of Women: See *Women's Human Rights*.

Human Rights Systems: Refers to the various groupings of human rights laws, courts, investigatory bodies and other organizations at the national, regional and international level which may provide appropriate *Enforcement Mechanisms*, such as court-like *Complaint* procedures and audit-like *Monitoring and Reporting Procedures*.

Human Rights: The rights people are entitled to simply as a result of being human, irrespective of their citizenship, nationalist, race, ethnicity, language, sex, sexuality or abilities; human rights become enforceable as they become *Codified* as *Conventions, Covenants* or *Treaties*, or as they become recognized as *Customary International Law*.

ICCPR: See *International Covenant on Civil and Political Rights*.

ILO: See *International Labour Organisation*.

Individual Complaints: *Complaints* of individuals or *Nongovernmental Organizations*; the *Optional Protocol to the International Covenant on Civil and Political Rights* permits the *Human Rights Committee* to hear individual complaints.

Inter-American Commission on Human Rights: An organ of the *Organization of American States (OAS)* with power to conduct investigations into alleged human rights violations, to recommend measures for the protection of human rights and refer cases to the *Inter-American Court of Human Rights*.

Inter-American Convention on Human Rights: See *American Convention on Human Rights*.

Inter-American Convention on The Prevention, Punishment and Eradication of Violence Against Women (entered into force 1995): Regional convention that obliges governments to prevent various forms of violence and provides a new mechanism for women in the Americas to seek redress for violence perpetrated against them.

Inter-American Convention to Prevent and Punish Torture (adopted 1985, entered into force 1985): Regional corollary to the *Convention Against Torture and Other Cruel, Inhuman or Degrading Treatment or Punishment*.

Inter-American Court of Human Rights: A seven-member judicial body which hears cases brought against member states concerning human rights abuses; an organ of the *Organization of American States*.

International Bill of Rights: Refers to basic human rights documents and includes: *The Universal Declaration of Human Rights*, the *International Covenant on Civil and Political Rights* and the *International Covenant on Economic, Social and Cultural Rights*.

International Covenant on Civil and Political Rights (ICCPR) (adopted 1966, entered into force 1976): Convention that declares that all people have a broad range of civil and political rights; the treaty-monitoring body charged with enforcing this covenant is the *Human Rights Committee*; one of three components of the *International Bill of Rights*.

International Covenant on Economic, Social and Cultural Rights (ICESCR) (adopted 1966, entered into force 1976): Convention that declares that all people have a broad range of economic, social and cultural rights; the treaty-monitoring body charged with enforcing this covenant is the *Committee on Economic, Social and Cultural Rights*; one of three components of the *International Bill of Rights*.

International Labour Organisation (ILO): Established in 1919 as part of the Versailles Peace Treaty to improve working conditions and promote social justice; the ILO became a *Specialized Agency* of the United Nations in 1946.

Inter-State Complaint: Complaint of one *State* (country) against another.

Jurisdiction: The authority of courts or court-like bodies to hear and decide *Claims*; "jurisdiction" can refer to the court's ability to hear particular subjects and/or to review cases brought by certain types of *Claimants*; jurisdiction can also refer to the geographic area of authority.

Maastricht: Popular term for the Treaty (TEU) which changed the *European Community* to the *European Union*.

Member States: Countries that are members of the United Nations.

Monitoring and Reporting Procedure: monitoring and reporting procedures resemble "audits" of government behavior which results in *Non-Binding* recommendations; at times, the reporting resembles a "self-inspection" governments report on their own compliance with human rights

obligations; and in other cases, a monitoring body initiates the report on government behavior.

Nairobi Forward-Looking Strategies for the Advancement of Women: Plan of action for women's equality that was the result of the Third United Nations Conference on Women held in Nairobi in 1985.

National Systems: Legal systems of a particular country; used synonymously with *Domestic Systems*.

Non-Binding: A document that carries no formal legal obligations, but which may still carry moral obligations.

Nongovernmental Organization (NGO): Organization formed by and of people outside of government; nonprofit, human rights, humanitarian aid and *Grassroots* organizations can all be NGOs.

Non-Treaty-Based Mechanisms: Provisions for the enforcement of human rights other than those that relate directly to a specific human rights *Treaty, Convention* or *Covenant*; for example, the *Specialized Agencies* of the United Nations often provide forms of complaint and/or monitoring procedures.

OAS: See *Organization of American States*.

OAU: See *Organisation of African Unity*.

Opened for Signature: Point at which states may sign and ratify a *Convention*; following the receipt of specified number of ratifications, the convention *Enters Into Force*.

Optional Protocol to the International Covenant on Civil and Political Rights (entered into force 1976): Addendum attached to the *International Covenant on Civil and Political Rights*; by signing this addendum, states agree to allow the *Human Rights Committee* to consider *Individual Complaints*, that is complaints from individuals claiming to be victims of any of the rights in the *International Covenant on Civil and Political Rights*.

Optional Protocol: Addendum to an international agreement to which the parties must agree separately; optional protocols often place additional obligations to the parties, such as an agreement to submit to the jurisdiction of an international court.

Organisation of African Unity (OAU): Organization of independent African States that work jointly to improve peace and the quality of life for the people of Africa; the OAU Charter, the guiding document of the group, was adopted in 1963.

Organisation on Security and Cooperation in Europe (OSCE): European entity which attempts to settle security issues peacefully through a series of creative collaborative ventures; formerly the Conference on Security and Cooperation in Europe; declared the *Helsinki Accords*.

Organization Commune Africaine er Malagache (OCAM): Organization of French-Speaking African states that works toward common political and economic goals.

Organization of American States (OAS): Regional organization of independent American states created to strengthen peace and security in the region and to promote regional cooperation on economic, social and cultural matters.

Peoples' Rights: Used synonymously with "solidarity rights" and "collective rights"; refers to the rights that belong to groups and not just individuals, such as the rights to development, to self-determination, to peace, to a healthy environment, etc.

Petition: See *Complaint*.

Procedural Requirements: Technical requirements that must be met to bring a *Claim;* distinguishable from *Substantive Requirements.*

Procedure: In the terms of *Human Rights Mechanisms,* procedures are the various ways in which human rights *Claims* can be made; see *Complaint-Information Procedure, Complaint-Resource Procedure,* and *Monitoring and Reporting Procedure.*

Ratification: In international law, the process by which a treaty may become binding; in domestic law, the process by which a legislature confirms a government's action in signing a treaty; formal procedure by which a state becomes bound to a treaty after acceptance.

Recommendation: In the language of *Treaty-Monitoring Bodies,* recommendations are documents explaining how a particular treaty should be interpreted and applied; the *Committee on the Elimination of All Forms of Discrimination Against Women* has issued several influential recommendations.

Refugee: A person who has fled from her country to escape persecution or fear of persecution based on race, religion, nationality, membership of a particular social group or political opinion. People who leave their homes but do not cross country boundaries are called *Displaced People;* people who meet the requirements for refugee status under the *Convention and Protocol Relating to the Status of Refugees* are called "Convention Refugees."

Remedy: In legal terms, the means by which a right is enforced or the violation of a right is prevented, redressed or compensated.

Reporting Procedure: See *Monitoring and Reporting Procedure.*

Reservations: In the law of *Treaties,* reservations are the exceptions that *State Parties* make to the document, that is, provisions that they do not agree to follow. Reservations, however, may not undercut the fundamental meaning of the treaty; there are more reservations to the *Convention on the Elimination of All Forms of Discrimination Against Women* than to any other convention.

Security Council: Organ of the United Nations comprised of five permanent members and ten non-permanent members elected by the *General Assembly;* this influential body has a political responsibility to bring about peaceful settlement of disputes.

Signatory States: States that have signed a particular *Treaty, Convention* or *Covenant.*

Solidarity Rights: See *Peoples' Rights.*

Sources of International Law: Primary sources listed in Article 38 of the Statue of the International Court of Justice: (1) *Treaty;* (2) *Customary International Law;* (3) *General Principles of Law;* (4) Judicial decisions.

Special Rapporteur: Official appointed to compile information on a subject, usually for a limited period.

Special Rapporteur on Violence Against Women: Official appointed by the *Commission on Human Rights* in 1994 to investigate and make reports on cases of violence against women worldwide.

Specialized Agencies of the United Nations: Institutions created by international agreement to carry out the mandate of the United Nations in particular fields, e.g. UNHCR.

State: Often synonymous with country; a group of people permanently occupying a fixed territory, having common laws and

government, and capable of conducting international affairs.

State Party: A State that has ratified a treaty; a state that is party to a treaty.

Substantive Requirement: Requirement pertaining to the nature or subject matter of the claim; distinguishable from *Procedural Requirements*.

Treaty: Formal agreement between states that defines their mutual duties and obligations; used synonymously with *Convention*. When *Conventions* are adopted by the United Nations *General Assembly*, they create legally binding international obligations for signatory member states; when national governments *Ratify* treaties, they become part of the nation's domestic legal obligations.

Treaty-Monitoring Body: Body (usually called a Committee or Commission) set up by a treaty to monitor how well *States Parties* follow their obligations under that treaty.

UNHCR, Office of the United Nations High Commissioner on Refugees: The *Specialized Agency* of the United Nations that deals with refugee issues and related humanitarian concerns.

United Nations Charter: Initial document of the United Nations setting forth its goals, functions and responsibilities; adopted in San Francisco in 1945.

United Nations Conference on Women: The first United Nations Conference on Women took place in Mexico in 1975. Subsequently, the UN proclaimed 1975-1985 the Decade for Women and conferences on women took place in Copenhagen in 1980 and Nairobi in 1985. The latest conference was in Beijing in 1995. The next world conference on women is scheduled for 2005. The Conferences produce *Declarations*

which, although legally *Non-Binding*, are important sources of international norms and standards.

United Nations Human Rights Committee: See *Human Rights Committee*.

Universal Declaration of Human Rights (UDHR) (1948): Primary United Nations document establishing human rights standards and norms; although the declaration was intended to be *non-binding* through time its various provisions have become so respected by states that it can be said to embody norms of *Customary International Law*.

Vienna Declaration and Programme of Action: Consensus document arising from the 1993 World Conference on Human Rights in Vienna; states that human rights are universal and indivisible; recognizes violence against women as a human rights violation.

Women's Convention: Term used for the *Convention on the Elimination of All Forms of Discrimination Against Women*.

Women's Human Rights Advocacy: In general, women's human rights advocacy consists of activities aimed at influencing policies and decision-making at national and international levels in order to assure recognition and respect for *Women's Human Rights* and assure that the treatment of women is consistent with international human rights standards.

Women's Human Rights: Rights to which women are entitled simply by being human. The primary international document stating women's human rights is the *Convention on the Elimination of All Forms of Discrimination Against Women*.

Selected United Nations Treaties

Note: International Legal Materials (ILM) *is a convenient periodical that publishes international documents such as declarations from international conferences, treaties, and important international and regional court decisions. To find a document that is not listed below, check the ILM issued during that time period.*

To check the status of human rights treaties, see: United Nations, *Multilateral Treaties Deposited With the Secretary-General: Status as of 31 December 1995,* UN Doc. ST/LEG/Ser.E/14, UN Sales No. F.95.V.5 (New York: United Nations, published annually). This document can be found on the World Wide Web at http://www.un.org/Depts/Treaty

Convention Against Torture and Other Cruel, Inhuman or Degrading Treatment or Punishment, adopted 10 Dec. 1984, entered into force 26 June 1987, UN Doc. A/39/51, at 197 (1984), reprinted in 23 *ILM* 1027, minor changes reprinted in 24 *ILM* 535 (1985).

Convention on the Elimination of All Forms of Discrimination Against Women, adopted 18 Dec. 1979, entered into force 3 Sept. 1981, UN Doc. A/34/46, at 193 (1979), reprinted in 19 *ILM* 33 (1980).

Convention on the Rights of the Child, adopted 20 Nov. 1989, entered into force 2 Sept. 1990, UN Doc. A/44/49, at 166 (1989), reprinted in 28 *ILM* 1448 (1989).

International Covenant on Civil and Political Rights, adopted 16 Dec. 1966, entered into force 23 march 1976, UN Doc. A/6316 (1966), reprinted in 6 *ILM* 368 (1967).

Optional Protocol to the International Covenant on Civil and Political Rights, adopted 16 Dec. 1966, entered into force 23 March 1976, G.A. Res. 44/128, reprinted in 6 *ILM* 383 (1967).

International Covenant on Economic, Social and Cultural Rights, adopted 16 Dec. 1966, entered into force 3 Jan. 1976, UN Doc. A/6316 (1966), reprinted in 6 *ILM* 360 (1967).

Other United Nations Instruments

Declaration on the Elimination of Violence Against Women, adopted 20 December 1993, UN Doc. A/48/29, reprinted in 33 *ILM* 1049 (1994).

Universal Declaration of Human Rights, adopted 10 Dec. 1948, UN Doc. A/810, at 71 (1948).

United Nations World Conference on Human Rights, Vienna Declaration and Programme of Action, adopted 25 June 1993, UN Doc. A/CONF. 157/23, at 5 (1993), reprinted in 32 *ILM* 1661 (1993).

United Nations Fourth World Conference on Women, Declaration and Platform for Action, *International Legal Materials,* vol. 35, p. 401 (1996).

Selected Regional Instruments

Africa
African Charter on Human and Peoples' Rights, adopted 27 June 1981, entered into force 21 Oct. 1986, O.A.U. Doc. CAB/LEG/67/3 Rev. 5, reprinted in 21 *ILM* 58 (1982).

Charter of the Organisation of African Unity, adopted 25 May 1963, 47 UNTS 39, reprinted in 2 *ILM* 766 (1963).

Americas
American Convention on Human Rights, signed 22 Nov. 1969, entered into force 18 July 1978, OASTS 36, O.A.S. Off. rec. OEA/Ser.L/V/II.23, doc. 21, rev.6(1979), reprinted in 9 *ILM* 673 (1970).

American Declaration of the Rights and Duties of Man, signed 2 May 1948, OEA/Ser.L./V/II.71, at 17 (1988).

Inter-American Convention on the Prevention, Punishment and Eradication of Violence Against Women, signed 9 June 1994, entered into force 3 March 1995, reprinted in 33 *ILM* 1534 (1994).

Inter-American Convention to Prevent and Punish Torture, signed 9 Dec. 1985, entered into force, 28 Feb. 1987, OASTS 67, GA Doc. OEA/Ser.P, AG/doc.2023/85 rev.1 (1986), reprinted in 25 *ILM* 519 (1986).

Europe

European Convention for the Prevention of Torture and Inhumane or Degrading Treatment or Punishment, signed 26 Nov. 1987, entered into force 1 Feb. 1989, Doc. No. H(87)4 1987, ETS 126, reprinted in 27 *ILM* 1152 (1988).

European Convention for the Protection of Human Rights and Fundamental Freedoms, signed 4 Nov. 1950, entered into force 3 Sept. 1953, 213 UNTS 221, ETS 5.

European Social Charter, signed 18 Oct. 1961, entered into force 26 Feb. 1965, 529 UNTS 89, ETS 35; Protocol amending Charter, adopted 21 Oct. 1991, not in force, ETS 142, reprinted in 31 *ILM* 155 (1990).

	Convention against Torture	Convention for the elimination of all forms of Discrimination Against Women	Convention on the rights of the child	Convention on Civil & Political rights	(First) Optional protocol	Convention Social, Economic & Cultural rights
Afghanistan	•		•	•		•
Albania	•	•	•	•		•
Algeria	•	•	•	•	•	•
Andorra		•	•			
Angola		•	•	•	•	•
Antigua and Barbuda	•		•			
Argentina	•	•	•	•	•	•
Armenia	•	•	•	•	•	•
Australia	•	•	•	•	•	•
Austria	•	•	•	•	•	•
Azerbaijan	•	•	•	•		•
Bahamas		•	•			
Bahrain			•			
Bangladesh		•	•			
Barbados			•	•	•	
Belarus	•	•	•	•	•	•
Belgium		•	•	•	•	•
Belize	•	•	•	•		
Benin	•	•	•	•	•	•
Bhutan		•	•			
Bolivia		•	•	•	•	•
Bosnia and Herzegovina	•	•	•	•	•	•
Botswana		•	•			
Brazil	•	•	•	•		•
Brunei			•			
Bulgaria	•	•	•	•	•	•
Burkina Faso		•	•			
Burundi	•	•	•	•		•
Cambodia	•	•	•	•		•
Cameroon	•	•	•	•	•	•
Canada	•	•	•	•	•	•
Cape Verde	•	•	•	•		•

	Convention against Torture	Convention for the elimination of all forms of Discrimination Against Women	Convention on the rights of the child	Convention on Civil & Political rights	(First) Optional protocol	Convention Social, Economic & Cultural rights
Central African Rep		•	•	•	•	•
Chad	•	•	•	•	•	•
Chile	•	•	•	•	•	•
China	•	•	•			
Colombia	•	•	•	•	•	•
Comoros						
Congo		•	•	•	•	•
Costa Rica	•	•	•	•	•	•
Cote d'Ivoire	•	•	•	•		•
Croatia	•	•	•	•	•	•
Cuba	•	•	•			
Cyprus	•	•	•	•	•	•
Czech Rep	•	•	•	•	•	•
Darussalam						
Democratic People's Rep of Korea			•	•		•
Denmark	•	•	•	•	•	•
Djibouti			•			
Dominica		•	•	•		•
Dominican Republic		•	•	•	•	•
Ecuador	•	•	•	•	•	•
Egypt	•	•	•	•		•
El Salvador	•	•	•	•		•
Equatorial Guinea		•	•	•	•	•
Eritrea		•	•			
Estonia	•	•	•	•	•	•
Ethiopia	•	•	•			•
Fiji		•	•			
Finland	•	•	•	•	•	•
France	•	•	•	•	•	•
Gabon		•	•	•		•
Gambia		•	•	•		•
Georgia	•	•	•	•	•	•

175

	Convention against Torture	Convention for the elimination of all forms of Discrimination Against Women	Convention on the rights of the child	Convention on Civil & Political rights	(First) Optional protocol	Convention Social, Economic & Cultural rights
Germany	●	●	●	●	●	●
Ghana		●	●			
Greece	●	●	●			●
Grenada		●	●	●		●
Guatemala	●	●	●	●		●
Guinea	●	●	●	●		●
Guinea Bissau		●	●			●
Guyana	●	●	●	●	●	●
Haiti		●	●	●		
Holy See			●			
Honduras	●	●	●			●
Hungary	●	●	●	●	●	●
Iceland		●	●	●	●	●
India		●	●	●		●
Indonesia		●				
Iran (Islamic Rep of)			●	●		●
Iraq		●	●	●		●
Ireland		●	●	●	●	●
Israel	●	●	●	●		●
Italy	●	●	●	●	●	●
Jamaica		●	●	●	●	●
Japan		●	●	●		●
Jordan	●	●	●	●		●
Kazakhstan			●			
Kenya		●	●			
Kiribati			●			
Kuwait	●	●	●			●
Kyrgyzstan		●	●	●	●	●
Lao People's Dem Republic		●	●			
Latvia	●	●	●	●	●	●
Lebanon		●	●	●		●
Lesotho		●	●	●		●

	Convention against Torture	Convention for the elimination of all forms of Discrimination Against Women	Convention on the rights of the child	Convention on Civil & Political rights	(First) Optional protocol	Convention Social, Economic & Cultural rights
Liberia		•	•			
Libyan Arab Jamahiriya	•	•	•	•	•	•
Liechtenstein	•	•	•			
Lithuania	•	•	•	•	•	•
Luxembourg	•	•	•	•	•	•
Madagascar		•	•			
Malawi	•	•	•	•	•	•
Malaysia		•	•			
Maldives		•	•			
Mali		•	•	•		•
Malta	•	•	•	•	•	•
Marshall Islands			•			
Mauritania			•			
Mauritius	•	•	•	•	•	•
Mexico	•	•	•	•		•
Micronesia (Fed States of)			•			
Monaco	•		•			
Mongolia		•	•	•	•	•
Morocco	•	•	•	•		•
Mozambique			•	•		
Myanmar			•			
Namibia	•		•	•	•	•
Nauru			•			
Nepal	•	•	•	•	•	•
Netherlands	•	•	•	•	•	•
New Zealand	•	•	•	•	•	•
Nicaragua		•	•	•	•	•
Niger			•	•	•	•
Nigeria		•	•	•		•
Niue			•			
Norway	•	•	•	•	•	•
Oman			•			

	Convention against Torture	Convention for the elimination of all forms of Discrimination Against Women	Convention on the rights of the child	Convention on Civil & Political rights	(First) Optional protocol	Convention Social, Economic & Cultural rights
Pakistan		•	•			
Palau			•			
Panama	•	•	•	•	•	•
Papua New Guinea		•	•			
Paraguay	•	•	•	•	•	•
Peru	•	•	•	•	•	•
Philippines	•	•	•	•	•	•
Poland	•	•	•	•	•	•
Portugal	•	•	•	•	•	•
Qatar			•			
Republic of Korea	•	•	•	•		•
Republic of Moldova	•	•	•	•		•
Romania	•	•	•			•
Russian Federation	•	•	•	•	•	•
Rwanda		•	•			•
Saint Kitts and Nevis		•	•			
Saint Lucia		•	•			
St Vincent and the Grenadines		•	•	•		•
Samoa		•	•			
San Marino			•	•		•
Sao Tome and Principe			•			
Saudi Arabia			•			
Senegal	•	•	•	•	•	•
Seychelles	•	•	•	•	•	•
Sierra Leone		•	•	•	•	•
Singapore		•	•			
Slovakia	•	•	•	•	•	•
Slovenia	•	•	•	•	•	•
Solomon Islands			•			•
Somalia	•			•	•	•
South Africa		•	•			
Spain	•	•	•	•	•	•

	Convention against Torture	Convention for the elimination of all forms of Discrimination Against Women	Convention on the rights of the child	Convention on Civil & Political rights	(First) Optional protocol	Convention Social, Economic & Cultural rights
Sri Lanka	•	•	•	•		•
Sudan			•	•		•
Suriname		•	•	•	•	•
Swaziland			•			
Sweden	•	•	•		•	
Switzerland	•					
Syrian Arab Republic			•	•		•
Tajikistan	•	•	•			
Thailand		•	•			
Yugoslav Rep of Macedonia	•	•	•	•	•	
Togo	•	•	•	•	•	•
Tonga			•			
Trinidad and Tobago		•	•	•	•	•
Tunisia	•	•	•	•		•
Turkey	•					
Turkmenistan			•			
Uganda	•	•	•	•	•	•
Ukraine	•	•	•	•	•	•
United Arab Emirates			•			
United Kingdom	•	•	•	•		•
United Rep of Tanzania		•	•	•		
United States of America	•					
Uruguay	•	•	•	•	•	•
Uzbekistan	•	•	•	•	•	•
Vanuatu		•	•			
Venezuela	•	•	•	•	•	•
Viet Nam		•	•	•		•
Yemen	•	•	•	•		•
Yugoslavia	•	•	•	•		•
Zaire	•	•	•	•	•	•
Zambia		•	•	•		•
Zimbabwe		•	•	•		•

Note: This list of resources, although not exhaustive, can direct you to additional information about the topics discussed in this book. Resources that could be considered "practice guides" ("how to" books) are marked with an. For in-depth research on human rights issues, see: Jack Tobin and Jennifer Green,* Guide to Human Rights Research *(Cambridge, MA: Human Rights Program, Harvard Law School, 1994) or Katherine C. Hall,* International Human Rights Law: A Resource Guide *(Queenstown, MD: The Aspen Institute 1993).*

International System

"Symposium: International Human Rights," *Santa Clara Law Review*, vol. 20, pp. 559-772 (1980)("how to" articles on the 1503 procedure, ILO, European Convention and the Inter-American Commission on Human Rights). *

Alston, Philip. "The Commission on Human Rights," *The United Nations and Human Rights* (New York: Oxford University Press 1992).

Amnesty International, *Summary of Selected International Procedures and Bodies Dealing With Human Rights Matters* (London: Amnesty International, 1989).*

Andreopoulos, George and Richard Pierre Claude, eds., *Human Rights Education for the 21st Century: Conceptual and Practical Challenges*, (University of Pennsylvania Press, 1996).

Buergenthal, Thomas, *International Human Rights in a Nutshell*, 2nd ed., (St. Paul, MN: West Publishing Co., 1995).

Burgers, J. Herman and Hans Danelius, *The United Nations Convention Against Torture: A Handbook on the Convention Against Torture and Other Cruel, Inhuman or Degrading Treatment or Punishment* (Boston: M. Nijhoff, 1988).

de Zayas, Alfred M., "The Follow-Up Procedure of the UN Human Rights Committee," *International Commission of Jurists Review*, n.47, p. 28 (December 1991).

de Zayas, Alfred M., Jacob Moller, and Torkel Opsahl, *"Application of the International Covenant on Civil and Political Rights Under the Optional Protocol by the Human Rights Committee,"* Comparative Juridical Review, vol. 26, p. 3 (1989).

Drzemczewski, Andrew and Jens Meyer-Ladewig, *"Principal Characteristics of the New ECHR Control Mechanism, As Established by Protocol No. 11, Signed on 11 May 1994,"* 15 Human Rights Law Journal 81 (1994).

Hannum, Hurst, ed., *Guide to International Human Rights Practice*, 2nd ed. (Philadelphia: University of Pennsylvania Press, 1992). *

Harris, D.J., M. O'Boyle, and C. Warbrick, *Law of the European Convention on Human Rights*, (London: Butterworths, 1995).

Human Rights Watch, Women's Rights Project, *The Human Rights Watch Global Report on Women's Human Rights*, (New York: Human Rights Watch, 1995).

INFO-PACK, *Information on UN Human Rights Procedures: Beyond Vienna* (Geneva: International Service for Human Rights, 1995).*

International Labour Office, *Manual on Procedures Relating to International Labour Conventions and Recommendations* (Geneva: ILO 1984).*

Manual on Human Rights Reporting: Under Six Major International Human Rights Instruments, (New York: United Nations, 1991).

Shelton, Dinah, "Individual Compliant Procedure under the United Nations 1503 Procedure and the Optional Protocol to the International Covenant on Civil and Political Rights," *Guide to International Human Rights Practice*, Hannum, Hurst, ed. (University of Pennslvania Press: 1984)

United Nations Reference Guide in the Field of Human Rights, (New York: United Nations, 1993).

Regional Systems

Overview

Weston, Burns H., Lukes, Robin Ann, Hnatt, Kelly M., "Regional Human Rights Regimes: A Comparison and Appraisal," *Vanderbilt Journal of Transnational Law*, vol. 20, n. 4, p. 585 (October 1987).

African System

Amnesty International, *A Guide to the African Charter on Human and Peoples' Rights* (London: Amnesty International, 1991). *

Folsom, Ralph. *European Union Law.* (West Publishing, St. Paul: 1994).

Feldman, David, "Protecting Human Rights in Africa: Strategies and Roles of NGOs," *International and Comparative Law Quarterly*, vol. 45, n. 3, p. 757 (July 1996).

International Commission of Jurists, *How to Address a Communication to the African Commission on Human and Peoples' Rights* (Geneva: International Commission of Jurists, 1992). *

Jensen, Marianne and Karin Poulsen, *Human Rights and Cultural Change: Women in Africa*, (Copenhagen: Danish Centre for Human Rights, 1993).

Jensen, Marianne, and Karin Poulsen, *Rethinking Women and Human Rights in Africa: A Cross-Cultural Comparison Between Ghana and Swaziland* (Copenhagen: Institu for Kultursociologi, 1992).

Liebenberg, Sandra, ed., *The Constitution of South Africa From a Gender Perspective* (Cape Town: Community Law Centre at the University of the Western Cape, 1995).

Nyamu, Celestine Itumbi, "Rural Women

and the United Nations Convention on the Elimination of All Forms of Discrimination Against Women: A Critical Appraisal," (monograph, May 1995).

Oloka-Onyango, J. and Sylvia Tamale, "'The Personal is Political,' or Why Women's Rights are Indeed Human Rights: an African Perspective on International Feminism," *Human Rights Quarterly*, vol. 17, n. 4, p. 691 (Nov. 1995).

Welch, Claude E., "Human Rights and African Women: A Comparison of Protections Under Two Major Treaties," *Human Rights Quarterly*, vol. 15, n.3, p. 549 (August 1993).

Inter-American System

Buergenthal, Thomas, *Protecting Human Rights in the Americas*, 3rd ed., (Kehl am Rhein: N.P. Engel, 1990).

Culliton, Katherine M., "Finding a Mechanism to Enforce Women's Right to State Protection from Domestic Violence in the Americas," *Harvard International Law Journal*, vol. 34, n. 2, p. 507 (Spring 1993).

Dulitzky, Ariel, *Los Tratados de Derechos Humanos en el Constitucionalismo Iberoamericano, en Estudios Especializados de Derechos Humanos I*, (Costa Rica: Instituto Interamericano de Derechos Humanos, 1996), pp. 129-166.

Grossman, Claudio, "The Inter-American System: Opportunities for Women's Rights," *American University Law Review*, vol. 44, n. 4, p. 1304 (April 1995).

Krsticevic, Viviana. "The Development and Implementation of Legal Standards Relating to Impunity in the Inter-American System of Human Rights Protection," *Interrights Bulletin*, 1996, p. 91.

Krsticevic, Viviana, *La Denuncia individ-*

ual ante la Comision Interamericana de Derechos Humanos en el sistema interamericano de proteccion de los derechos humanos, in Proteccion internacional de los derechos humanos de las mujeres, (San Jose, Costa Rica: Instituto Interamericano de Derechos Humanos (IIDH), 1997), pp. 185-217.

Nieto-Navia, Rafael, Introduccion al sistema interamericano de proteccion a los derechos humanos, (Bogota: Temis, 1993).

Norris, Robert, "Observations in Loco: Practice and Procedure of the Inter-American Commission on Human Rights, 1979-1983, Texas Journal of International Law, vol.19, p. 285 (1984).*

Nunez Palacios, Susana, Actuacion de la comision y la corte interamericanas de derechos humanos, (Azcapotzalco: Universidad Autonoma Metropolitana, 1994).

Shelton, Dinah L., "Improving Human Rights Protections: Recommendations for Enhancing the Effectiveness of the Inter-American Commission and the Inter-American Court of Human Rights," American Journal of International Law and Policy, vol. 3, p. 323 (1988).

Vivanco, Jose Miguel, Human Rights in the Inter-American System: Possibilities and Limitations, (booklet, no publisher listed, May 10, 1990).

Wilson, Richard J. "Researching the Jurisprudence of the Inter-American Commission on Human Rights: A Litigator's Perspective," 10 American University International Law and Policy Journal 1 (Fall 1994).

European System

Bloed, Arie, ed., The Conference on Security and Co-operation in Europe: Analysis and Basic Documents, 1972-1993, 2nd ed. (Boston: Martinus Nijhoff, 1993).

Buquicchio-De Boer, Maud, Equality Between the Sexes and the European Convention on Human Rights: A Survey of Strasbourg Case Law (Human Rights Files No. 14) (Strasbourg, Council of Europe 1995).

Callender, Rosheen and Frances, Meenan, Equality in Law Between Men and Women in the E.C. (Norwell, Mass., Kluwer Academic Publishers 1994).

Cameron, Iain, and Maja Kirilova, Eriksson, An Introduction to the European Convention on Human Rights, (Uppsala: Iustus Forlag, 1995). *

Clements, Luke, European Human Rights: Taking a Case Under the Convention, (London: Sweet and Maxwell, 1994). *

Directorate of Human Rights, Council of Europe, Women in the Working World: Equality and Protection Within the European Social Charter, (Strasbourg, Council of Europe Publishing, 1995).

Gomien, Donna, David Harris, and Leo Zwaak, Law and Practice of the European Convention on Human Rights and the European Social Charter, (Strasbourg: Council of Europe, 1996). *

Hendriks, Aart, "Revised European Social Charter," Netherlands Quarterly of Human Rights Vol. 14, No. 3, p. 341 (September 1996).

Catherine Hoskyns, "The European Union and the Women Within," p. 19 in Elman, R. Amy, Sexual Politics and the European Union: The New Feminist Challenge (Providence, R.I. and Oxford: Berghahn Books, 1996)].

Jacobs, Francis Geoffrey and Robin C.A. White, The European Convention on Human Rights (Oxford : Clarendon Press, 2nd ed. 1996).

Klerk, Yvonne, "Protocol No. 11 to the European Convention for Human Rights: A Drastic Revision of the Supervisory Mechanism Under ECHR," Netherlands

Quarterly of Human Rights Vol. 14, no. 1 (March 1996).

Lasok, K.P.E., *The European Court of Justice: Practice and Procedure* (London: Butterworths, 2nd ed. 1994).

Schmidt, Marcus, "Individual Based Human Rights Complaints Procedures Based on United Nations Treaties and the Need for Reform," *International and Comparative Law Quarterly* Vol. 41 no. 3 p. 645 (July 1992).

Asia

Guhathakurta, Meghna and Khadija Lina, *Empowering Women at the Grassroots: A manual for women's human rights education*, (Dhaka: Nagorik Uddyog [Citizen's Initiative], August 1995).

Jones, Sidney, "Regional Instruments and Protecting Human Rights in Asia," *Proceedings of the Annual Meeting— American Society of International Law*, vol. 89, p. 475 (1989).

Law and Society (Symposium on Women and Law in Asia, various authors), *Law and Society*, vol. 28 (August 1994).

Leary, Virginia, "Human Rights in the Asian Context: Prospects for Regional Human Rights Institutions," *Connecticut Journal of International Law*, vol. 2, n.2, p. 319 (Spring 1987).

Qayyum, Shabnam, *Kashmir men khavatin ki be hurmati* (Mirpur, Azad Kashmir: Tahrik-i Hurriyat-i Jammun Kashmir, 1991)(women and human rights in India, Kashmir).

Samuels, Harriet, "Upholding the Dignity of Hong Kong Women: Legal Responses to Sexual Harassment," *Asia Pacific Law Review*, vol. 4, n. 2, p. 90 (Winter 1995).

Van Dyke, John M., "Prospects for the Development of Inter-Governmental Human Rights Bodies in Asia and the Pacific," *Molanesian Law Journal*, vo., 16, p. 28 (1988).

Welch, Claude E. and Leary, Virginia A, *Asian Perspectives on Human Rights*, (Boulder: Westview Press, 1990).

Women's Human Rights

Afkhami, Mahnaz, *Faith and Freedom, Women's Human Rights in the Muslim World*, (Syracuse, NY: Syracuse University Press, 1995).

Afkhami, Mahnaz and Haleh Vaziri, *Claiming Our Rights: A Manual for Women's Human Rights Education in Muslim Societies*, (Bethesda, MD: Sisterhood is Global Institute, 1996).

Alfredsson, Gudmundur and Katarina Tomasevski, eds., *A thematic guide to documents on the human rights of women: global and regional standards adopted by intergovernmental organizations, international non-governmental organizations, and professional associations*, (Cambridge, MA: Kluwer Law International, 1995).

Blatt, Deborah, "Recognizing Rape as a Method of Torture," *NYU Review of Law and Social Change*, (New York: New York University Law Publications, 1992), pp. 821-865.

Bunch, Charlotte, "Women's Rights as Human Rights: Toward a Re-Vision of Human Rights," *Human Rights Quarterly*, (Baltimore: Johns Hopkins University Press, 1990).

Bunch, Charlotte, and Roxana Carillo, *Gender Violence: A Development and Human Rights Issue*, (New Brunswick, NJ: Center for Women's Global Leadership, 1991).

Bunch, Charlotte, and Niamh Reilly, *Demanding Accountability: The Global Campaign and Vienna Tribunal for Women's Human Rights* (New York: United Nations Development Fund for Women, 1994).

Butegwa, Florence, "Women's Human Rights: A Challenge to the International Human Rights Community," *The Review*

(International Commission of Jurists, 1993), pp. 71-80.

Byrnes, Andrew and Jane Connors, "Enforcing the Human Rights of Women: A Complaints Procedure for the Women's Convention? Draft Optional Protocol to the Convention on the Elimination of All Forms of Discrimination Against Women," *21 Brooklyn Journal of International Law 679* (1996).

Charlesworth, H., C. Chinkin, and S. Wright, (1991). "Feminism Approaches to International Law" *American Journal of International Law*, 1991.

Cook, Rebecca J., "State Responsibility for Violations of Women's Human Rights," *Harvard Human Rights Journal* (Cambridge, MA: Harvard Human Rights Journal, 1994), pp. 125-175.

Cook, Rebecca J., "International Protection of Women's Reproductive Rights," *New York University Journal of International Law and Politics*, (New York: New York University, 1992).

Cook, Rebecca J., ed. *Human Rights of Women: National and International Perspectives*, (Philadelphia: U. Penn. Press, 1994). (See, especially, Byrnes, Andrew, "Toward More Effective Enforcement of Women's Human Rights Through the Use of International Human Rights Laws and Procedures", and Bayefsky, Anne, "General Approaches to the Domestic Application of Women's International Human Rights Law").

Coomaraswamy, Radhika, *Report(s) Submitted by the Special Rapporteur on Violence Against Women, Its Causes and Consequences, Ms. Radhika Coomaraswamy, in Accordance with Commission on Human Rights Resolution*, U.N. Doc. E/CN.4/1995/42 (1995); UN Doc. E/CN.4/1996/53 (1996) ;UN Doc. E/CN.4/1997/47 (1997).

Copelon, Rhonda and B.E. Hernandez. *Sexual and Reproductive Rights and Health as Human Rights: Concepts and Strategies–An Introduction for Activists.* (New York: City University of New York Law School, International Human Rights Law Clinic, 199)

Dunlap, Joan, Rachel Kyte, and Mia MacDonald, "Women Redrawing the Map: The World After the Beijing and Cairo Conferences," *SAIS Review*, vol. 16, n.1, p. 153 (winter-spring 1996).

Freedman, L. and S. Isaacs. "Human Rights and Reproductive Choice" *Studies In Family Planning*, No. 24, 1993, pp. 18-30.

Freeman, Marsha A. and Arvonne S. Fraser, "Women's Human Rights: Making the Theory a Reality," *Human Rights: An Agenda for the Next Century*, (Washington, DC: American Society of International Law, 1994), pp. 103-135.

Green, Jennifer, Rhonda Copelon, Patrick Cotter and Beth Stephens, "Affecting the Rules for the Prosecution of Rape and Other Gender-Based Violence Before the International Criminal Tribunal for the Former Yogoslavia: A Feminist Proposal and Critique" *Hasting's Women's Law Journal*, Vol. 5, No. 2, Summer 1994. (University of California, Hastings College of Law).

Kerr, Joanna, ed., *Ours By Right: Women's Rights as Human Rights*, (London and New Jersey: Zed Books Ltd. in association with The North-South Institute, 1993).

Mayer, Ann Elizabeth, *Islam and Human Rights: Tradition and Politics*, (Boulder and San Francisco: Westview Press, London: Pinter Press, 1991).

Mertus, Julie and Pamela Goldberg, "A Perspective on Women's Human Rights After the Vienna Declaration: The Inside/Outside Construct," *New York University Journal of International Law and Politics*, vol. 26, n. 2, p. 201 (Winter 1994).

Mertus, Julie, with Mallika Dutt, and Nancy Flowers, *Local Action/ Global Change: Learning About the Human Rights of Women and Girls* (New York: United Nations/ UNIFEM, forthcoming 1997)(editions available in Albanian, Arabic, Croatian, Russian, Serbian, Spanish, Ukrainian and other languages — contact the Center for Women's Global Leadership, 27 Clifton Ave., New Brunswick, NJ 08903, USA or e-mail suitcase@igc.apc.org). *

Peters, Julie and Andrea Wolper, *Women's Rights, Human Rights: International Feminist Perspectives*, (New York: Routledge, 1995).

Rehof, Lars Adam, *Guide to the Travaux Preparatories of the United Nations Convention on the Elimination of All Forms of Discrimination Against Women* (Dordrecht: M. Nijhoff Publishers, 1993).

Reilly, Niamh, *Without Reservation: The Beijing Tribunal on Accountability for Women's Human Rights* (New Brunswick: Center for Women's Global Leadership, 1996).

Rodriguez-Trias, Helen, "From Cairo to Beijing — Women's Agenda for Equality," *American Journal of Public Health*, vol. 86, n. 3, p. 305 (March 1996).

Schuler, Margaret, ed., *Claiming Our Place: Working the Human Rights Systems to Women's Advantage*, (Washington, D.C.: Women, Law and Development International, 1993). *

Schuler, Margaret, ed., *From Basic Needs to Basic Rights: Women's Claim to Human Rights*, (Washington, D.C.: Women, Law and Development International, 1995).

Sweeney, Jane P., "Promoting Human Rights Through Regional Organizations: Women's Rights in Western Europe," *Human Rights Quarterly*, vol. 6, n. 4, p. 491 (November 1984).

Thomas, Dorothy Q. and Michele E. Beasley, "Domestic Violence as a Human Rights Issue," *Human Rights Quarterly* (Baltimore: Johns Hopkins University Press, 1993), pp. 36-62.

Thomas, Dorothy Q. and Regan E. Ralph, "Rape in War: Challenging the Tradition of Impunity," *SAIS Review*, (Washington, DC: Johns Hopkins University Foreign Policy, 1994).

Tomasevski, Katarina, *Women and Human Rights*, (London and New Jersey: Zed Books Ltd, 1993).

United Nations High Commissioner for Refugees, *Sexual Violence Against Refugees: Guidelines on Prevention and Response*, (Geneva: United Nations High Commissioner for Refugees, 1995).

United Nations High Commissioner for Refugees, *Guidelines on the Protection of Refugee Women*, (Geneva: United Nations High Commissioner for Refugees, 1991).

United Nations High Commissioner for Refugees, *Women Refugees in International Perspectives, 1980-1990: An Annotated Bibliography*, (Geneva: UNHCR, 1997).

University of California, *Hastings College of Law. Hastings Women's Law Journal*, Vol. 5, No. 2, Summer 1994. (this volume contains multiple articles on international law and women's rights)

Wagley, Anne "How to Use the New Human Rights Laws," *National Lawyers Guild Practitioner*, vol. 51, n. 3, Summer pp. 71-95 1994.

Weissbrodt, David and Penny Parker, *The United Nations Commission on Human Rights, Its Sub-Commission, and Related Procedures: An Orientation Manual* (Geneva: International Service for Human Rights, 1993).*

Women's Rights in the United Nations: A Manual on How the UN Human Rights Mechanisms Can Protect Women's Rights (Geneva: International Service for Human Rights, 1995).

Human Rights Fact-Finding and Reporting

Centre for Human Rights, *Manual on Human Rights Reporting: Under Six Major International Human Rights Instruments,* UN Doc. HR/PUB/91/1, 79-125 (Geneva: United Nations, 1991). *

English, Kathryn and Adam Stapleton, *The Human Rights Handbook: A Practical Guide to Monitoring Human Rights* (Colchester, UK: The Human Rights Centre, University of Essex, 1995). *

Handbook on Fact-Finding and Documentation of Human Rights Violations, (Thailand: Asian Forum for Human Rights And Development and Union for Civil Liberty, 1993).

IWRAW and the Commonwealth Secretariat, *Assessing the Status of Women: A Guide to Reporting Under the Convention on the Elimination of All Forms of Discrimination Against Women* (Minneapolis: International Women's Rights Action Watch and Commonwealth Secretariat, Second Edition, 1996). *

Lillich, Richard, *Fact-Finding Before International Tribunals* (New York: Transnational Publishers, 1992).

Orentlicher, Diane, "Bearing Witness: The Art and Science of Human Rights Fact-Finding," *Harvard Human Rights Journal,* vol. 3, p. 83 (1990).

WOMEN'S HUMAN RIGHTS RESOURCES at the Bora Laskin Law Library, University of Toronto, includes a bibliography on international women rights

United Nations Documents: Collections

Brownlie, Ian, ed., *Basic Instruments on Human Rights,* 4th ed., (Oxford: Clarendon Press, 1995).

Hamalengwa, M., C. Flinterman, and E.V.O. Dankwa, *The International Law of*

Human Rights in Africa: Basic Documents and Annotated Bibliography, (Boston: M. Nijhoff, 1988).

Human Rights: A Compilation of International Instruments, 2 vols, (Geneva: United Nations Centre for Human Rights, 1994).

International Labour Conventions and Recommendations 1919-1991, 2 vols., (Geneva: International Labour Office, 1992).

Twenty-Five Human Rights Documents, 2nd ed. (New York: Columbia University, Center for the Study of Human Rights, 1994)(low price, high value volume good for all the essential documents).

Media Resources

Communications Consortium Media Center, *Strategic Media: Designing a Public Interest Campaign* (Washington, DC: Communications Consortium, 1994).

Women's Human Rights Resources on the Internet

General UN Human Rights Information
http://www.un.org

General page for most UN sources.

http://www.unhchr.ch

Site for the UN High Commissioner for Human Rights and the Centre for Human Rights in Geneva. Contains documents from the Human Rights Commission annual sessions, including all reports of the Special Rapporteur on Violence Against Women Its Causes and Consequences. Principle reports include: U.N. Doc. E/CN.4/1995/42 (1995); UN Doc. E/CN.4/1996/53 (1996); UN Doc. E/CN.4/1997/47 (1997).

International Human Rights Instruments –Women's Human Rights
http://www.umn.edu/humanrts/instree/auoe.htm

The Human Rights Library collection of instruments on women's human rights in English, French and Spanish.

Internet Resources for Women's Legal and Public Policy
http://asa.ugl.lib.umich.edu/chdocs/wome npolicy/womenlawpolicy.html

This guide directs users to Internet-based resources related to legal and public policy issues for women.

United Nations: Commission on the Status of Women
http://www.undp.org/fwcw/csw.htm

The CSW monitors the implementation of the Platform for Action adopted by the Fourth World Conference on Women.

United Nations: Committee on the Elimination of Discrimination Against Women (CEDAW)
http://www.un.org/DPCSD/daw/cedaw.htm

The Committee on the Elimination of Discrimination Against Women monitors compliance with the Convention on the Elimination of All Forms of Discrimination Against Women.

United Nations: Division for the Advancement of Women
http://www.un.org/DPCSD/daw/

The Division for the Advancement of Women (DAW) is responsible for servicing the Commission on the Status of Women (CSW), the main UN policy-making body for women. It also services the Committee on the Elimination of Discrimination against Women (CEDAW).

Women's Human Rights
http://www.law-lib.utoronto.ca/diana/

Women's Human Rights has internet links on the topic of women's human rights to make it easier to locate substantive research on the Internet. The links are divided into categories: Women's

Human Rights General, Fourth Conference on Women (Beijing), Girl Child, Labour / Employment Rights, Refugee Women, Reproductive Rights, Right to Health and Violence Against Women.

WomensNet@igc
http://www.igc.apc.org/womensnet/

WomensNet is a non-profit computer network for women, activists and organizations using computer networks for information sharing and increasing women's rights.

Women's Resources on the Web
http://www.women-online.com/women/

This page contains a large index of web resources including a section on politics and activism.

Please note that these links change and develop constantly. For the most up to date list of internet links on women's human rights, refer to http://www.wld.org

This alphabetical list of resources is not exhaustive. It offers a general sense of the range of international and regional organizations addressing women's human rights. For lack of space, national organizations are not listed here.
Refer to http://www.wld.org/hrlinks for updates to this list.

Global

Amnesty International-USA
322 Eighth Avenue
New York, NY 10001
USA
Tel: +1-212-633-4200
Fax: +1-212-627-1451
E-mail: aiaction@amnesty-usa.org_
Website: http://www.amnesty-usa.org

Center for Women's Global Leadership
27 Clifton Avenue
New Brunswick, NJ 08903
USA
Tel: +1-908-932-8782
Fax: +1-908-932-1180
Email: mailto:cwgl@icg.apc.org

Equality Now
226 West 58th Street
New York, NY 10019
Tel: +1-212-586-0906
Fax: +1-212-586-1611
Email: equalitynow@igc.apc.org

Global Alliance Against Traffic in Women
P.O. Box 1281
Bangkok Post Office
Bangkok 10500
Thailand
Tel: +662-435-5565
Fax: +662-434-6774

Human Rights Watch Women's Rights Project (New York)
485 Fifth Avenue,
New York, NY 10017-6104
USA
Tel: +1-212-972-8400
Fax: +1-212-972-0905
Email: hrwnyc@hrw.org
Website: http://www.hrw.org

Human Rights Watch Women's Rights Project (Washington)
1522 K Street, NW, #910
Washington, DC 20005-1202
USA
Tel: +1-202-371-6592
Fax: +1-202-371-0124
Email: hrwdc@hrw.org
Website: http://www.hrw.org

International Centre for Human Rights and Democratic Development (ICHRDD)
63 Rue de Bresoles, Suite 100
Montreal, Quebec H2Y 1V7
Canada
Tel: +1-514-283-6073
Fax: +1-514-283-3792
Email: ichrdd@web.apc.org
Website: http://www.ichrdd.ca/

International Gay and Lesbian Human Rights Commission
1360 Mission St., Suite 200
San Francisco, CA 94103
USA
Tel: +1-415-255-8680
Fax +1-415-255-8662 fax
Email: iglhrc@iglhrc.org
Website: http://www.iglhrc.org

International Human Rights Law Group
Women's Rights Project
1601 Connecticut Ave, NW
Suite 700
Washington, DC 20009
USA
Tel: +1-202-232-8500
Fax: +1-202-232-6731
Email: lawgroup@igc.apc.org

APPENDIX 5 NGO's RESOURCES: INTERNATIONAL WOMEN'S HUMAN RIGHTS ADVOCACY GROUPS

A
5

International Women Judges
Foundation
815 15th. St., NW
Suite 601
Washington, DC 20005
USA
Tel: +1-202-393-0955
Fax: +1-202-393-0125
Email: iwjf@igc.apc.org

International Women's Rights
Action Watch IWRAW
University of Minnesota
301 Nineteenth Avenue South
Minneapolis, MN 55455
USA
Tel: +1-612-625-5557
Fax: +1-612-625-3513
Email: mfreeman@hhh.umn.edu

International Women's Human Rights
Law Clinic
CUNY Law School
65-21 Main Street
Flushing, NY 11367
USA
Tel: +1-718-575-4300
Fax: +1-718-575-4478
Email: iwhr@maclaw.law.cuny.org

International Women's Tribune Center
777 UN Plaza
New York, NY 10017
USA
Tel: +1-212-687-8633
Fax: +1-212-661-2704
Email: iwtc@igc.apc.org

STV-Foundation Against Trafficking
P.O. Box 1455, 3500 BL
Utrecht
The Netherlands
Tel: +31-30-2716044
Fax: +31-30-2716084
S.T.V@inter.NL.net

Sisterhood is Global Institute
4343 Montgomery Ave
Suite 201
Bethesda, MD 20814
USA
Tel: +1-301-657-4355
Fax: +1-301-657-4381
Email: sigi@igc.apc.org_

Working Group on the Human Rights
of Women
7204 Central Avenue
Takoma Park, MD 20912-6451
USA
Tel: +1-301-270-0436
Fax: +1-301-270-0321
E-mail: lbrowning@igc.apc.org

Women, Law & Development
International
1350 Connecticut Avenue, NW,
Suite 407
Washington, DC 20036-1701
USA
Tel: +1-202-463-7477
Fax: +1-202-463-7480
E-mail: wld@wld.org
Website: http://www.wld.org

Women Living Under Muslim Laws
Boite Postale 23-34790
Grabels, Montpellier
France
Tel: +33467-109-166
Fax: +33467-109-167

Africa

ISIS-WICCE Uganda
P.O. Box 4934
Kampala
Uganda
Tel: +256-41-266-007/8
Fax: +256-41-268-676
Email: isis@starcom.co.ug

189

Women in Law and Development in Africa (WiLDAF)
Zambia House, Union Avenue
P.O. Box 4622
Harare
Zimbabwe
Tel: +2634-752-105
Fax: +2634-781-886
Email: wilda@mango.zw

Asia

Asia Pacific Forum on Women, Law & Development (APWLD)
APDC Pesiaran Duta, 9th Floor
P.O. Box 12224
Kuala Lumpur
Malaysia
Tel: +603-255-0648 or +603-254-1371
Fax: +603-255-1160
Email: apwld@pactok.peg.apc.org

Asian Center for Women's Human Rights (ASCENT)
309 Acacia Lane, Clairmont Townhomes
Mandalugong City MM
Philippines
Fax: +632-533-0452
Email: ascent@mnl.cyberspace.com.ph

ISIS International - Manila
P.O. Box 1837
Quezon City Main
Quezon City 1100
Philippenes
Tel: +1-632-96-72-97
Fax: +1-632-92-41-065
Email: isis@phil.gn.apc.org

Asian Women's Human Rights Council (AWHRC)
P.O. Box 190
1099 Manila
Philippines
Tel: +632-921-5571 Fax: +632 299-9437
Email: awhrc@phil.gn.apc.org

IWRAW-Asia Pacific
2nd Fl. Blk.F, Anjung Felda
Jl. Maktab
54000 Kuala Lumpur
Malaysia
Tel: +603-291-3292
Fax +603-292-9958

Latin America

Comité Latinoamericano por la Defensa de los Derechos de la Mujer (CLADEM - Latin American Committee for the Defense of Women's Rights)
Jr. Estados Unidos 1295, apt. 702
Apartado Postal 11-0470
Jesus Maria, Lima II
Peru
Tel: +51-1-463-9237
Fax: +51-1-463-5898
Email: postmast@cladem.org.pe

ILSA (Inter-American Association for Alternative Law)
Gender and Power Program
Calle 38 #16-24
Bogota D.C.
Colombia
Tel: +571-288-9061 or +571-288-0416
Fax: +571-268-0351

Inter-American Institute for Human Rights
Women and Human Rights Program
Apartado Postal 10081 - 1000
San Jose
Costa Rica
Tel: +506-234-0404
Fax: +506-234-0955

ISIS Santiago
Esmeraldas 636, 2o piso
Casilla 2067, Correo Central
Santiago
Chile
Tel: +562-633-4582
Fax: +562-638-3182
E-mail: isis@ax.apc.org

Central and Eastern Europe

East-East Legal Committee of the Network of East West Women
Urszula Nowakowska
Women's Rights Center
ul. Wilcza 60 lok. 19
00-679 Warsawa
Poland
Tel: +4822-620-7624
Fax: +4822-621-3537
Email: temida@medianet.com.pl

Network of East West Women
1601 Connecticut Ave. NW
Suite 302
Washington, DC 20009
USA
Tel: +1-202-265 3585
Fax: +1-202-667-4945
Email: newwdc@igc.apc.org.

Inter-American Commission on Human Rights
1889 F Street, NW
Washington DC, 20006
Tel: +1-202 458-6002
Fax: +1-202458-3992

Inter-American Commission on Women
1889 F Street, NW
Washington DC, 20006
Tel: +1-202 458-6084
Fax: +1-202458-6094

Inter-American Court of Human Rights
(*Corte Interamericana de Derechos Humanos*)
Oliver Jackman (Miembro)
Apartado 6906
San Jose, Costa Rica
Tel: +506-34-04-01 al/to 05.
Tel: +506-234-0581-0583
Fax: +506-234-0584

African Commission on Human and Peoples' Rights
Germaine Baricako
Issac Nuguema, Chairman
PO Box 673
B.P. 962
Kariaba Avenue
Banjul, GAMBIA
Libreville, Gabon
Tel: +220 392 962
Tel: +241-732-420
Fax: +220 390 764
Fax: +241-760-993

Organisation of African Unity
P.O. Box 3243
Addis Ababa, Ethiopia
Tel: +15-77-00

European Commission on Human Rights
Hans Christian Kruger, Secretaire de la Commission
Council of Europe
BP-431, R6-67006
Strasbourg-CEDEX
FRANCE
Tel: +33-88 412018; 41-2000
Fax: +33-88 412792; 41-2791

European Court of Human Rights
Herbert Petzold, Registrar
Consil de l'Europe
BP-431, R6-67006
Strasbourg-CEDEX
FRANCE
Tel: +33-88 41-2000
Fax: +33-88 41-2791

Centre for Human Rights
United Nations Office
Palais des Nations
CH-1211 Geneva 10
SWITZERLAND
Tel: +41-22 917 1234
Fax: +41-22 917 0123

UN Division for the Advancement of Women

2 United Nations Plaza
Rm. DC2-1220
New York, N.Y. 10017
Tel: +1-212 963-5086
Fax: +1-212 963-3463

Special Rapporteur on Violence Against Women
Radhika Coomaraswamy
Centre for Human Rights
United Nations Office
Palais des Nations
CH-1211 Geneva 10
SWITZERLAND
Tel: +41-22 917 1234
Fax: +41-22 917 0123

Commission on the Status of Women
Division for the Advancement of Women
2 United Nations Plaza
New York, New York 10017
USA

In addition to the bodies listed above, EU institutions include: the Court of Auditors, the Economic and Social Committee, the Committee of the Regions and the European Investment Bank.

1

1503 Procedure, 17, 19, 24, 40, 41, 42, 43, 40–45, 50

A

addresses of human rights offices, 13, 45, 52, 85, 96, 162
advocacy
 definition, 116
 human rights
 definition, 118
 effectiveness and, 128
 judicial action, 123
 political action and, 122, 123, 151
 strategy, 19, 20, 21, 111, 116, 118, 119, 120, 121, 122, 123, 125, 126, 127, 138, 139, 151, 153, 156, 157, 158, 159
Afkhami, Mahnaz, 183
African Charter on Human and People's Rights, 101, 102, 103, 104, 162, 173, 181
African human rights system, 104
American Convention on Human Rights, 85, 86, 87, 88, 91, 92, 94, 95, 96, 98, 162, 173
American Declaration on the Rights and Duties of Man, 85, 86, 87, 91, 98, 162, 173
Amnesty International, 43, 180, 181, 188
Asia Pacific Forum on Women, Law & Development (APWLD), 189
Asian Center for Women's Human Rights, 189
Asian Center for Women's Human Rights (ASCENT), 189
Asian Women's Human Rights Council, 189

B

Beijing Declaration and Platform for Action, 162
Buergenthal, Thomas, 180, 181
Bunch, Charlotte, 184
Buquicchio-De Boer, 182
Byrnes, Andrew, 183, 184

C

Cairo Programme of Action, 162
 cases of emergency, 62
Center for Women's Global Leadership, 188
Centre For Human Rights, 162
CERD (Committee on the Elimination of Racism), 24, 27
Charter of the United Nations, 8, 13
Charter of The United Nations, 163
Charter-based bodies, 13–15
civil and political rights, 10, 11, 12, 63, 109, 167, 168

CLADEM (Latin American Committee for the Defense of Women's Rights), 190
Cold War, 76, 78
Commission on the Status of Women, 13, 14, 19, 24, 50, 51, 163, 187, 191
Committee of Independent Experts, 69, 70
Committee of Ministers, 59, 63, 66, 69, 73, 163
Committee on Economic, Social and Cultural Rights, 15, 163
Committee on the Elimination of Discrimination Against Women, 36–38
complaint procedures
 complaint information, 40, 50, 53, 101
Complaint procedures, 17
 complaint information, 40, 50, 53, 101
 complaint recourse, 15, 19, 24
Complaint-Recourse Procedures, 164
Conference on Security and Cooperation in Europe (CSCE):, 164
Connors, Jane, 183
Convention Against Torture and Other Cruel, Inhuman or Degrading Treatment or Punishment, 164, 172, 180
Convention for the Elimination of All Forms of Violence Against Women (CEDAW), 11, 15, 19, 24, 36, 37, 38, 50, 96, 103, 104, 110, 119, 162, 187
Convention for the Suppression of the Traffic Of Persons and the Exploitation of the Prostitution of Others, 164
Convention on the Prevention and Punishment of Genocide, 10
Convention on the Rights of the Child, 34, 164, 172
Convention Relating to the Status of Refugees, 164
Cook, Rebecca, 36, 38, 184
Coomaraswamy, Radhika, 184
Council of Europe, 58, 59, 61, 62, 63, 64, 66, 67, 69, 73, 74, 80, 81, 165, 182, 191
Covenant on Economic, Social and Cultural Rights (ICESCR), 15, 172
Customary International Law, 165

D

Declaration on the Elimination of Violence Against Women, 104, 165, 172
discrimination, 9, 27, 32, 36, 37, 38, 40, 46, 50, 52, 53, 59, 60, 67, 68, 76, 83, 101, 104, 111, 113, 114, 119, 125, 140, 163, 164
documenting violations
 analysis, 13, 92, 118, 120, 122, 123, 124, 127, 149, 152, 156, 158

follow up, 152

interviewing and, 53, 141, 142, 145, 146, 147, 148, 153

methods, 140–53

purpose,, 139

reporting on, 151

domestic remedies, 28, 29, 61, 62, 86, 94, 102

E

East-East Legal Committee of the Network of East West Women, 190

Economic and Social Council (ECOSOC):, 13, 14, 165

ECOSOC, 13, 14, 15, 29, 40, 42, 50, 51, 163, 165

enforcement mechanisms, 8, 9, 11, 12, 13, 15, 17, 18, 19, 20, 21, 24, 30, 32, 34, 37, 38, 41, 43, 48, 50, 52, 53, 58, 59, 60, 61, 68, 69, 70, 76, 77, 78, 80, 85, 86, 91, 98, 99, 101, 104, 108, 110, 111, 112, 116, 117, 120, 121, 122, 123, 127, 128, 138, 139, 150, 151, 153, 157, 166, 168, 169

equal treatment, 67, 80, 82, 84, 109

equality, 9, 36, 45, 46, 76, 84, 109, 114, 151, 164, 169

European Commission on Human Rights, 59, 61, 62, 63, 66, 80, 191

European Community, 58, 59, 63, 66, 78, 80, 82

European Court of Human Rights, 59, 60, 61, 63, 66, 70, 73, 80, 81, 191

European Court of Justice, 59, 60, 81, 83, 84, 182

European Economic Community, 80

European human rights system, 58–84

European Parliament, 59, 81, 84

European Social Charter, 59, 67, 68, 69, 70, 73, 173, 182

European Union, 80, 82, 80–82, 84, 165, 166

evidence, 34, 40, 42, 47, 62, 63, 66, 74, 98, 104, 138, 139, 145, 146, 148, 149, 152

F

friendly settlement, 63, 66, 87

G

gay and lesbian rights, 60

gender, 27, 32, 36, 50, 54, 98, 109, 111, 112, 113, 114, 119, 125, 127, 149, 150, 166, 167

gender-based violation, 53, 149

Grossman, Claudio, 181

H

Helsinki Accord, 76

Helsinki Final Act, 59, 76

human rights, 8, 12, 14, 59, 77, 117, 119, 139, 144, 166, 186

definition, 8

enforcement, 12–15

history, 8–11

law, 11–12

women, 27, 52, 53, 54, 86, 89, 92, 116, 119, 120, 121, 126, 127, 140

human rights advocacy, 118, 117–18

Human Rights Centre (Geneva), 41, 186

Human Rights Watch Women's Rights Project, 188

I

ICCPR, 10, 18, 24, 27, 28, 29, 30, 37, 38, 151, 167, 168

ICCPR (International Covenant on Civil and Political Rights), 10, 18, 24, 27, 28, 29, 30, 37, 38, 151, 167, 168

ICESCR, 10, 168

ICESCR (International Covenant on Economic, Social, and Cultural Rights), 10, 168

ILSA (Inter-American Association for Alternative Law, 190

initiate a case, 68

Inter-American Commission on Human Rights, 85, 86, 88, 89, 91, 93, 86–93, 94, 95, 96, 98, 99, 180, 181, 187

Inter-American Commission on Women, 98–99

Inter-American Convention on the Prevention, Punishment and Eradication of Violence Against Women, 98, 173

Inter-American Convention to Prevent and Punish Torture, 173

Inter-American Court of Human Rights, 85, 87, 88, 89, 94, 95, 96, 94–97, 99, 162, 181, 191

Inter-American human rights system, 85–101

Inter-American Institute for Human Rights, 190

interim measures, 64

International Bill of Rights, 10

International Centre for Human Rights and Democratic Development, 188

International Centre for Human Rights and Democratic Development (ICHRDD), 188

International Commission of Jurists, 180, 181

International Covenant on Civil and Political Rights (ICCPR), 10, 15, 18, 24, 172, 180

International Covenant on Economic, Social, and Cultural Rights (ICESCR), 10, 168

International Human Rights Law Group, 188

International Labour Organisation (ILO), 48, 45–50

International Women Judges Foundation, 188

International Women's Human Rights Law

Clinic, 189
International Women's Rights Action Watch
 (IWRAW), 186, 188
International Women's Rights Action Watch
 IWRAW, 186, 189
internet resources, 187
inter-state complaints, 27, 61, 68, 102
investigation, see documenting violations, fact
 finding, 28, 29, 42, 50, 59, 74, 77, 78, 87, 88,
 93, 103, 120, 138, 139, 140, 141, 142, 143,
 144, 145, 146, 149, 150, 151, 152, 153
ISIS International, 189, 190
IWRAW-Asia Pacific, 190

J

judges, 61, 66, 94, 96, 125, 127, 166

L

law reform, 111, 128
litigation, 18, 82, 83, 85, 89, 92, 95, 96, 123,
 157, 158
lobbying, 92, 93, 158

M

Maastricht Treaty, 80, 82
mechanisms
 charter-based, 13, 15
 of special interest to women, 45, 68, 73, 76,
 85
 specialized agencies, 13, 32
 treaty monitoring, 168
 treaty monitoring bodies, 168
 types of, 13, 32
 media, 53, 54, 62, 74, 77, 88, 92, 102, 119,
 126, 152, 153, 158
Mertus, Julie, 127, 184
mobilization, 116, 117, 118, 126, 127, 128, 159,
 167
Mobilization, 128
monitoring compliance, 13, 167

N

national human rights systems, 108–14
Network of East West Women, 190
Network of East West Women (NEWW), 190

O

OAS, 85, 86, 88, 91, 94, 162, 169
OAS (Organization of American States), 85,
 86, 88, 91, 94, 162, 169
OAU (Organisation of African Unity), 101,
 102, 103, 168, 169
obligations, 8, 9, 10, 11, 12, 13, 15, 17, 18, 27,
 29, 36, 37, 38, 45, 47, 53, 69, 73, 76, 77, 88,
 111, 113, 119, 139, 142, 150, 151, 152, 164,
 165, 169, 171
oral hearing, 30, 63, 66
Orentlicher, Diane, 186
Organisation of African Unity, 101, 102, 103,
 168, 169, 173, 191
Organisation on Security and Cooperation in
 Europe (OSCE), 164
Organization of American States, 85, 86, 88, 91,
 94, 162, 169
Organization on Security and Cooperation in
 Europe, 78, 76–78
OSCE (Organisation on Security and
 Cooperation in Europe), 164
OSCE Organisation on Security and
 Cooperation in Europe, 59, 76, 77, 78, 164, 169

P

Peters, Julie, 185
Platform for Action (Beijing), 14, 162, 173, 187
press freedom, 60
Protocol Relating to the Status of Refugees, 164
protocols, 19, 58, 64, 65, 104, 148, 169

R

rapporteurs, 33, 34
ratification, 10, 12, 58, 70, 111
refugees, 52, 53, 54, 146, 164
Refugees, 15, 19, 24, 52, 164, 170
reporting, 9, 12, 14, 15, 17, 19, 24, 27, 28, 29,
 30, 32, 37, 38, 46, 52, 54, 68, 69, 70, 73, 74,
 76, 77, 91, 103, 104, 164, 168
reservations, 11, 12, 36, 37, 38, 64, 170
right of disabled persons, 67
right to a fair trial, 60
right to equal opportunities, 67
right to housing, 67
right to protection against poverty, 67
role of advocates, 28, 37, 41, 47, 50, 53, 62, 68,
 73, 74, 77, 86, 91, 94, 98, 102
rules of evidence, 63

S

Schuler, Margaret, 127, 185
Secretary General, 37, 40, 41, 102, 103, 162
Sisterhood is Global Institute, 189
Special Rapporteur on Violence Against
Women, 32–33
Special Rapporteurs and Working Groups,
 32–34
specialized agencies of the UN, 13
state complaints, 59, 66

T

Third Committee, 10
Thomas, Dorothy Q, 186
treaty, 9, 10, 11, 12, 13, 15, 17, 18, 19, 20, 24,
 27, 32, 36, 38, 50, 58, 76, 80, 81, 95, 109,
 110, 111, 122, 150, 157, 162, 164, 165, 168,
 170, 171, 172
Treaty of Rome, 59, 80, 82, 83
Treaty-monitoring bodies, 15

U

UDHR (Universal Declaration of Human
 Rights), 9, 10, 171
UN Centre for Human Rights (Geneva), 15, 29,
 34, 40, 41, 181, 186, 191
UN Commission on Human Rights, 9, 185
UN Committee on Human Rights, 32, 24–32
UN Conferences
 Conference on Human Rights (Vienna,
 1993), 8, 11, 76, 77, 119, 171, 173, 180, 184
 World Conference on Population and
 Development (Cairo, 1994), 162, 184, 185
 World Conference on Women (Beijing,
 1995), 14, 50, 109, 162, 171, 173, 184,
 185, 187
 World Conference on Women (Nairobi,
 1985), 50, 169, 171
UN High Commissioner for Refugees, 54, 52–54
UN human rights system, 9, 15, 18, 119
UNHCR, 15, 52, 53, 54, 170, 171
Universal Declaration of Human Rights, 9, 10,
 41, 113, 173
unlawful detention, 60

V

Vienna Declaration, 8, 11, 119, 173, 184
Vienna Declaration and Programme of Action,
 8
Vivanco, Jose Miguel, 181

W

Women in Law and Development in Africa
(WiLDAF), 189
Women Living Under Muslim Laws, 189
Women, Law & Development International,
189
women's human rights
 violations of, 27, 52, 53, 54, 86, 89, 92, 116,
 119, 120, 121, 126, 127, 140
World Conference on Human Rights. See UN
 Conferences
written argument, 63